THE FILM SENSE

THE FILM SENSE

SERGEI M. EISENSTEIN
translated and edited by
JAY LEYDA

faber and faber
LONDON · BOSTON

First published in 1943
by Faber and Faber Limited
3 Queen Square London WC1N 3AU

First paperback edition
published in 1958
This edition published
in 1986

Printed in Great Britain by Clays Ltd, St Ives plc
All rights reserved

ISBN 0 571 08575 X

4 6 8 10 9 7 5 3

CONTENTS

ILLUSTRATIONS

TRANSLATOR'S NOTE

Sergei Eisenstein's contribution to the film medium is a double one—as film-maker and as film-teacher. Since all but one of his six completed films have enjoyed wide circulation in this country, his contribution as a creative director is well known. American and English film-makers have had, however, only scattered opportunities to appreciate his contribution in the field of theory. His Soviet pupils in the State Institute of Cinematography are his chief beneficiaries in this regard.

This film-maker's first book of theory is primarily for the use of other film-makers. Yet, without any paradoxical intent, it can be said that only such a professionally aimed book can to any appreciable extent inform the layman or the artist in another medium, or can encourage the reader to dive below the surface of general appreciation.

One factor is taken so much for granted in Eisenstein's native land that it obviously seemed unnecessary to stress it in this text. He has discussed in detail certain means whereby the spectator's reactions can be fused with the creative process, producing a richer emotional expression of a film's theme. But the thoroughness with which he investigates these means should mislead no one into assuming that in his view they represent ends in themselves, or that an emotion or a sensation represents an end in itself. The purposive direction of the spectator's emotion is a social responsibility, and all art in the Soviet Union is conscious of that responsibility—in time of peace as well as of war. This social function—which to-day merits particular attention from our own film-makers—underlines every word of Eisenstein's film theory.

Although this is Eisenstein's first book, its uncompromising persistence of argument will not surprise readers who have followed his articles on film theory as they have appeared in American and English journals. For readers to whom the present work is an introduction to Eisenstein as analyst, a guide to his earlier writing has been provided among the appendices.

The choice of documents in the appendices has been governed largely by an effort to show the stages of a film concept on its way to completed film form—from the first sketched structure of *Que Viva Mexico!* through the notes for picture and sound images of *Sutter's Gold*, through the first full outline of a sequence in *An American Tragedy*, to the blueprint of *Ferghana Canal*—ready for final construction. (The searching reader will discover in this last fragment evidence that Eisenstein has employed the contents of this book to teach himself as well as others.) The analysis of *Alexander Nevsky* in Part IV, 'Form and Content: Practice', covers that final stage.

Work on this book provided the kind of pleasure which leaves no room for discussion of difficulties. The only just complaints can come from the many friends upon whom I imposed for the purpose of presenting in its maximum clarity the material of the book. My greatest debt is to Miss Leda Swan for her unstinting contribution of her knowledge of the Russian language. In the other language problems—the translations of the French and German citations from Eisenstein's unlimited field of reference—I am indebted to Helen Grayson, Leonard Mins and Samuel Brody. The text has been materially enriched by Muriel Rukeyser's translation of Rimbaud's *Voyelles*, prepared for this volume. The Chinese citation has been provided through the courtesy of Dr. Chi-Chen Wang of Columbia University, the characters themselves having been lent by the Yale University Press.

The translation has further benefited by the attention and patience with which Lee Strasberg examined the manuscript and Max Goberman's check on its musical material. I owe thanks to Jack Rau for his adaptations of the original Russian

diagrams. A special kind of gratitude is due to the U.S.S.R. Society for Cultural Relations with Foreign Countries (VOKS) for their interest and their facilitating this American edition.

Part I of this book is substantially as translated by Stephen Garry as 'Montage in 1938' in *Life and Letters To-day*, London, and it is through the kind permission of translator and publisher that we are using it in this form.

The section entitled Sources, beginning on page 217, lists the books to which the author refers or the editions from which citations have been made. Acknowledgment is due the publishing houses of Covici, Friede; Dodd, Mead; E. P. Dutton; Houghton Mifflin; International Publishing Company; Alfred A. Knopf; Little, Brown; Macmillan; Random House and Reynal & Hitchcock for permission to reprint from their books. Thanks are due to *Theatre Arts Monthly* for their gracious loan of the engraving of *The Life of Sir Henry Unton*.

There is another debt—a basic debt—to be acknowledged: to those institutions whose profession is intelligent assistance. I want to thank at this time the staffs in the Libraries of Congress, of Columbia University, of the American-Russian Institute, of the Metropolitan Museum, of the Museum of Modern Art, of the Hispanic Society, of the Academy of Medicine and the Frick Art Reference Library. Literally all departmental staffs of the New York Public Library were generous with their time, undoubtedly through the force of generous habit.

J. L.

Although the author is himself of the profession and knows the things that long practice, aided by much special reflection, can teach him about it, he will not linger as much as might be thought over that part of the art which seems the whole of art to many mediocre artists, but without which art would not exist. He will thus seem to encroach on the domain of the critics of esthetic affairs, men who doubtless think that practice is not needed for them to rise to speculative consideration of the arts.

He will treat of philosophic more than of technical matters. That may seem singular in a painter who writes on the arts: many semi-erudite men have treated the philosophy of art. It would seem that their profound ignorance of technical matters was looked on by them as a title to respect, persuaded as they were that preoccupation with this matter, so vital to every art, debarred professional artists from esthetic speculation.

It would seem almost that they had imagined a profound ignorance of technical matters to be one reason more for rising to purely metaphysical considerations, in a word that preoccupation with a craft must render professional artists rather unfit to rise to the heights which are forbidden to the people outside esthetics and pure speculation.

EUGÈNE DELACROIX[1]

CHAPTER I

WORD AND IMAGE

Every word has been permeated, as every image has been transmuted, through the imaginative intensity of one compelling creative act. 'Consider it well,' says Abt Vogler of the musician's analogous miracle:

> *Consider it well: each tone of our scale in itself is nought;*
> *It is everywhere in the world—loud, soft, and all is said:*
> *Give it to me to use! I mix it with two in my thought:*
> *And, there! Ye have heard and seen: consider and bow the head!*

Give Coleridge one vivid word from an old narrative; let him mix it with two in his thought; and then (translating terms of music into terms of words) 'out of three sounds he [will] frame, not a fourth sound, but a star'.

<div align="right">JOHN LIVINGSTON LOWES[2]</div>

There was a period in Soviet cinema when montage was proclaimed 'everything'. Now we are at the close of a period during which montage has been regarded as 'nothing'. Regarding montage neither as nothing nor everything, I consider it opportune at this juncture to recall that montage is just as indispensable a component feature of film production as any other element of film effectiveness. After the storm 'for montage' and the battle 'against montage', we must approach its problems simply and afresh. This is all the more necessary because in the period of 'renunciation' of montage, its most incontrovertible aspect, the one really immune to challenge, was also repudiated. The point is that the creators of a number of films in recent years have so completely 'discarded' montage that they have forgotten even its basic aim and function: that role set itself by every work of art, *the need for connected and sequential exposition of the theme, the material, the plot, the action,* the movement within the film sequence and within the film drama as a whole. Aside from

the *excitement* of a story, or even its logic or continuity, the simple matter of telling *a connected story* has often been lost in the works of some outstanding film masters, working in various types of films. What we need, of course, is not so much an individual criticism of those masters, but primarily an organized effort to recover the montage culture that so many have lost. This is all the more necessary since our films are faced with the task of presenting not only a narrative that is *logically connected*, but one that contains a *maximum of emotion and stimulating power*.

Montage is a mighty aid in the resolution of this task.

Why do we use montage at all? Even the most fanatical opponent of montage will agree that it is not merely because the film strip at our disposal is not of infinite length, and consequently, being condemned to working with pieces of restricted lengths, we have to stick one piece of it on to another occasionally.

The 'leftists' of montage saw it from the opposite extreme. While playing with pieces of film, they discovered a certain property in the toy which kept them astonished for a number of years. This property consisted in the fact *that two film pieces of any kind, placed together, inevitably combine into a new concept, a new quality, arising out of that juxtaposition*.

This is not in the least a circumstance peculiar to the cinema, but is a phenomenon invariably met with in all cases where we have to deal with juxtaposition of two facts, two phenomena, two objects. We are accustomed to make, almost automatically, a definite and obvious deductive generalization when any separate objects are placed before us side by side. For example, take a grave, juxtaposed with a woman in mourning weeping beside it, and scarcely anybody will fail to jump to the conclusion: *a widow*. It is precisely on this feature of our perception that the following miniature story by Ambrose Bierce bases its effect. It is from his *Fantastic Fables* and is entitled 'The Inconsolable Widow':

A Woman in widow's weeds was weeping upon a grave.

'Console yourself, madam,' said a Sympathetic Stranger.

'Heaven's mercies are infinite. There is another man somewhere, besides your husband, with whom you can still be happy.'

'There was,' she sobbed—'there was, but this is his grave.'[3]

The whole effect of this is built upon the circumstance that the grave and the woman in mourning beside it lead to the inference, from established convention, that she is a widow mourning her husband, whereas in fact the man for whom she is weeping is her lover.

The same circumstances is often found in riddles—for example, this one from international folk-lore: 'The raven flew, while a dog sat on its tail. How can this be?' We automatically combine the juxtaposed elements and reduce them to a unity. As a result, we understand the query as though the dog were sitting on the tail of the raven, while actually, the riddle contains two unrelated actions: the raven flies, while the dog sits on its own tail.

This tendency to bring together into a unity two or more independent objects or qualities is very strong, even in the case of separate words, characterizing different aspects of some single phenomenon.

An extreme instance of this can be found in that inventor of the 'portmanteau word', Lewis Carroll. His modest declaration of his invention, of 'two meanings packed into one word like a portmanteau', concludes his introduction to *The Hunting of the Snark:*

For instance, take the two words 'fuming' and 'furious'. Make up your mind that you will say both words, but leave it unsettled which you will say first. Now open your mouth and speak. If your thoughts incline ever so little towards 'fuming', you will say 'fuming-furious'; if they turn, by even a hair's breadth, towards 'furious', you will say 'furious-fuming'; but if you have that rarest of gifts, a perfectly balanced mind, you will say 'frumious'.[4]

Of course, in this instance we do not gain a new concept, or a new quality. The charm of this 'portmanteau' effect is built upon the sensation of duality residing in the arbitrarily formed single word. Every language has its 'portmanteau' practitioner—the American language has its Walter Win-

chell. Obviously, the greatest manipulation of the portmanteau word is to be found in *Finnegans Wake*.

Essentially, therefore, Carroll's method is a *parody* of a natural phenomenon, a part of our common perception—the formation of qualitatively new unities; hence it is a basic method of building comic effects.

This comic effect is achieved through the perception of both the new result and its two independent parts—all at the same time. Instances of this kind of wit are innumerable. I shall cite here only three such examples that one can find— in Freud:

During the war between Turkey and the Balkan States, in 1912, *Punch* depicted the part played by Roumania by representing the latter as a highwayman holding up the members of the Balkan alliance. The picture was entitled: *Kleptoroumania*. . . .

A naughty jest of Europe has rebaptized a former potentate, Leopold, into *Cleopold* because of his relation to a lady surnamed Cleo. . . .

In a short story . . . one of the characters, a 'sport', speaks of the Christmas season as the *alcoholidays*. By reduction it can be easily seen that we have here a compound word, a combination of *alcohol* and *holidays*. . . .[5]

I think it is apparent that the phenomenon we are discussing is more than widespread—it is literally universal.

Hence there is nothing surprising in the circumstance that a film audience also draws a definite inference from the juxtaposition of two strips of film cemented together.

We are certainly not criticizing all these facts, nor their noteworthiness, nor universality, but simply the false deductions and conclusions that have been drawn from them. On this basis it will be possible to make the necessary corrections.

Of what omission were we guilty when we first remarked the undoubted importance of the above phenomenon to an understanding and mastery of montage? What was true, and what false, in our enthusiastic declarations at that time?

The basic fact was true, and remains true to this day, that

the juxtaposition of two separate shots by splicing them together resembles not so much a simple sum of one shot plus another shot—as it does a *creation*. It resembles a creation—rather than a sum of its parts—from the circumstance that in every such juxtaposition *the result is qualitatively* distinguishable from each component element viewed separately. At this late date no one need really be reminded that quantity and quality are not two different properties of a phenomenon but only different aspects of the same phenomenon. This law of physics is just as true in other spheres of science and in art. Of the many fields to which it can be applied, Professor Koffka's application of it to the field of behaviour is apropos to our discussion:

It has been said: The whole is more than the sum of its parts. It is more correct to say that the whole is something else than the sum of its parts, because summing is a meaningless procedure, whereas the whole-part relationship is meaningful.[6]

The woman, to return to our first example, is a representation, the mourning robe she is wearing is a representation—that is, both are *objectively representable*. But '*a widow*', arising from a juxtaposition of the two representations, is objectively unrepresentable—a new idea, a new conception, a new image.

What was the 'distortion' in our attitude at that time to this 'ndisputable phenomenon?

The error lay in placing the main emphasis on the possibilities of juxtaposition, while less attention seemed to be paid to the problem of *analysing* the *material* that was juxtaposed.

My critics did not fail to represent this as a lack of interest in the *content* of the film shot-pieces, confusing *research* in one aspect of a problem with the attitude of the researcher to the representation of reality.

I leave them to their consciences.

The trouble arose from my having been charmed primarily with that newly revealed feature of the film strips—that, no matter how unrelated they might be, and frequently despite themselves, they engendered a 'third something' and became

correlated when juxtaposed according to the will of an editor.

Hence I was preoccupied by a potentiality untypical in normal film construction and film composition.

Operating at the outset with such material and such occurrences, it was natural to speculate principally upon the potentialities of juxtaposition. Less attention was given to an *analysis* of the actual nature of the pieces juxtaposed. Such attention would not have been sufficient in itself. History has proved that such attention, directed solely to the content of single shots, led in practice to a decline of montage to a level of 'special effects', 'montage sequences', etc., with all the consequences this involved.

What should have been the proper emphasis, what should have received the principal attention, in order that neither element would be unduly exaggerated?

It was necessary to turn to that fundamental basis which equally determines both the content enclosed by single frames and the compositional juxtaposition of these separate contents with each other, i.e., to the content of the *whole*, of the general and *unifying* needs.

One extreme consisted in distraction with problems of the technique of unification (the methods of montage), the other —with the unified elements (the content of the shot).

We should have occupied ourselves more with an examination of the nature of the *unifying principle* itself. This is precisely that principle which should determine both the content of the shot and that content which is revealed through a given *juxtaposition of these shots*.

But with this in mind it was necessary for the researcher's interest to be turned primarily not in the direction of paradoxical cases, where this whole, general, final result is not *foreseen* but emerges unexpectedly. We should have turned to those cases where the shot-pieces are not only not unrelated to each other, but where this *final*, this *general*, this *whole* result is not merely foreseen, but itself predetermines both the individual elements and the circumstances of their juxtaposition. Such cases are normal, generally accepted and fre-

quent in occurrence. In such cases the whole emerges perfectly as 'a third something'. The full picture of the whole, as determined both by the shot and by montage, also emerges, vivifying and distinguishing both the content of the shot and the content of the montage. It is cases of this kind that are typical for cinematography.

With montage considered in this light, both single shots and their juxtaposition fall into a correct mutual relationship. In addition to this, the very nature of montage not only ceases to be divorced from the principles of realistic film delineation, but serves as one of the most coherent and practical resources for realistic narration of film content.

What is essentially involved in such an understanding of montage? In such a case, each montage piece exists no longer as something unrelated, but as a given *particular representation* of the general theme that in equal measure penetrates *all* the shot-pieces. The juxtaposition of these partial details in a given montage construction calls to life and forces into the light that *general* quality in which each detail has participated and which binds together all the details into a *whole*, namely, into that generalized *image*, wherein the creator, followed by the spectator, experiences the theme.

If *now* we consider two pieces of film placed together, we appreciate their juxtaposition in a rather different light. Namely:

Piece *A* (derived from the elements of the theme being developed) and piece *B* (derived from the same source) in juxtaposition give birth to the image in which the thematic matter is most clearly embodied.

Expressed in the imperative, for the sake of stating a more exact working formula, this proposition would read:

Representation A and *representation* B must be so selected from all the possible features within the theme that is being developed, must be sought for, that their *juxtaposition*—that is, the juxtaposition of *those very elements* and not of alternative ones—shall evoke in the perception and feelings of the spectator the most complete *image of the theme itself*.

Into our discussion of montage two new terms have entered: 'representation' and 'image'. I want to define the demarcation between these terms before we proceed further.

We turn to an example for demonstration. Take a white circular disc of average size and smooth surface, its circumference divided into sixty equal parts. At every fifth division is set a figure in the order of succession of 1 to 12. At the centre of the disc are fixed two metal rods, moving freely on their fixed ends, pointed at their free ends, one being equal to the radius of the disc, the other rather shorter. Let the longer pointed rod have its free end resting at the figure 12, and the shorter, in succession, have its free end pointing toward the figures 1, 2, 3, and so on up to 12. This will comprise a series of *geometrical* representations of successive relations of the two metal rods to one another expressed in the dimensions 30, 60, 90 degrees, and so on up to 360 degrees.

If, however, this disc be provided with a mechanism that imparts steady movement to the metal rods, the geometrical figure formed on its surface acquires a special meaning: it is now not simply a *representation*, it is an *image* of time.

In this instance, the representation and the image it evokes in our perception are so completely fused that only under special conditions do we distinguish the geometrical figure formed by the hands on the dial of the clock from the concept of time. Yet this can happen to any one of us, given, admittedly, the unusual circumstances.

It happened to Vronsky after Anna Karenina tells him that she is pregnant:

When Vronsky looked at his watch on the Karenins' verandah he was so agitated and so preoccupied that he saw the hands and the face of the watch without realizing the time.[7]

In his case, the *image* of time created by the watch did not arise. He saw only the geometrical representation formed by the watch dial and the hands.

As we can see in even so simple an instance, where the question touches only astronomical time, the hour, the representation formed by the clock dial is insufficient in itself. It is not enough merely to see—something has to happen to the representation, something more has to be done with it, before it can cease to be perceived as no more than a simple geometrical figure and can become perceptible as the image of some particular 'time' at which the event is occurring. Tolstoy points out to us what happens when this process does not take place.

What exactly is this process? A given order of hands on the dial of a clock invokes a host of representations associated with the time that corresponds to the given order. Suppose, for example, the given figure be five. Our imagination is trained to respond to this figure by calling to mind pictures of all sorts of events that occur at that hour. Perhaps tea, the end of the day's work, the beginning of rush hour on the subway, perhaps shops closing, or the peculiar late afternoon light. . . . In any case we will automatically recall a series of pictures (representations) of what happens at five o'clock.

The image of five o'clock is compounded of all these individual pictures.

This is the full sequence of the process, and it is such at the point of assimilating the representations formed by the figures which evoke the images of the times of day and night.

Thereafter the laws of economy of psychic energy come into force. There occurs 'condensation' within the process above described: the chain of intervening links fall away, and there is produced instantaneous connection between the figure and our perception of the time to which it corresponds. The example of Vronsky shows us that a sharp mental disturbance can cause this connection to be destroyed, and the representation and the image become severed from each other.

We are considering here the *full* presentation of the process which takes place when an image is formed from a representation, as described above.

These 'mechanics' of the formation of an image interest us

because the mechanics of its formation in *life* turn out to be the prototype of the method of creating images in art.

To recapitulate: between the representation of an hour on the dial of the clock and our perception of the image of that hour, there lies a long chain of linked representations of separate characteristic aspects of that hour. And we repeat: that psychological habit tends to reduce this intervening chain to a minimum, so that only the beginning and the end of the process are perceived.

But as soon as we need, for any reason, to establish a connection between a representation and the image to be evoked by it in the consciousness and feelings, we are inevitably compelled to resort again to a chain of intervening representations which, in aggregate, form the image.

Consider first an example approximating closely the other example from everyday life.

In New York City most of the streets have no names. Instead, they are distinguished by numbers—Fifth Avenue, Forty-Second Street, and so on. Strangers find this method of designating streets extraordinarily difficult to remember at first. We are used to streets with names, which is much easier for us, because each name at once brings up an image of the given street, i.e., when you hear the street name, this evokes a particular complex of sensations and, together with them, the image.

I found it very difficult to remember the *images* of New York's streets and, consequently, to recognize the streets themselves. Their designations, neutral numbers like 'Forty-second' or 'Forty-fifth', failed to produce images in my mind that would concentrate my perception on the general features of one or the other street. To produce these images, I had to fix in my memory a set of objects characteristic of one or another street, a set of objects aroused in my consciousness in answer to the signal 'Forty-second', and quite distinct from those aroused by the signal 'Forty-fifth'. My memory assembled the theatres, stores and buildings, characteristic of each of the streets I had to remember. This process went through

definite stages. Two of these stages should be noted: in the first, at the verbal designation: 'Forty-second Street', my memory with great difficulty responded by enumerating the whole chain of characteristic elements, but I still obtained no true perception of the street because the various elements had not yet been consolidated into a single image. Only in the second stage did all the elements begin to fuse into a single, emerging image: at the mention of the street's 'number', *there still arose this whole host of its separate elements, but now not as a chain, but as something single*—as a whole characterization of the street, *as its whole image*.

Only after this stage could one say that one had really *memorized* the street. The image of the given street began to emerge and live in the consciousness and perception exactly as, in the course of creating a work of art, its single, recognizable whole image is gradually composed out of its elements.

In both cases—whether it be a question of memorizing or the process of perceiving a work of art—the procedure of entering the consciousness and feelings through the whole, the whole *through the image*, remains obedient to this law.

Further, though the image enters the consciousness and perception *through aggregation*, every detail is preserved in the sensations and memory *as part of the whole*. This obtains whether it be a sound image—some rhythmic or melodic sequence of sounds, or whether it be a plastic, a visual image, embracing in pictorial form a remembered series of separate elements.

In one way or another, the series of ideas is built up in the perception and consciousness into a whole image, storing up the separate elements.

We have seen that in the process of remembering there are two very essential stages: the first is the *assembling* of the image, while the second consists in the *result* of this assembly and its significance for the memory. In this latter stage it is important that the memory should pay as little attention as possible to the first stage, and reach the result after passing through

the stage of assembling as swiftly as possible. Such is practice in life in contrast to practice in art. For when we proceed into the sphere of art, we discover a marked displacement of emphasis. Actually, to achieve its result, a work of art directs all the refinement of its methods to the *process*.

A work of art, understood dynamically, is just this process of arranging images in the feelings and mind of the spectator.* It is this that constitutes the peculiarity of a truly vital work of art and distinguishes it from a lifeless one, in which the spectator receives the represented result of a given consummated process of creation, instead of being drawn into the process as it occurs.

This condition obtains everywhere and always, no matter what the art form under discussion. For example, the life-like acting of an actor is built, not on his representing the copied results of feelings, but on his causing the feelings to *arise, develop, grow into other feelings—to live before the spectator*.

Hence the image of a scene, a sequence, of a whole creation, exists not as something fixed and ready-made. It has to arise, to unfold before the senses of the spectator.

In the same way a character (both in the writing and in the performing of a role), if it is to produce a genuinely living impression, must be built up for the spectator in the course of the action, and not be presented as a clockwork figure with set *a priori* characteristics.

In drama it is particularly important that the course of the action should not only build up an *idea* of the character, but also should build up, should 'image', *the character itself*.

Consequently, in the actual method of creating images, a work of art must reproduce that process whereby, *in life itself*, new images are built up in the human consciousness and feelings.

We have just shown the nature of this in our example of the numbered streets. And we should be correct in expecting an

* Later we shall see that this same dynamic principle lies at the base of all truly vital images, even in such an apparently immobile and static medium as, for example, painting.

artist, faced with the task of expressing a given image by factual representation, to resort to a method precisely like this 'assimilation' of the streets of New York.

We also used the example of the representation formed by the dial of a clock, and revealed the process whereby the image of time arises in consequence of this representation. To create an image, a work of art must rely upon a precisely analogous method, the construction of a chain of representations.

Let us examine more broadly this example of time.

With Vronsky, above, the geometrical figure failed to come to life as an image of time. But there are cases when what is important is not to perceive the hour of twelve midnight chronometrically, but to experience midnight in all the associations and sensations the author chooses to evoke in pursuance of his plot. It may be an hour of the anxious awaiting of a midnight assignation, an hour of death at midnight, the hour of a fateful midnight elopement, in other words it may well be far from a simple representation of the chronometrical hour of twelve midnight

In such a case, *from a representation of the twelve strokes* must emerge the image of midnight as a kind of 'hour of fate', charged with significance.

This can also be illustrated by an example—this time from Maupassant's *Bel Ami*. The example has an additional interest in that it is auditory. And yet another because, in its nature pure montage, by the correctly chosen method of its resolution it is presented in the story as a narration of actual events.

The scene is the one where Georges Duroy (who now writes his name Du Roy) is waiting in the cab for Suzanne, who has agreed to flee with him at midnight.

Here twelve o'clock at night is only in the slightest degree the chronometrical hour and is in the greatest degree the hour at which all (or at any rate a very great deal) is at stake. ('*It is all over. It is a failure. She won't come.*')

This is how Maupassant drives into the reader's conscious-

ness and feelings the image of this hour and its *significance*, in distinction from a mere description of the particular time of night:

He went out towards eleven o'clock, wandered about some time, took a cab, and had it drawn up in the Place de la Concorde, by the Ministry of Marine. From time to time he struck a match to see the time by his watch. When he saw midnight approaching, his impatience became feverish. Every moment he thrust his head out of the window to look. A distant clock struck twelve, then another nearer, then two together, then a last one, very far away. When the latter had ceased to sound, he thought: 'It is all over. It is a failure. She won't come.' He had made up his mind, however, to wait till daylight. In these matters one must be patient.

He heard the quarter strike, then the half-hour, then the quarter to, and all the clocks repeated 'one', as they had announced midnight. . . .[8]

In this example, we see that when Maupassant wanted to chisel into the reader's consciousness and sensations the *emotional* quality of the midnight hour, he did not confine himself to saying merely that first midnight struck and then one. He forced us to experience the sensation of midnight by making twelve o'clock strike in various places on various clocks. Combining in our perception, these individual groups of twelve strokes are built up into a general sensation of midnight. *The separate representations are built up into an image.* This was done entirely through montage.

The example from Maupassant can serve as a model for the most polished kind of montage scripting, where '12 o'clock' in sound is denoted by means of a whole series of shots 'from different camera-angles': 'distant', 'nearer', 'very far away'. This striking of the clocks, recorded at various distances, is like the shooting of an object from various camera set-ups and repeated in a series of three different shot-pieces: 'long shot', 'medium shot', 'distant shot'. Moreover, the actual striking or, more correctly, the varied striking of the clocks is chosen not in the least for its virtue as a naturalistic detail of Paris at night. The primary effect of this conflicting

striking of clocks in Maupassant is the insistent stressing of the emotional image of the 'fateful midnight hour', not the mere information that it is '12.0 p.m.'.

If his object had been merely to convey the information that it was then twelve o'clock at night, Maupassant would scarcely have resorted to such a polished piece of writing. Just as, without a carefully chosen creative-montage solution of this kind, he would never have achieved, by such simple means, so palpable an emotional effect.

While we are on the subject of clocks and hours, I am reminded of an example from my own practice. During the filming of *October*, we came across, in the Winter Palace, a curious specimen of clock: in addition to the main clock dial, it possessed also a wreath of small dials ranged around the rim of the large one. On each of the dials was the name of a city: Paris, London, New York, Shanghai, and so on. Each told the time as it happened to be in each city, in contrast with the time in Petrograd shown by the main face. The appearance of this clock stuck in our memory. And when in our film we needed to drive home especially forcefully the historic moment of victory and establishment of Soviet power this clock suggested a specific montage solution: we repeated the hour of the fall of the Provisional Government, depicted on the main dial in Petrograd time, throughout the whole series of subsidiary dials recording the time in London, Paris, New York, Shanghai. Thus this hour, unique in history and in the destiny of peoples, emerged through all the multitudinous variety of local readings of time, as though uniting and fusing all peoples in the perception of the moment of victory. The same concept was also illuminated by a rotating movement of the wreath of dials itself, a movement which, as it grew and accelerated, also made a plastic fusion of all the different and separate indices of time in the sensation of one single historic hour. . . .

At this point I hear a question from my invisible opponents: 'That's all very well for you to say, but what about a single unbroken, uncut strip of film containing the perform-

ance of an actor—what has this to do with montage? Doesn't
his acting, of itself, make an impression? Doesn't the per-
formance of a role by Cherkasov* or Okhlopkov,† Chirkov‡
or Sverdlin§ also make an impression?' It is futile to suppose
that this question inflicts a mortal blow on the conception of
montage. The principle of montage is far broader than such
a question assumes. It is entirely incorrect to assume that as
an actor acts in a single unbroken strip of film, uncut by the
director and cameraman into different camera-angles, such
a construction is untouched by montage! By no means!

In such a case all we have to do is look for montage else-
where, in fact, *in the performance of the actor*. And the question
of the extent to which the principle of the 'inner' technique
of acting is related to montage we shall discuss later. At the
moment it will be sufficient to let a leading artist of the stage
and screen, George Arliss, contribute to this question:

> I had always believed that for the movies, acting must be ex-
> aggerated, but I saw in this one flash that *restraint* was the chief
> thing that the actor had to learn in transferring his art from the
> stage to the screen. . . . The art of restraint and suggestion on
> the screen may any time be studied by watching the acting of the
> inimitable Charlie Chaplin.[9]

To emphasized representation (exaggeration), Arliss coun-
terposes restraint. He sees the degree of this restraint in the
reduction of actuality to suggestion. He rejects not merely
the exaggerated representation of actuality, but even the
representation of actuality in entirety! In its place he coun-
sels suggestion. But what is 'suggestion' if it not be an ele-
ment, a detail of actuality, a 'close-up' of actuality, which, in
juxtaposition with other details, serves as a determination of

* Nikolai Cherkasov, as Prof. Polezhayev in *Baltic Deputy*, the Tzare-
vich Alexei in *Peter the First*, and as Alexander Nevsky.

† Nikolai Okhlopkov, as Vasili in *Lenin in October* and *Lenin in 1918*, and
as Vasili Buslai in *Alexander Nevsky*.

‡ Boris Chirkov, as Maxim in the *Maxim* Trilogy, and as *The New
Teacher*.

§ Lev Sverdlin, as the spy Tzoi, in *In the Far East*, Colonel Usizhima
in *The Defence of Volochayevsk*, and as Chubenko in *Guerrilla Brigade*.

the entire fragment of actuality? Thus, according to Arliss, the fused effective piece of acting is nothing but a juxtaposition of determining close-ups of this kind; combined, they create the image of the acting's content. And, to proceed further, the actor's acting may have the character of a flat representation or of a genuine image according to the method he uses to construct his performance. Even though his performance be shot entirely from a single set-up (or even from a single seat in a theatre auditorium), none the less—in a felicitous case—the performance will itself be 'montage' in character.

It should be remarked that the second example of montage cited above (from *October*) is not an example of everyday montage, and that the first example (from Maupassant) illustrates only a case where an object is shot from various set-ups with various camera-angles.

Another example that I will cite is quite typical for cinematography, no longer concerned with an individual object, but instead, with an image of a whole phenomenon—composed, however, in exactly the same way.

This example is a certain remarkable 'shooting-script'. In it, from a cumulative massing of contributory details and pictures, an image palpably arises before us. It was not written as a finished work of literature, but simply as a note of a great master in which he attempted to put down on paper for his own benefit his visualization of The Deluge.

The 'shooting-script' to which I refer is Leonardo da Vinci's notes on a representation of The Deluge in painting. I choose this particular example because in it the *audio-visual* picture of The Deluge is presented with an unusual clarity. Such an accomplishment of sound and picture co-ordination is remarkable coming from any painter, even Leonardo:

Let the dark, gloomy air be seen beaten by the rush of opposing winds wreathed in perpetual rain mingled with hail, and bearing hither and thither a vast network of the torn branches of trees mixed together with an infinite number of leaves.

29

All around let there be seen ancient trees uprooted and torn in pieces by the fury of the winds.

You should show how fragments of mountains, which have been already stripped bare by the rushing torrents, fall headlong into these very torrents and choke up the valleys,

until the pent-up rivers rise in flood and cover the wide plains and their inhabitants.

Again there might be seen huddled together on the tops of many of the mountains many different sorts of animals, terrified and subdued at last to a state of tameness, in company with men and women who had fled there with their children.

And the fields which were covered with water had their waves covered over in great part with tables, bedsteads, boats and various other kinds of rafts, improvised through necessity and fear of death,

upon which were men and women with their children, massed together and uttering various cries and lamentations, dismayed by the fury of the winds which were causing the waters to roll over and over in mighty hurricane, bearing with them the bodies of the drowned;

and there was no object that floated on the water but was covered with various different animals who had made truce and stood huddled together in terror, among them wolves, foxes, snakes and creatures of every kind, fugitives from death.

And all the waves that beat against their sides were striking them with repeated blows from the various bodies of the drowned, and the blows were killing those in whom life remained.

Some groups of men you might have seen with weapons in their hands defending the tiny footholds that remained to them from the lions and wolves and beasts of prey which sought safety there.

Ah, what dreadful tumults one heard resounding through the gloomy air, smitten by the fury of the thunder and the lightning it flashed forth, which sped through it, bearing ruin, striking down whatever withstood its course!

Ah, how many might you have seen stopping their ears with their hands in order to shut out the loud uproar caused through the darkened air by the fury of the winds mingled together with the rain, the thunder of the heavens and the raging of the thunderbolts!

Others were not content to shut their eyes but placing their hands

over them, one above the other, would cover them more tightly in order not to see the pitiless slaughter made of the human race by the wrath of God.

Ah me, how many lamentations!

How many in their terror flung themselves down from the rocks!

You might have seen huge branches of the giant oaks laden with men borne along through the air by the fury of the impetuous winds.

How many boats were capsized and lying, some whole, others broken in pieces, on the top of men struggling to escape with acts and gestures of despair which foretold an awful death.

Others with frenzied acts were taking their own lives, in despair of ever being able to endure such anguish;

some of these were flinging themselves down from the lofty rocks.

others strangled themselves with their own hands;

some seized hold of their own children,

and with mighty violence slew them at one blow;

some turned their arms against themselves to wound and slay; others falling upon their knees were commending themselves to God.

Alas! how many mothers were bewailing their drowned sons, holding them upon their knees, lifting up open arms to heaven, and with divers cries and shrieks declaiming against the anger of the gods!

Others with hands clenched and fingers locked together gnawed and devoured them with bites that ran blood, crouching down so that their breasts touched their knees in their intense and intolerable agony.

Herds of animals, such as horses, oxen, goats, sheep, were to be seen already hemmed in by the waters, and left isolated upon the high peaks of the mountains, all huddling together,

and those in the middle climbing to the top and treading on the others, and waging fierce battles with each other, and many of them dying from want of food.

And the birds had already begun to settle upon men and other animals, no longer finding any land left unsubmerged which was not covered with living creatures.

Already had hunger, the minister of death, taken away their life from the greater number of animals, when the dead bodies already becoming lighter began to rise from out the bottom of the deep

waters, and emerged to the surface among the contending waves; and there lay beating one against another, and as balls puffed up with wind rebound back from the spot where they strike, these fell back and lay upon the other dead bodies.

And above these horrors the atmosphere was seen covered with murky clouds that were rent by the jagged course of the raging thunderbolts of heaven, which flashed light hither and thither amid the obscurity of the darkness. . . .[10]

The foregoing was not intended by its author as a poem or literary sketch. Péladan, the editor of the French edition of Leonardo's *Trattata della Pittura*, regards this description as an unrealized plan for a picture, which would have been an unsurpassed 'chef d'œuvre of landscape and the representation of elemental struggles'.[11] None the less the description is not a chaos but is executed in accordance with features that are characteristic rather of the 'temporal' than of the 'spatial' arts.

Without appraising in detail the structure of this extraordinary 'shooting-script', we must point, however, to the fact that the description follows a quite definite *movement*. Moreover, *the course of this movement* is not in the least fortuitous. The movement follows a definite order, and then, in corresponding *reverse order*, returns to phenomena matching those of the opening. Beginning with a description of the heavens, the picture ends with a similar description, but considerably increased in intensity. Occupying the centre is the group of humans and their experiences; the scene develops from the heavens to the humans, and from the humans to the heavens, passing groups of animals. The details of largest scale (the close-ups) are found in the centre, at the climax of the description ('. . . *hands clenched and fingers locked together . . . bites that ran blood . . .*'). In perfect clarity emerge the typical elements of a montage composition.

The content within each frame of the separate scenes is enforced by the increasing intensity in the action.

Let us consider what we may call the 'animal theme': animals trying to escape; animals borne by the flood; animals

drowning; animals struggling with human beings; animals fighting one another; the carcasses of drowned animals floating to the surface. Or the progressive disappearance of terra firma from under the feet of the people, animals, birds, reaching its culmination at the point where the birds are forced to settle on the humans and animals, not finding any unsubmerged and unoccupied land. This passage forcibly recalls to us that the distribution of details in a picture on a single plane also presumes movement—a compositionally directed movement of the eyes from one phenomenon to another. Here, of course, movement is expressed less directly than in the film, where the eye *cannot* discern the succession of the sequence of details in any other order than that established by him who determines the order of the montage.

Unquestionably though, Leonardo's exceedingly sequential description fulfils the task not of merely listing the details, but of outlining the trajectory of the future movement of the attention over the surface of the canvas. Here we see a brilliant example of how, in the apparently static simultaneous 'co-existence' of details in an immobile picture, there has yet been applied exactly the same montage selection, there is exactly the same ordered succession in the juxtaposition of details, as in those arts that include the time factor.

Montage has a realistic significance when the separate pieces produce, in juxtaposition, the generality the synthesis of one's theme. This is the image, incorporating the theme.

Turning from this definition to the creative process, we shall see that it proceeds in the following manner. Before the inner vision, before the perception of the creator, hovers a given image, emotionally embodying his theme. The task that confronts him is to transform this image into a few basic *partial representations* which, in their combination and juxtaposition, shall evoke in the consciousness and feelings of the spectator, reader, or auditor, that same initial general image which originally hovered before the creative artist.

This applies both to the image of the work of art as a whole and the image of each separate scene or part. This holds true

in precisely the same sense for the actor's creation of an image.

The actor is confronted with exactly the same task: to express, in two, three, or four features of a character or of a mode of behaviour, those basic elements which in juxtaposition create the integral image that was worked out by the author, director and the actor himself.

What is most noteworthy in such a method? First and foremost, its dynamism. This rests primarily in the fact that the desired image is *not fixed or ready-made, but arises—is born*. The image planned by author, director and actor is concretized by them in separate representational elements, and is assembled—again and finally—in the spectator's perception. This is actually the final aim of every artist's creative endeavour.

Gorky put this eloquently in a letter to Konstantin Fedin:

You say: You are worried by the question, 'how to write?': I have been watching for 25 years how that question worries people. . . . Yes, it is a serious question; I have worried about it myself, I do worry about it, and I shall go on worrying about it to the end of my days. But for me the question is formulated: How must I write so that the man, no matter who he may be, shall emerge from the pages of the story about him with that strength of physical palpability of his existence, with that cogency of his *half-imaginary* reality, with which I see and feel him That is the point as I understand it, that is the secret of the matter. . . .[12]

Montage helps in the resolution of this task. The strength of montage resides in this, that it includes in the creative process the emotions and mind of the spectator. The spectator is compelled to proceed along that selfsame creative road that the author travelled in creating the image. The spectator not only sees the represented elements of the finished work, but also experiences the dynamic process of the emergence and assembly of the image just as it was experienced by the author. And this is, obviously, the highest possible degree of approximation to transmitting visually the author's perceptions and intention in all their fullness, to transmitting them with 'that strength of physical palpability' with which

would all be, in film terms, *representations shot from a single set-up*. But, as fashioned by artists, they constitute *images*, brought to life by means of *montage construction*.

And now we can say that it is precisely the *montage* principle, as distinguished from that of *representation*, which obliges spectators themselves to *create* and the montage principle, by this means, achieves that great power of inner creative excitement* in the *spectator* which distinguishes an emotionally exciting work from one that stops without going further than giving information or recording events.

Examining this distinction we discover that the montage principle in films is only a sectional application of the *montage principle in general*, a principle which, if fully understood, passes far beyond the limits of splicing bits of film together.

As stated above, the compared montage methods of *creation by the spectator* and *creation by the actor* can lead to absorbing conclusions. In this comparison a meeting occurs between the montage method and the sphere of the *inner* technique of the actor; that is, the form of that *inner process* through which the actor creates a living feeling, to be displayed subsequently in the truthfulness of his activity on the stage or on the screen.

A number of systems and doctrines have been erected upon the problems of the actor's performance. More accurately, there are really two or three systems with various offshoots. These offshoot schools are distinguished one from the other not merely by differences in terminology, but chiefly by their varying conceptions of the principal role played by *different* basic points of acting technique. Sometimes a school almost

* It is quite obvious that the *theme as such* is capable of exciting emotionally, independently of the form in which it is presented. A brief newspaper report of the victory of the Spanish Republicans at Guadalajara is more moving than a work by Beethoven. But we are discussing here how, by means of art, to raise a given theme or subject, that may already be exciting 'in itself', to a maximum degree of effectiveness. It is further quite obvious that montage, as such, is in no way an exhaustive means in this field, though a tremendously powerful one.

37

completely forgets an entire link in the psychological process of image-creation. Sometimes a link that is *not basic* is raised to the foremost place. Within even such a monolith as the method of the Moscow Art Theatre, with all its body of basic postulates, there are independent offshoots in the interpretation of these postulates.

I have no intention of delving into the nuances of either essential or terminological differences in methods of training or creation with the actor. Our purpose here is to consider those features of inner technique which enter necessarily and directly into the technique of the actor's work and enable it to achieve results—seizing the imagination of the spectator. Any actor or director is, as a matter of fact, in a position to deduce these features from his own 'inner' practice, if he would but manage to halt that process in order to examine it. The techniques of the *actor* and the *director* are, in regard to this section of the problem, indistinguishable, since the director in this process is also, to some extent, an actor. From observations of this 'actor's share' in my own directorial experience, I shall try to outline this inner technique we are considering through a concrete example. In so doing there is no intention of saying anything *new* on *this* particular question.

Let us suppose that I am faced with the problem of playing the 'morning after' of a man who, the night before, has lost government money at cards. Suppose the action to be full of all kinds of matters, including, let us say, a conversation with a completely unsuspecting wife, a scene with a daughter gazing intently at her father whose behaviour seems strange, a scene of the embezzler nervously awaiting the telephone call that is to call him to account, and so on.

Suppose that a series of such scenes leads the embezzler into an attempt to shoot himself. The task before the actor is to act the final fragment of the climax, where he arrives at this realization that there is only one solution—suicide—and his hands begins to fumble in the drawer of his writing-table, searching for the revolver. . . .

I believe that it would be almost impossible to find an

actor of any training to-day who in this scene would start by trying to 'act the feeling' of a man on the point of suicide. Each of us, instead of sweating and straining to imagine how a man would behave under such circumstances, would approach the task from quite another direction. We should compel the appropriate consciousness and the appropriate feeling to *take possession* of us. And the authentically felt state, sensation, experience would, in direct consequence, 'manifest' itself in true and emotionally correct movements, actions, general behaviour. This is the way towards *a discovery of the initiating elements* of correct behaviour, correct in the sense that it is appropriate to a genuinely experienced state or feeling.

The next stage of an actor's work consists in compositionally sorting these elements, cleansing them of every fortuitous accretion, refining the premises to the furthest degree of expressiveness. But this is the *following* stage. Our concern here is with the stage *preceding* this.

We are interested in that part of the process in which the actor becomes *possessed* by the feeling. How is this achieved? We have already said that it cannot be done with the 'sweating and straining' method. Instead we pursue a path that should be used for all such situations.

What we actually do is compel our imagination to depict for us a number of concrete pictures or situations appropriate to our theme. The aggregation of the pictures so imagined evokes in us the required emotion, the feeling, understanding and actual experience that we are seeking. Naturally the material of these imagined pictures will vary, depending on the particular characteristics of the character and image of the person being played by the actor at the time.

Suppose that a characteristic feature of our embezzler be fear of public opinion. What will chiefly terrify him will not be so much the pangs of conscience, a consciousness of his guilt or the burden of his future imprisonment, as it will be 'what will people say'?

Our man, finding himself in this position, will imagine

first of all the terrible consequences of his act in these particular terms.

It will be these imagined consequences and their combinations which will reduce the man to such a degree of despair that he will seek a desperate end.

This is exactly how it takes place in life. Terror resulting from awareness of responsibility initiates his feverish pictures of the consequences. And this host of imagined pictures, reacting on the feelings, increases his terror, reducing the embezzler to the utmost limit of horror and despair.

The process is exactly similar to that by which the actor induces a similar state in the conditions of the theatre. A difference exists only in his use of will to force his imagination to paint the same pictured consequences that in life a man's imagination would awake spontaneously.

The methods whereby the imagination is induced to do this on the basis of presumed and imaginary circumstances are not at the moment pertinent to my exposition. We are dealing with the process from the point where the imagination is already depicting whatever is necessary for the situation. It is not necessary for the actor to force himself to feel and experience the foreseen consequences. Feeling and experience, like the actions that flow from them, arise of themselves, called to life by the pictures his imagination paints. The living feeling will be evoked by the pictures themselves, by their aggregation and juxtaposition. In seeking ways of waking the required feeling, one can depict to oneself an innumerable quantity of relevant situations and pictures that all advance the theme in various aspects.

By way of example I shall take the first couple of situations that come to me from the multiplicity of imagined pictures. Without weighing them carefully I shall try to record them here as they occur to me. 'I am a criminal in the eyes of my former friends and acquaintances. People avoid me. I am ostracized by them,' and so on. To feel this through all my senses I follow the process outlined above by depicting to myself concrete situations, actual pictures of the fate that awaits me.

The first situation in which I imagine myself is the court-room where my case is being tried. The second situation will be my return to normal life after serving my sentence. These notes will attempt to reproduce the plastic and graphic quali-ties that such multifold fragmentary situations naturally pos-sess when our imagination is fully functioning. The manner in which such situations arise differs with each actor.

This is merely what came to *my* mind when I set *myself* the task:

The courtroom. My case is being tried. I am on the stand. The hall is crowded with people who know me—some casually, some very well. I catch the eye of my neighbour fixed upon me. For thirty years we lived next door to each other. He notices that I have caught him staring at me. His eyes slip past me with feigned abstraction. He stares out of the window, pretending boredom. . . . Another spectator in court—the woman who lives in the apart-ment above mine. Meeting my look, she drops her gaze terrified, while watching me out of the corners of her eyes. . . . With a clearly motivated half-turn my usual billiards partner presents his back to me. . . . There are the fat owner of the billiards parlour and his wife—staring at me with set insolence. . . . I try to shrink by gazing at my feet. I see nothing, but all around me I hear the whisper of censure and the murmur of voices. Like blow upon blow fall the words of the prosecuting attorney's summing-up. . . .

I imagine the other scene with the same vividness—my return from prison:

The clang of the gates closing behind me as I am released. . . . The astonished stare of the servant girl, who stops cleaning the windows next door when she sees me enter my old block. . . . There is a new name on the mail-box. . . . The floor of the hall has been newly varnished and there is a new mat outside my door. . . . The door of the next apartment opens. People whom I have never seen look out suspiciously and inquisitively. Their children huddle against them; they instinctively withdraw from my appearance. From below, his spectacles awry on his nose, the old janitor, who remembers me from the past, stares up the stair-well. . . . Three or four faded letters sent to my address before my

shame was generally known. . . . Two or three coins jingling in my pocket. . . . And then—my door is closed in my face by the former acquaintances who now occupy my apartment. . . . My legs reluctantly carry me up the stairs towards the apartment of the woman I used to know and then, when there are only two further steps to go, I turn back. The hurriedly raised collar of a passer-by who recognizes me. . . .

And so on. The above is the result of merely jotting down all that crowds through my consciousness and feelings when, either as director or actor, I try to get an emotional grasp of the proposed situation.

After mentally placing myself in the first situation and then mentally passing through the second, doing the same with two or three other relevant situations of various intensities, I gradually arrive at a genuine perception of what awaits me in the future and hence—at a real experiencing of the hopelessness and tragedy of my position. The juxtaposition of the details of the first imagined situation produces one shade of this feeling. The juxtaposition of the details of the second situation—another. Nuance of feeling is added to nuance of feeling, and from all these the image of hopelessness begins to arise, linked inseparably with the sharp emotional experience of actually feeling such hopelessness.

In this way, without straining to act the feeling itself, it is successfully evoked by the assembly and juxtaposition of deliberately selected details and situations from all those that first crowded into the imagination.

It is quite irrelevant here whether the description of this process, as I have outlined it above, tallies or not in its mechanical details with that laid down by this or the other existing school of acting technique. Here the important matter to be settled is that a stage similar to that which I have described exists on every path to the *shaping and intensification* of emotion, whether in real life or in the technique of the creative process. We can convince ourselves of this by a minimum of self-observation, whether in the conditions of creation or in the circumstances of real life.

Another important matter here is the fact that the technique of creation recreates a life process, conditioned only by those special circumstances required by art.

It should be appreciated, of course, that we have been dealing not with the entire body of acting technique, but only with a single link in its system.

We have, for instance, not touched here at all on the nature of the imagination itself, particularly the technique of 'warming' to the point where it paints the pictures we wish it to, those demanded by the particular theme. Lack of space does not allow an examination of these links, though an analysis of them would only confirm the soundness of the assertions made here. For the present we confine ourselves to the point already made, while keeping in mind that the link we have analysed occupies no greater place in the actor's technique than does montage among the expressive resources of the film. Nor can we assume that montage occupies any lesser place, either.

The question will be asked, In what way does the above presentation in the sphere of the actor's inner technique differ in practice or in principle from that which we had previously outlined as the essence of film montage? The distinction here is in the sphere of application and not in essential method.

Our latter question was how to make the living feelings and experience emerge within the actor.

The former question was how to evoke for the spectator's feelings an emotionally experienced image.

In both questions the static elements, the given factors and the devised factors, all in juxtaposition with one another, give birth to a dynamically emerging emotion, a dynamically emerging image.

We see this as not in the least different in principle from the montage process in film: here is the same sharp concretization of the theme being made perceptible through determining details, the resulting effect of the juxtaposition of the details being the evocation of the feeling itself.

As for the actual nature of these component 'visions' that appear before the 'inner eye' of the actor, their plastic (or auditory) features are completely homogeneous with the characteristics that are typical of the film shot. The terms 'fragments' and 'details' as applied above to these visions were not idly chosen, since the imagination does not call up completed pictures, but the decisive and determining properties of these pictures. For if we examine the crowd of 'visions' noted down almost automatically above, which I honestly tried to record with the photographic accuracy of a psychological document, we shall see that these 'visions' have a positively film-like order—with camera-angles, set-ups at various distances, and rich montage material.

One shot, for example, was chiefly that of a man turning his back, obviously a composition cut by the frame-lines of his back rather than of the whole figure. Two heads with a glassy-eyed and stubborn stare are in contrast to the lowered eyelashes from under which the woman of the apartment above me stole sidelong glances at me—obviously requiring a distinction in the distance of the camera from the subjects. There are several obvious close-ups—of the new mat before the door, of the three envelopes. Or, employing another sense that is just as much a part of our medium—the sound long-shot of the whispering visitors in the courtroom, contrasting with the few coins jingling in my pocket, etc. The mental lens works like this with variety—it enlarges the scale or diminishes it, adjusting as faithfully as a film camera to varying frame requirements—advancing or drawing away the microphone. All that is lacking to turn these imagined fragments into a typical shooting-script is to set numbers before each of the fragments!

This example reveals the secret of writing shooting-scripts with genuine emotion and movement, instead of a mere sprinkling of a numbing alternation of close-ups, medium shots, and long-shots!

The basic validity of the method obtains in both spheres. The first task is the creative breaking-up of the theme into

determining representations, and then combining these representations with the purpose of bringing to life *the initiating image of the theme*. And the process whereby this image is perceived is identical with the original experiencing of the theme of the image's content. Just as inseparable from this intense and genuine experience is the work of the director in writing his shooting-script. This is the only way that suggests to him those decisive representations through which the whole image of his theme will flash into creative being.

Herein lies the secret of that emotionally exciting quality of exposition (as distinguished from the affidavit-exposition of mere information) of which we spoke earlier, and which is just as much a condition of a living performance by an actor as of living film-making.

We shall find that a similar crowd of pictures, carefully selected and reduced to the extreme laconism of two or three details, is to be found in the finest examples of literature.

Take Pushkin's narrative poem, *Poltava*—the scene of Kochubei's execution. In this scene the theme of 'Kochubei's end' is expressed with unusual vividness in the image of 'the end of Kochubei's execution'. But the actual image of this end of the execution arises and grows out of the juxtaposition of three almost 'documentarily' selected representations of three detail incidents from the episode:

> *'Too late,' someone then said to them,*
> *And pointed finger to the field.*
> *There the fatal scaffold was dismantled,*
> *A priest in cassock black was praying,*
> *And on to a wagon was being lifted*
> *By two cossacks an oaken coffin. . . .*[14]*

It would be difficult to find a more effective selection of details to convey the sensation of the image of death in all its

* In the majority of the following citations from Russian poets a translation has been made to preserve the original relation of sense and line, important to the context. In these translations an effort has been made to preserve also the quantities, but the rhyme is ignored. Whenever the quotation serves a more general purpose, a recognized translation is used.—EDITOR.

horror, than these from the conclusion of the execution scene.

The validity of choosing a realistic method to produce and achieve an emotional quality can be confirmed by some very curious examples. Here, for instance, is another scene from Pushkin's *Poltava*, in which the poet magically causes the image of a nocturnal flight to rise before the reader in all its picturesque and emotional possibilities:

> *But no one knew just how or when*
> *She vanished. A lone fisherman*
> *In that night heard the clack of horses' hoofs,*
> *Cossack speech and a woman's whisper. . . .*[16]

Three shots:
1. Clack of horses' hoofs.
2. Cossack speech.
3. A woman's whisper.

Once more three objectively expressed representations (in sound!) come together in an emotionally expressed unifying image, distinct from the perception of the separate phenomena if encountered apart from their association with each other. The method is used solely for the purpose of evoking the necessary emotional experience in the reader. The emotional experience only, because the information that Marya has vanished has been given in a previous single line ('*She vanished. A lone fisherman*'). Having told the reader that she had vanished, the author wanted to give him the experience as well. To achieve this, he turns to montage. With three details selected from all the elements of flight, his image of nocturnal flight emerges in montage fashion, imparting the experience of the action to the senses.

To the three sound pictures he adds a fourth picture. It has the effect of a full stop. To attain this effect he chooses his fourth picture from another sense. This last 'close-up' is not in sound, but in sight:

> *. . . And eight horseshoes had left their traces*
> *Over the meadow morning dew. . . .*

Thus Pushkin uses montage in creating the images of a work of art. But Pushkin uses montage just as skilfully when he creates the image of a character, or of an entire *dramatis personae*. With a superlative combination of various aspects (i.e., 'camera set-ups') and of different elements (i.e., montage pieces of pictorially represented things, clarified by the framing of the shot) Pushkin gains astonishing reality in his delineations. Man, indeed, complete and feeling, emerges from the pages of Pushkin's poems.

When Pushkin works with a large quantity of montage pieces, his use of montage grows more intricate. Rhythm constructed with successive long phrases and phrases as short as a single word, introduces a dynamic characteristic to the image of the montage construction. This rhythm serves to establish the actual temperament of the character being depicted, giving us a dynamic characterization of his behaviour.

One can also learn from Pushkin how an orderly succession in transmitting and disclosing a man's characteristics and personality can heighten the total value of the image. An excellent value in this connection is his description of Peter the Great in *Poltava*:

```
    I. . . . And then with highest exaltation
   II. There sounded, ringing, Peter's voice:
  III. 'To arms, God with us!' From the tent,
   IV. By crowding favourites surrounded,
    V. Peter emerges. His eyes
   VI. Are flashing. His look is terrible.
  VII. His movements swift. Magnificent he,
 VIII. In all his aspect, wrath divine.
   IX. He goes. His charger is led him.
    X. Fiery and docile faithful steed.
   XI. Scenting the fray's fire
  XII. It quivers. It turns its eyes aslant
 XIII. And dashes into the fight's dust,
  XIV. Proud of its mighty rider.[16]
```

The above numbering is of the poem's lines. Now we shall

write out this same passage again as a shooting-script, numbering the 'shots' as edited by Pushkin:

1. And then with highest exaltation there sounded, ringing, Peter's voice: 'To arms, God with us!'
2. From the tent, by crowding favourites surrounded,
3. Peter emerges.
4. His eyes are flashing.
5. His look is terrible.
6. His movements swift.
7. Magnificent he,
8. In all his aspect, wrath divine.
9. He goes.
10. His charger is led him.
11. Fiery and docile faithful steed.
12. Scenting the fray's fire it quivers.
13. It turns its eyes aslant.
14. And dashes into the fight's dust, proud of its mighty rider.

The number of *lines* and the number of *shots* prove to be *identical*, fourteen in each case. But there is almost no internal congruence between the lay-out of the lines and the lay-out of the shots; such congruence occurs only twice in the entire fourteen lines: VIII = 8 and X = 11. Furthermore the content of a shot varies as much as two complete lines (1, 14) and as little as a single word (9).*

This is very instructive for film-workers, particularly those specializing in sound.

Let us examine how Peter is 'edited':

Shots 1, 2, 3 contain an excellent example of the *significant* presentation of a figure in action. Here three degrees, three stages of his appearance, are absolutely distinct: (1) Peter is not yet shown, but is introduced in sound—his voice. (2) Peter has emerged from the tent, but he is not yet visible. All we can see is the group of favourites surrounding his emergence from the tent. (3) At last, only in a third stage, is Peter actually seen as he comes from the tent.

These are followed by *flashing eyes*, as the most important detail in his general appearance (4). And then—the whole

* In Russian 'he goes' is a single word, *idët* (phonetically, 'id-yót').

face (5). Only then his full figure is displayed (although very likely cut at the knees by the lower frame-line of a travelling shot) to show his movements, their swiftness and brusqueness. The rhythm of the movement and the character it illuminates are expressed 'impetuously' by the clash of short phrases. The full display of the full figure is given only in Shot 7, and now in a manner beyond the conveyance of information—vividly, as an image: 'Magnificent he'. In the following shot this description is strengthened and heightened: 'In all his aspect, wrath divine.' Only in this eighth shot does Pushkin reveal Peter with the full power of a plastic representation. This eighth shot, obviously, contains Peter at full height, emphasized by all the resources of shot composition, with a crown of clouds above him, with tents and people surrounding him at his feet. After this broad shot the poet at once returns us to the realm of movement and action with the single word: 'He goes' (idët). It would be difficult to seize more vividly Peter's second decisive characteristic: Peter's stride—the most important since the 'flashing eyes'. The laconic 'He goes', completely conveys the feeling of that enormous, elemental, impetuous stride of Peter, who always made such difficulties for his suite in keeping up with him. It was in as masterly a manner that Valentin Serov seized and impressed that 'stride of Peter' in his celebrated picture of Peter at the construction of St. Petersburg.[17]

I believe that the presentation above is a correct film reading of the passage. In the first place, such an 'introduction' of a Pushkin character is generally typical of his style. Take, for example, another brilliant passage of exactly the same type of 'presentation', that of the ballerina Istomina in *Eugene Onegin*. *

> *The theatre's full, the boxes glitter,
> The stalls are seething, the pit roars,
> The gallery claps and stamps, atwitter;
> The curtain rustles as it soars;
> A fairy light about her playing,
> The magic of the bow obeying,
> A crowd of nymphs around her—lo!
> Istomina on lifted toe. . . .*[18]

A second proof of the correctness of the above reading is the determination of the order of the words that, with absolute exactitude, in turn *order the successive appearance* of each element, all of which finally fuse into the image of the character, plastically 'revealing' it.

Shots 2 and 3 would be constructed quite differently if, instead of:

> *. . . From the tent,*
> *By crowding favourites surrounded,*
> *Peter emerges. . . .*

the text had read:

> *. . . Peter emerges,*
> *By crowding favourites surrounded,*
> *From the tent. . . .*

If the emergence had begun with, instead of leading up to, Peter, the impression would have been quite different. As Pushkin wrote it, it is a model of expressiveness, achieved by a purely montage method and with purely montage means. For every instance there is available a different expressive construction. But the expressive construction chosen for each instance prescribes and outlines in advance that 'only right arrangement of the only suitable words', about which Tolstoy wrote in *What Is Art?* [19]

The sound of Peter's voice and his words are arranged with just the same quality of logical succession that pervades the pictorial images (see Shot 1). For Pushkin did not write:

> *. . . 'To arms, God with us!'*
> *Sounded Peter's voice, ringing,*
> *And with highest exaltation.*

but:

> *And then with highest exaltation*
> *There sounded, ringing, Peter's voice:*
> *'To arms, God with us!' . . .*

If we, as film-makers, should be faced with the task of building up the expressiveness of such an exclamation, we too, must transmit it so that there is an ordered succession,

revealing first its *exaltation*, then its ringing quality, followed by our *recognition of the voice* as Peter's, and finally, to distinguish *the words* that this exalted, ringing voice of Peter *utters:* 'To arms, God with us!' It seems clearly evident that in 'staging' such a passage, the solution of the opening could simply be resolved by hearing first a phrase of exclamation coming from the tent, in which the words could not be distinguished, but which would already resound the exalted and ringing qualities which we would later recognize as characteristic of Peter's voice.

As we see, this has enormous importance in connection with the problem of enriching the expressive resources of film.

The example is a model of the most complex type of sound-picture, or audio-visual composition. It seems amazing that there are those who think it hardly necessary to seek assistance from such media, and that one can accumulate quite enough experience in the study of co-ordination of music and action exclusively from the opera or ballet!

Pushkin even teaches us how to work so that the picture shots avoid a mechanical coincidence with the beats on the music track.

To consider only the simplest of circumstances—non-coincidence of the measures (in this case, the poetic lines) with the ends, beginnings and lengths of the separate plastic pictures. In a rough diagram this would appear something like this:

MUSIC	I	II	III	IV	V	VI	VII	VIII	IX	X	XI	XII	XIII	XIV		
PICTURE	1		2		3	4	5	6	7	8	9	10	11	12	13	14

The upper row is occupied by the fourteen lines of the passage. The lower row—by the fourteen pictures carried through the lines.

The diagram indicates their relative distribution through the passage.

This diagram makes it clearly evident what exquisite contrapuntal writing of sound-picture elements Pushkin employs

to achieve the remarkable results of this polyphonic passage of poetry. As we have already noted, with the exception of VIII =8 and X =11, we do not encounter in the remaining twelve lines a single case of identical correspondence of line and picture.

Moreover picture and line coincide in regard to order only once: VIII =8. This cannot be accidental. This single exact correspondence between the articulations of the music and the articulations of the pictures marks the most significant montage-piece in the whole composition. Of its particular type it is unique: within his eighth shot the features of Peter are fully developed and fully revealed and, in addition to this, it is the only line to employ a pictorial comparison: 'In all his aspect, wrath divine.' We see that this device of coinciding stress of music with stress of representation is used by Pushkin for his strongest blow in the passage. This is exactly what would be done in film by an experienced editor—as a composer in audio-visual co-ordinations.

In poetry the carrying-over of a picture-phrase from one line to another is called 'enjambement'. In his *Introduction to Metrics*, Zhirmunsky writes:

When the metrical articulation does not coincide with the syntactic, there arises the so-called carry-over (*enjambement*). . . . The most characteristic sign of a carry-over is the presence within a line of *syntactic pause* more significant than that at the beginning or end of the given line. . . .[20]

Or, as one can read in Webster's *Dictionary*:

ENJAMBEMENT. . . . Continuation of the sense in a phrase beyond the end of a verse or couplet, the running over of a sentence from one line into another, so that closely related words fall in different lines. . . .

A good example of enjambement may be recalled from Keats' *Endymion*:

> . . . *Thus ended he, and both*
> *Sat silent: for the maid was very loth*
> *To answer; feeling well that breathed words*
> *Would all be lost, unheard, and vain as swords*

Against the enchased crocodile, or leaps
Of grasshoppers against the sun. She weeps,
And wonders; struggles to devise some blame
To put on such a look as would say, Shame
On this poor weakness! *but, for all her strife,*
She could as soon have crush'd away the life
From a sick dove. At length, to break the pause,
She said with trembling chance: 'Is this the cause?' . . .

Zhirmunsky also speaks of a particular one of the compositional *interpretations* of this type of construction that is also not without a certain interest for our audio-visual co-ordinations in film, where the picture plays the role of syntactical phrase and the musical construction the role of rhythmical articulation:

Any non-coincidence of the syntactic articulation with the metrical is an artistically deliberate dissonance, which reaches its resolution at the point where, after a series of non-coincidences, the syntactic pause at last coincides with the bounds of the rhythmic series.[21]

This can be illustrated by an example, this time from Shelley:

He ceased, and overcome leant back awhile, ‖
Then rising, with a melancholy smile
Went to a sofa, ‖ *and lay down,* ‖ *and slept*
A heavy sleep, ‖ *and in his dreams he wept*
And muttered some familiar name, ‖ *and we*
*Wept without shame in his society. . . .**

In Russian poetry 'enjambement' takes on particularly rich forms in the work of Pushkin.

In French poetry the most consistent use of this technique is in the work of Victor Hugo and André Chénier, although the clearest example that I have ever found in French poetry is in a poem by Alfred de Musset:

L'antilope aux yeux bleus, | *est plus tendre peut-être*
Que le roi des forêts; ‖ *mais le lion répond*
Qu'il n'est pas antilope, | *et qu'il a nom* ‖ *lion.*[22]

* *Julian and Maddalo.*

'Enjambement' enriches the work of Shakespeare and Milton, reappearing with James Thomson, and with Keats and Shelley. But of course the most interesting poet in this regard is Milton, who greatly influenced Keats and Shelley in their use of this technique.

He declared his enthusiasm for enjambement in the introduction to *Paradise Lost*:

> ... true musical delight ... consists onely in apt Numbers, fit quantity of Syllables, and the sense variously drawn out from one Verse into another. ...[23]

Paradise Lost itself is a first-rate school in which to study montage and audio-visual relationships. I shall quote several passages from different parts of it—firstly, because Pushkin in translation can never succeed in giving the English or American reader the direct delight in the peculiarities of his composition obtained by the Russian reader from such passages as those analysed above. This the reader can successfully get from Milton. And secondly, because I doubt whether many of my British or American colleagues are in the habit of dipping often into *Paradise Lost*, although there is much in it that is very instructive for the film-maker.

Milton is particularly fine in battle scenes. Here his personal experience and eye-witness observations are frequently embodied. Hilaire Belloc justly wrote of him:

> Everything martial, combining as such things do both sound and multitude, had appealed to Milton since the Civil Wars. ... His imagination seized especially upon the call of its music and the splendour of its colour. ...[24]

And, consequently, he frequently described the heavenly battles with such strongly earthly detail that he was often the subject of serious attacks and reproaches.

Studying the pages of his poem, and in each individual case analysing the determining qualities and expressive effects of each example, we become extraordinarily enriched in experience of the audio-visual distribution of images in his sound montage.

But here are the images themselves:

(The Approach of the 'Host of Satan')

> . . . at last
> Farr in th' Horizon to the North appeer'd
> From skirt to skirt a fierie Region, stretcht
> In battailous aspect, and neerer view
> Bristl'd with upright beams innumerable
> Of rigid Spears and Helmets throng'd, and Shields
> Various, with boastful Argument portraid,
> The Banded Powers of Satan hasting on
> With furious expedition. . . .[25]

Note the cinematographic instruction in the third full line
to *change the camera set-up*: 'neerer view'!

(The Corresponding Movement of the 'Heavenly Hosts')

> . . . that proud honour claim'd
> Azazel as his right, a Cherube tall:
> Who forthwith from the glittering Staff unfurld
> Th' Imperial Ensign, which full high advanc't
> Shon like a Meteor streaming to the Wind,
> With Gemms and Golden lustre rich imblaz'd,
> Seraphic arms and Trophies: all the while
> Sonorous mettal blowing Martial sounds:
> At which the universal Host upsent
> A shout that tore Hells Concave, and beyond
> Frighted the Reign of Chaos and old Night.
> All in a moment through the gloom were seen
> Ten thousand Banners rise into the Air
> With Orient Colours waving: with them rose
> A Forrest huge of Spears: and thronging Helms
> Appear'd, and serried Shields in thick array
> Of depth immeasurable: Anon they move
> In perfect Phalanx to the Dorian mood
> Of Flutes and soft Recorders; such as rais'd
> To hight of noblest temper Hero's old
> Arming to Battel, . . .[26]

And here is a section from the battle itself. I will give it in
the same two types of transcription as I did the passage from
Pushkin's *Poltava*. First, *as broken by Milton into lines*, and then

arranged in accordance with the various compositional set-ups, as a shooting-script, where each number will indicate a new montage-piece, or shot.

First transcription:

> . . . in strength each armed hand
> I. A Legion, led in fight, yet Leader seemd
> II. Each Warrior single as in Chief, expert
> III. When to advance, or stand, or turn the sway
> IV. Of Battel, open when, and when to close
> V. The ridges of grim Warr; no thought of flight,
> VI. None of retreat, no unbecoming deed
> VII. That argu'd fear; each on himself reli'd,
> VIII. As onely in his arm the moment lay
> IX. Of victorie; deeds of eternal fame
> X. Were don, but infinite: for wide was spred
> XI. That Warr and various; somtimes on firm ground
> XII. A standing fight, then soaring on main wing
> XIII. Tormented all the Air; all Air seemd then
> XIV. Conflicting Fire: long time in eeven scale
> XV. The Battel hung. . . .[27]

Second transcription:

1. led in fight, yet Leader seemd each Warriour single as in Chief,
2. expert when to advance,
3. or stand,
4. or turn the sway of Battel,
5. open when,
6. and when to close the ridges of grim Warr;
7. no thought of flight,
8. none of retreat, no unbecoming deed that argu'd fear;
9. each on himself reli'd, as onely in his arm the moment lay of victorie;
10. deeds of eternal fame were don, but infinite:
11. for wide was spred that Warr and various;
12. somtimes on firm ground a standing fight,
13. then soaring on main wing tormented all the Air;
14. all Air seemd then conflicting Fire:
15. long time in eeven scale the Battel hung. . . .

As in the Pushkin quotation, here also there proves to be

an identical number of lines and shots. Again as in Pushkin there is built up here a contrapuntal design of non-coincidences between the limits of the representations and the limits of the rhythmical articulations.

One is moved to exclaim, in the words of Milton himself —from another part of the poem:

> . . . *mazes intricate,*
> *Eccentric, intervolv'd yet regular*
> *Then most, when most irregular they seem. . . .*[28]

One more passage from Book VI, where the rebellious angels are cast into Hell:

> Yet half his strength he put not forth, but check'd
> His Thunder in mid Volie, for he meant
> Not to destroy, but root them out of Heav'n:
> I. The overthrown he rais'd, and as a Heard
> II. Of Goats or timerous flock together throngd
> III. Drove them before him Thunder-struck, pursu'd
> IV. With terrors and with furies to the bounds
> V. And Chrystall wall of Heav'n, which op'ning wide,
> VI. Rowld inward, and a spacious Gap disclos'd
> VII. Into the wastful Deep; the monstrous sight
> VIII. Strook them with horror backward, but far worse
> IX. Urg'd them behind; headlong themselves they threw
> X. Down from the verge of Heav'n, Eternal wrauth
> XI. Burnt after them to the bottomless pit.
>
> . . .
> Nine dayes they fell. . . .[29]

And as a shooting-script:

1. The overthrown he rais'd, and
2. as a Heard of Goats or timerous flock together throngd
3. drove them before him Thunder-struck,
4. pursu'd with terrors and with furies to the bounds and Chrystall wall of Heav'n,
5. which op'ning wide, rowld inward,
6. and a spacious Gap disclos'd
7. into the wastful Deep;
8. the monstrous sight strook them with horror backward,
9. but far worse urg'd them behind;

10. headlong themselves they threw down from the verge of Heav'n,
11. Eternal wrauth burnt after them to the bottomless pit.

It would be possible to find in Milton as many such instructive examples of co-ordination as might be desired.

The formal outline of a poem usually observes the form of stanzas internally distributed according to metrical articulation—in lines. But poetry also provides us with another outline, which has a powerful advocate in Mayakovsky. In his 'chopped line' the articulation is carried through not to accord with the limits of the line, but with the limits of the 'shot'.

Mayakovsky does not work in lines:

> *Emptiness. Wing aloft,*
> *Into the stars carving your way.*

He works in shots:

> *Emptiness.*
> *Wing aloft,*
> *Into the stars carving your way.* *

Here Mayakovsky cuts his line just as an experienced film editor would in constructing a typical sequence of 'impact' (the *stars*—and *Yesenin*). First—the one. Then—the other. Followed by the impact of one against the other.

1. *Emptiness* (if we were to film this 'shot', we should take the stars so as to emphasize the void, yet at the same time making their presence felt).
2. *Wing aloft.*
3. And only in the *third* shot do we plainly portray the contents of the first and second shots in the circumstances of impact.

As we can see, and as could be multiplied by other instances, Mayakovsky's creation is exceedingly graphic in this respect of montage. In general, however, in this direction it is more exciting to turn back to the classics, because they belong to a period when 'montage' in this sense was not dreamt

* *To Sergei Yesenin.* The poem is in memoriam.

of. Mayakovsky, after all, belongs to that period in which montage thinking and montage principles had become widely current in all the border-arts of literature: in the theatre, in the film, in photo-montage, and so on. Consequently, examples of realistic montage writing taken from the treasury of our classic inheritance, where interactions of this nature with bordering spheres (for example, with the film), were either less, or else entirely non-, existent, are the more pointed and more interesting and, perhaps, the most instructive.

However, whether in picture, in sound, or in picture-sound combinations, whether in the creation of an image, a situation, or in the 'magical' incarnation before our eyes of the images of the *dramatis personae*—whether in Milton or in Mayakovsky—everywhere we find similarly present this same method of montage.

What conclusion can be drawn from what has been said up to this point?

The conclusion is that there is no inconsistency between the method whereby the poet writes, the method whereby the actor forms his creation *within himself*, the method whereby the same actor acts his role *within the frame of a single shot*, and that method whereby his actions and whole performance, as well as the actions surrounding him, forming his environment (or the whole material of a film) are made to flash in the hands of the director through the agency of the montage exposition and construction of the entire film. At the base of all these methods lie in equal measure the same vitalizing human qualities and determining factors that are inherent in every human being and every vital art.

No matter how opposed the poles in which each of these spheres may appear to move, they meet in the final kinship and unity of a method such as' we now perceive in them.

These premises place before us with new force the issue that workers in the art of film should not only study play-writing and the actor's craft, but must give equal attention to mastering all the subtleties of montage creation in all cultures.

SYNCHRONIZATION OF SENSES

... indeed the more the arts develop the more they depend on each other for definition. We will borrow from painting first and call it pattern. Later we will borrow from music and call it rhythm.

E. M. FORSTER[1]

He gradually melted into the Infinite—already his bodily senses were left behind, or at any rate all mixed up: so that the little green tables of the café only penetrated to him as a tinkling arpeggio to the blaring bass of the sunlight, the booming sky outside: while the rattle of a passing bullock-cart was translated into a series of vivid flashes of colour, and the discomfort of the rickety chair he sat on smelt bitter in his nostrils. . . .

RICHARD HUGHES[2]

Montage has been defined above as:

Piece *A*, derived from the elements of the theme being developed, and piece *B*, derived from the same source, in juxtaposition to give birth to the image in which the thematic matter is most clearly embodied.

Or:

Representation A and *representation* B must be so selected from all the possible features within the theme that is being developed, must be so sought for, that their *juxtaposition*—the juxtaposition of *those very elements* and not of alternative ones—shall evoke in the perception and feelings of the spectator the most complete *image of the theme itself*.

This formulation was presented in this way, without our limiting ourselves by attempting any determination of the *qualitative* degrees of A or of B, or by fixing any system of measuring A or B. The formulation stands, but we must develop its *qualities* and its *proportions*.

'*From all the possible features within the theme that is being*

developed.' This phrase was not included in the formulation by chance.

Granted that the single, unifying image that is determined by its component part plays the decisive role in creative film work, we want to point out at the outset of this part of the discussion that the means of expression can be drawn from any number of various fields in order to enrich the image further.

There should be no arbitrary limits set on the variety of expressive means that can be drawn upon by the film-maker. I should think that this has been conclusively demonstrated by the examples above drawn from Leonardo da Vinci and Milton and Mayakovsky.

In Leonardo's notes for The Deluge, all its various elements—those that are purely plastic (the visual element), those indicating human behaviour (the dramatic element), and the noise of crashing and crying (the sound element)— all equally fuse into a single, unifying, definitive image of a deluge.

Keeping this in mind, we see that the transition from silent montage to sound-picture, or audio-visual montage, changes nothing *in principle*.

The conception of montage that has been presented here encompasses equally the montage of the silent film and of the sound-film.

However, this does not mean that in working with sound-film, we are not faced with new tasks, new difficulties, and even entirely new methods.

On the contrary!

That is why it is so necessary for us to make a thorough analysis of the nature of audio-visual phenomena. Our first question is: Where shall we look for a secure foundation of experience with which to begin our analysis?

As always, the richest source of experience is Man himself. The study of his behaviour and, particularly in this case, of his methods of perceiving reality and of forming images of reality will always be our determinant.

Later in our examination of strictly compositional questions, we shall see that Man and the relations between his *gestures* and the *intonations* of his voice, which arise from the same emotions, are our models in determining audio-visual structures, which grow in an exactly identical way from the governing image. Of this—later. Until we go into further detail about that parallel, this thesis will be sufficient: In selecting the montage material which is to be fused into this or that particular image which is to be made manifest, we must study ourselves.

We must keep sharp notice of the means and the elements through which the image forms itself in our consciousness.

Our first and *most spontaneous* perceptions are often our most valuable ones, because these sharp, fresh, lively impressions *invariably derive from the most widely various fields*.

Therefore, in approaching the classics, it is useful to examine not only finished works, but also those sketches and notes in which the artist endeavoured to set down his first vivid and immediate impressions.

For this reason a sketch is often more alive than the resulting finished canvas—a fact noted by Byron in his criticism of a fellow-poet:

. . . Campbell smells too much of the oil: he is never satisfied with what he does; his finest things have been spoiled by over-polish—the sharpness of the outline is worn off. Like paintings, poems may be too highly finished. The great art is effect, no matter how produced. [3]

Leonardo's The Deluge was not a sketch in the sense of a 'sketch from life', but certainly a sketch in which he strove to jot down all those features of the image as it passed before his inner eye. This accounts for the profusion in his description not only of graphic and plastic elements, but also of sound and dramatic elements.

Let us examine another sketch, containing all the 'palpitation' of our first, immediate impressions.

This is from the Goncourt *Journals*—a footnote to the entry of 18th September 1867:

I find a description of the *Athletic Arena* in the notebook for our *future novels*, which haven't been realized, alas!

... In the deep shadow of the two ends of the hall, the scintillation of the buttons and sword hilts of the policemen.

The glistening limbs of wrestlers darting into the full light.—Challenging eyes.—Hands slapping flesh in coming to grips.—Sweat smelling of the wild beast.—Paleness blending with blonde moustaches.—Bruised flesh growing pink.—Backs sweating like the stone walls of a steam-bath.—Advancing by dragging on their knees.—Whirling on their heads, etc., etc.[4]

The scene has been brought close to us by a combination of well-chosen 'close-ups', and by the unusually tangible image rising from their juxtaposition. But what is most remarkable about it? It is that in these few lines of description the different shots—the 'montage elements'—touch literally every sense—except perhaps that of taste, which is, however, present in implication:

1. The sense of *touch* (backs sweating like the stone walls of a steam-bath)
2. The sense of *smell* (sweat smelling of the wild beast)
3. The sense of *sight*, including both
 light (the deep shadow, and the glistening limbs of wrestlers darting into the full light; the buttons and sword hilts of the policemen gleaming in the deep shadow) and
 colour (paleness blending with blonde moustaches, bruised flesh growing pink)
4. The sense of *hearing* (hands slapping flesh)
5. The sense of *movement* (advancing on knees, whirling on their heads)
6. *Pure emotion*, or drama (challenging eyes)

Countless examples of this kind could be cited, but all would illustrate, to a greater or a lesser degree, the thesis presented above, namely:

There is no fundamental difference in the approaches to be made to the problems of purely visual montage and to a montage that links different spheres of feeling—particularly

the visual image with the sound image, in the process of creating a single, unifying sound-picture image.

As a principle this was known to us as far back as 1928 when Pudovkin, Alexandrov and I issued our 'Statement' on the sound-film. *

But a principle is no more than a principle, while our present urgent task is to find the correct approach to this new kind of montage.

My search for this approach has been closely linked with the production of *Alexander Nevsky*. And this new kind of montage, associated with this film, I have named:

vertical montage.

What are the origins of this term—and why this particular term?

Everyone is familiar with the appearance of an orchestral score. There are several staffs, each containing the part for one instrument or a group of like instruments. Each part is developed horizontally. But the vertical structure plays no less important a role, interrelating as it does all the elements of the orchestra within each given unit of time. Through the progression of the *vertical* line, pervading the entire orchestra, and interwoven horizontally, the intricate harmonic musical movement of the whole orchestra moves forward.

When we turn from this image of the orchestral score to that of the audio-visual score, we find it necessary to add a new part to the instrumental parts: this new part is a 'staff' of visuals, succeeding each other and corresponding, according to their own laws, with the movement of the music—and vice versa.

This correspondence, or relationship, could be just as successfully described if, for the image of the orchestral score, we had substituted the montage structure of the silent film.

In order to do this, we will have to draw from our silent film experience an example of *polyphonic* montage, where shot is linked to shot not merely through one indication—move-

* See item number 4, Bibliography.

ment, or light values, or stage in the exposition of the plot, or the like—but through a *simultaneous advance* of a multiple series of lines, each maintaining an independent compositional course and each contributing to the total compositional course of the sequence.

Such an example may be found in the montage structure of the 'procession' sequence in *Old and New*.

In this sequence the several interdependent lines virtually resemble a ball of vari-coloured yarn, with the lines running through and binding together the entire sequence of shots.

These were the sequence lines:

1. The line of heat, increasing from shot to shot.
2. The line of changing close-ups, mounting in plastic intensity.
3. The line of mounting ecstasy, shown through the dramatic content of the close-ups.
4. The line of women's 'voices' (faces of the singers).
5. The line of men's 'voices' (faces of the singers).
6. The line of those who kneel under the passing ikons (increasing in tempo). This counter-current gave movement to a larger counter-stream which was threaded through the primary theme—of the bearers of ikons, crosses and banners.
7. The line of grovelling, uniting both streams in the general movement of the sequence, 'from heaven to the dust'. From the radiant pinnacles of the crosses and banners against the sky to the prostrate figures beating their heads in the dust. This theme was announced at the opening of the sequence with a 'key' shot: a swift camera pan downwards from the belfry cross glittering in the sky down to the church base from where the procession is moving.

The general course of the montage was an uninterrupted interweaving of these diverse themes into one unified movement. Each montage-piece had a double responsibility—to build the *total line* as well as to continue the movement within *each of the contributory themes*.

Occasionally a montage-piece would contain all the lines, and sometimes only one or two, excluding the other lines for a moment; at times one of the themes would take a necessary

step backwards only to make more effective its two steps forward, while the other themes proceeded ahead in equal quantities, and so forth. But the value of a montage-piece was gauged, not by *one* feature alone, but always by the *whole series of features*, before its place in the sequence could be fixed.

One piece, satisfactory in its *intensity* for the heat line, would be out of place in that particular '*chorus*' into which it would have fallen if gauged alone by its intensity. While the *dimensions* of a close-up face might fit one place, the face's *expression* would better suit another place in the sequence. The difficulty of this work should not surprise anyone, because the process is exactly analogous to the preparation of the most unassuming orchestration. Its chief difficulty was of course that the work was being done with the far less flexible material of film, and that the amount of variation was limited by the demands of *this particular sequence*.

On the other hand, we must keep in mind that this polyphonic structure made up of many separate lines achieves its *final form* not alone from the plan for it that was determined beforehand. This final form depends just as much on the character of the film sequence (or complete film) as a complex—*a complex composed of film strips containing photographic images*.

It was exactly this kind of 'welding', further complicated (or perhaps further simplified?) by another line—the sound-track—that we tried to achieve in *Alexander Nevsky*, especially in the sequence of the attacking German knights advancing across the ice. Here the lines of *the sky's tonality—clouded or clear*, of the accelerated *pace* of the riders, of their *direction*, of *the cutting back and forth* from Russians to knights, of the faces in close-up and the *total* long-shots, the *tonal* structure of the music, its *themes*, its *tempi*, its *rhythm*, etc.—created a task no less difficult than that of the silent sequence above. Many hours went into the fusing of these elements into an *organic* whole.

It is naturally helpful that, aside from the individual elements, the polyphonic structure achieves its total effect through the *composite sensation of all pieces as a whole*. This

'physiognomy' of the finished sequence is a summation of the individual *features* and the *general sensation* produced by the sequence. On the occasion of the release of *Old and New*, I wrote of this quality of polyphonic montage in relation to the 'future' sound-film.[5]

In matching music with the sequence, this *general sensation* is a decisive factor, for it is directly linked with the *imagery perception* of the music as well as of the pictures. This requires constant corrections and adjustments of the individual features to preserve the important general effect.

In order to diagram what takes place in *vertical montage*, we may visualize it as *two* lines, keeping in mind that each of these lines represents *a whole complex of a many-voiced scoring*. The search for correspondence must proceed from the intention of matching both picture and music to the general, complex 'imagery' produced by the whole.

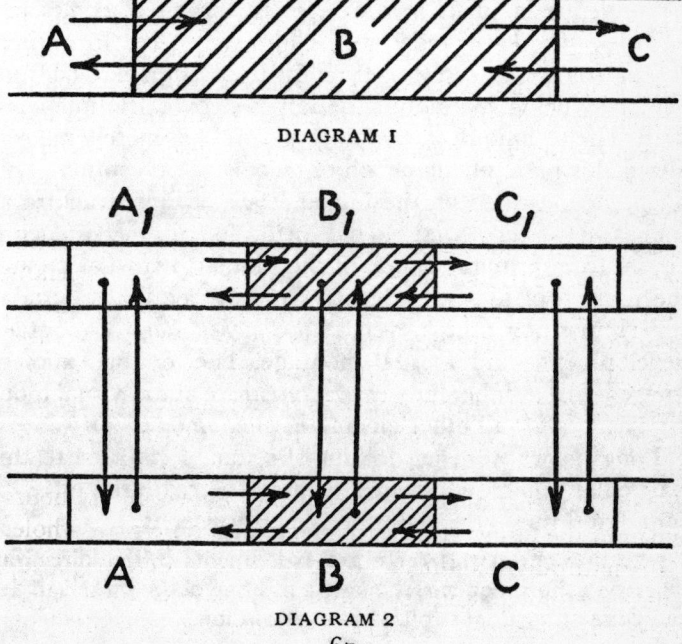

DIAGRAM I

DIAGRAM 2

Diagram 2 reveals the new 'vertical' factor of inter-correspondence which arises the moment that the pieces of the sound-picture montage are connected.

From the viewpoint of montage structure, we no longer have a simple horizontal succession of pictures, but now a new 'super-structure' is erected vertically over the horizontal picture structure. Piece for piece these new strips in the 'super-structure' *differ in length* from those in the picture structure, but, needless to say, they are equal in total length. Pieces of sound do not fit into the picture pieces in sequential order, but in simultaneous order.

It is interesting to note that *in principle* these sound-picture relationships do not differ from relationships within music, nor do they differ from relationships within the structure of silent montage.

Putting aside for the while our discussion of music relationships, let us speak first of the solution to the question of correspondence in silent montage. Here the effect comes not from the simple sequence of the film strips, but from their actual *simultaneity*, resulting from the impression derived from one strip being mentally superimposed over the following strip. The technique of 'double-exposure' has merely materialized this basic phenomenon of cinematic perception. This phenomenon exists on the higher levels of film structure as well as on the very threshold of film illusion, for 'persistence of vision' from frame to frame of the film strip is what creates the illusion of film movement. We shall see that a similar superimposition occurs even at the *highest stage* of montage development—audio-visual montage. The 'double-exposed' image is just as inherently characteristic of audio-visual montage as it is for all other cinematic phenomena.

Long before we even dreamt of sound, I resorted to this particular technique when I wanted to create the effect of sound and music through purely plastic means:

. . . in *Strike* (1924) there are experiments in this direction. There is a short sequence showing a meeting of the strikers under the guise of a casual stroll with an accordion.

68

This sequence ended in a shot where we tried to create an aural effect through purely visual means.

The two tracks of the future—picture and sound—were, in this instance, both picture tracks, a double-exposure. In the first exposure a pond could be seen at the bottom of a hill, up which were moving towards the camera a throng of strollers with their accordion. The second exposure was of the huge accordion in close-up, filling the entire screen with its moving bellows and its high-lighted keys. This movement, seen from different angles, over the other continuous exposure, created the full sensation of a melodic movement, which drew together the whole sequence.[6]

Diagrams 1 and 2 show how the compositional joining in a silent film (1) is distinguished from that of the sound-film (2). It appears as a diagram of a *splice*, for montage is actually a *large, developing thematic movement*, progressing through a continuing diagram of individual splices.

The compositional structure of related movements as indicated by Diagram 2 (A_1—B_1—C_1) is familiar in music.

And the laws of compositional movement (A—B—C) have been evolved in the practice of the *silent film*.

The new problem facing the audio-visual cinema is to find a system for co-ordinating A—A_1; A_1 B_1 C_1; B—B_1; C—C_1 etc.—a system which will determine the intricate plastic and aural movements of a theme through all the diverse correspondences of A—A_1—B_1—B—C—C_1, etc. (see diagrams on page 67).

Our present problem is to find the key to these newly discovered *vertical splices*, A—A_1, B—B_1, learning to bring them together and to separate them as rhythmically as is now possible within the highly developed medium of music, or within the highly developed medium of visual montage. Both these media of cultural activity long since learned how to handle the lengths of A_1, B_1, etc., with complete assurance.

This leads us to the primary question of finding those means of *establishing the proportions between pictures and sound*, and of perfecting the compasses, rulers, tools and methods that will make it practicable. This is actually a question of

finding *an inner synchronization between the tangible picture and the differently perceived sounds*. We have already mastered the problem of physical synchronization, even to the point of detecting the discrepancy of a single frame in the matching of lips and speech!

But this co-ordination is far beyond that external synchronization that matches the boot with its creaking—we are speaking of a 'hidden' inner synchronization in which the plastic and tonal elements will find complete fusion.

To relate these two elements, we find a natural language common to both—movement. Plekhanov has said that all phenomena in the final analysis can be reduced to movement. Movement will reveal all the substrata of inner synchronization that we wish to establish in due course. Movement will display to us in a concrete form the *significance and method* of the fusion process. Let us move from exterior and descriptive matters to matters of an inner and deeper character.

The role of movement in this problem of synchronization is self-evident. Let us examine a number of different approaches to synchronization in logical order. These are the ABC's of every sound-cutter, but their examination is essential.

The first will be in that sphere of synchronization properly outside the realm of artistic concern—a purely *factual* synchronization: the sound-filming of natural things (a croaking frog, the mournful chords of a broken harp, the rattle of wagon wheels over cobblestones).

In this case art begins only at that moment of synchronization when the natural connection between the object and its sound is not merely *recorded*, but is *dictated* solely by the demands of the expressive work in progress.

In the more rudimentary forms of expression both elements (the picture and its sound) will be controlled by an identity of *rhythm*, according to the content of the scene. This is the simplest, easiest and most frequent circumstance of audio-visual montage, consisting of shot cuts and edited to-

gether to the rhythm of the music on the parallel sound-track. Whether movement exists in these shots is not of serious consequence. If movement happens to be present, the only demand upon it is that it conform with the rhythm fixed by the parallel track.

However, it is evident that even on this comparatively low plane of synchronization there is a possibility for creating interesting and expressive compositions.

From these simplest circumstances—simple 'metrical' coincidence of accent (film 'scansion')—it is possible to arrange a wide variety of syncopated combinations and a purely rhythmical 'counterpoint' in the controlled play of off-beats, shot-lengths, echoed and repeated subjects, and so on.

Which step follows this second level of synchronized surface movement? It may possibly be one that will enable us to show not only rhythmic movement, but *melodic movement* as well.

Lanz spoke correctly of melody when he said:

. . . strictly speaking, one does not 'hear' a melody. We are able or unable to follow it, which means that we either have or have not the ability to organize the tones into a higher unity[7]. . . .

From all the plastic means of expression at our disposal we can surely find those whose movements harmonizes not only with the movement of the rhythmic pattern, but also with the movement of the melodic *line*. We already have some idea as to what these means might be, but since we are about to deal with this question in full detail, we will mention at this point that we can assume that these elements will probably be drawn basically from a 'linear' element of plastic art.

'The higher unity' into which we are capable of organizing the *separate tones* of the sound-scale may be visualized as a line that unites them through movement. The tonal *changes* on this line may also be characterized as movement, no longer as an intermingling movement, but as a *vibrating* movement, whose characteristics we can perceive as sounds of varying pitch and tone.

What visual element echoes this new type of 'movement' introduced to our discussion by tones? Obviously it will be an element that also moves in vibrations (although of a differing physical formation), and is also characterized by tones. This visual equivalent is colour. (In a rough analogy pitch can correspond to the play of *light*, and tonality to *colour*.)

Pausing for a moment to recapitulate, we see that we have demonstrated that synchronization can be 'natural', metric, rhythmic, melodic and tonal.

Matching of picture and sound may achieve a synchronization that fulfils all these potentialities (although this is a very rare occurrence), or it may be built upon a combination of unlike elements, without attempting to conceal the resulting dissonance between the aurals and the visuals. This occurs frequently. When it does, we explain that the visuals 'exist for themselves', that the music 'exists for itself': sound and picture each run on independently, without uniting in an organic whole. It is important to keep in mind that our conception of synchronization does not presume consonance. In this conception full possibilities exist for the play of both corresponding and non-corresponding 'movements', but in either circumstance the relationship must be *compositionally controlled*. It is apparent that any one of these synchronization approaches may serve as the 'leading', determining factor in the structure, dependent on the need. Some scenes would require rhythm as a determining factor, others would be controlled by tone, and so on.

But let us turn back to those varying forms, or more accurately, various fields of synchronization.

We observe that these varying forms coincide with those varying forms of silent montage which were established in 1928-9, and which we later included in the programme for teaching film direction.*

At that time these 'terms' may have seemed to some of my colleagues unnecessarily pedantic or playful analogies to other media. But even then we pointed out the importance

* See item number 49, Bibliography.

of such an approach to the 'future' problems of the sound-film. Now this is obviously and concretely a sensible part of our experiments in audio-visual relationships.

These forms included 'overtonal' montage. This kind of synchronization has been touched upon, above, in connection with *Old and New*. By this perhaps not altogether exact term, we are to understand an intricate polyphony, and a perception of the pieces (of both music and picture) *as a whole*. This totality becomes the factor of perception which synthesizes that original image towards the final revelation of which all of our activity has been directed.

This brings us to the basic and primary matter that forms *the definitive inner synchronization—that between the image and the meaning of the pieces*.

The circuit is complete. From the same formula that unites the *meaning* of the whole piece (whether whole film or sequence) and the *meticulous, cunning selection* of the pieces, *emerges the image* of the theme, *true to its content*. Through this fusion, and through that fusion of the logic of the film's subject with the *highest form* in which to cast this subject, comes the full *revelation* of the film's meaning.

Such a premise naturally serves as a source and departure for the whole series of varying approaches to synchronization. For each 'different' kind of synchronization is embraced by the organic whole, and embodies the basic image through its own specifically defined limits.

Let us begin our investigation in the field of colour, not only because colour is the most immediate and stimulating problem of the film to-day, but chiefly because colour has long been (and still is) used in *deciding* the question of *pictorial and aural correspondence, whether absolute or relative*—and as an indication of specific *human emotions*. This would certainly be of cardinal importance to the problems and principles of the audio-visual image. The most graphic and effective development of a *method* of investigation would be in the field of *melodic synchronization* for the convenience of graphic analysis and our primary field of black and white reproduction.

So we first turn to the question of associating music with colour, which will lead us in turn to consideration of that form of montage which may be called chromophonic, or colour-sound montage.

To remove the barriers between sight and sound, between the seen world and the heard world! To bring about a unity and a harmonious relationship between these two opposite spheres. What an absorbing task! The Greeks and Diderot, Wagner and Scriabin—who has not dreamt of this ideal? Is there anyone who has made no attempt to realize this dream? Our survey of dreams cannot begin here, however.

Our survey must lead us to some method of fusing sound with sight, to some investigation of the preliminary indications leading towards this fusion.

We will begin by observing the forms taken by these dreams of a picture and sound fusion that have disturbed mankind for so long. Colour has always received more than an average share of these dreams.

The first example is not too remote, drawn from no further back than the borderline between the eighteenth and the nineteenth centuries. But it is a very graphic example. We first give the floor to Karl von Eckartshausen, author of *Disclosures of Magic from Tested Experiences of Occult Philosophic Sciences and Veiled Secrets of Nature*[8]

I have long tried to determine the harmony of all sense impressions, to make it manifest and perceptible.

To this end I improved the ocular music invented by Père Castel.[9]

I constructed this machine in all its perfection, so that whole colour chords can be produced, just line tonal chords. Here is the description of this instrument.

I had cylindrical glasses, about half an inch in diameter, made, of equal size, and filled them with diluted chemical colours. I arranged these glasses like the keys of a clavichord, placing the shades of colour like the notes. Behind these glasses I placed little lobes of brass, which covered the glasses so that no colour could be seen. These lobes were connected by wires with the keyboard

of the clavichord, so that the lobe was lifted when a key was struck, rendering the colour visible. Just as a note dies away when the finger is removed from a key, so the colour disappears, since the metal lobe drops quickly because of its weight, covering the colour. The clavichord is illuminated from behind by wax candles. The beauty of the colours is indescribable, surpassing the most splendid jewels. Nor can one express the visual impression awakened by the various colour chords. . . .

A Theory of Ocular Music

Just as tones of music must harmonize with the playwright's words in a melodrama, so must colours likewise correspond with the words.

I set down an example to make this more understandable. I wrote a little poem, which I accompany with my colour music. It reads:

WORDS: *Sadly she wandered, loveliest of maidens . . .*
MUSIC: The notes of a flute, plaintive.
COLOUR: Olive, mixed with pink and white.

WORDS: *. . . in flowery meadows—*
MUSIC: Gay, rising tones.
COLOUR: Green, mixed with violet and daisy yellow.

WORDS: *Singing a song, joyful as a lark.*
MUSIC: Soft notes, rising and gently falling in quick succession.
COLOUR: Dark blue streaked with scarlet and yellowish-green.

WORDS: *And God, in the temple of creation, hears her.*
MUSIC: Majestic, grand.
COLOUR: A mixture of the most splendid colours—blue, red and green—glorified with the yellow of the dawn and purple —dissolving into soft green and pale yellow.

WORDS: *The sun rises over the mountains . . .*
MUSIC: A majestic bass, from which middle tones rise imperceptibly!
COLOUR: Bright yellows, mixed with the colour of the dawn— dissolving into green and whitish yellow.

WORDS: *And shines upon the violets in the valley . . .*
MUSIC: Softly descending tones.
COLOUR: Violet, alternating with varied greens.

This should be sufficient to prove that colours also hold the power of expressing the emotions of the soul. . . .

If this citation should be thought too unfamiliar, let us next choose one of the best-known examples—Arthur Rimbaud's famous 'colour' sonnet, *Voyelles*, whose scheme of colour-sound correspondences has disturbed so many intellects:

> *Vowels: black A, white E, red I, green U, blue O,*
> *Someday I shall name the birth from which you rise:*
> *A is a black corset and over it the flies*
> *Boil noisy where the cruel stench fumes slow,*
>
> *Shadow-pits; E, candour of mists and canopies,*
> *Shiver of flowers, white kings, spears of the glacial snow:*
>
> *I, purples, blood spit out, laugh of lips so*
> *Lovely in anger or penitent ecstasies;*
>
> *U, cycles, divine vibrations of green seas;*
> *The peace of animal pastures, peace of these*
> *Lines printed by alchemy on the great brows of the wise;*
>
> *O, the great Trumpet strange in its stridencies,*
> *The angel-crossed, the world-crossed silences:*
> *—O the Omega, the blue light of the Eyes!*

> (Translation by Muriel Rukeyser)

Rimbaud's scheme occasionally approaches that of René Ghil,[1] although for the most part these two diverge sharply:

oû, ou, oui, iou, oui	Bruns, noirs à roux
ô, o, io, oi	Rouges
â, a, aï, ai	Vermillons
eû, eu, ieu, euï, eui	Orangés à ors, verts
û, u, iu, uï, ui	Jaunes, ors, verts
e, è, é, ei, eï	Blancs, à azurs pâles
ie, iè, ié, î, i, i, ii	Bleus, à azurs noirs

It was after Helmholtz had published the results of his experiments in correlating the timbres of voices and instruments[11] that Ghil 'perfected' his own chart, introducing not only consonants and instrumental timbres, but also a whole catalogue of emotions, premises and hypotheses which were to be understood as maintaining an absolute correspondence.

In an analysis of romanticism, Max Deutschbein concluded that 'synthesis of the various sensations' is one of the fundamental indications of a romantic work of art.[12]

In complete harmony with this definition is the chart of correspondences between vowels and colours determined by A. W. Schlegel (1767-1845):

A represents the light, clear red (*das rote lichthelle A*), and signifies Youth, Friendship and Radiance. *I* stands for celestial blue, symbolizing Love and Sincerity. *O* is purple; *U* stands for violet and *OO* is adorned in navy blue.[13]

Later in this century another romanticist gave a great deal of attention to this problem. Lafcadio Hearn, however, does not attempt any 'classification', and even criticizes departures from a spontaneous approach towards such a system, as we can see in his letter of 14th June 1893,[14] in which he disapproves of John Addington Symonds' newly published *In the Key of Blue*.

But in this same letter, written to his friend, Basil Hall Chamberlain, he tells him:

. . . *you* immediately illustrated the values for me. When you wrote of 'the deep bass' of that green I could see, feel, smell, taste, and chew the leaf; it was rather bitter in taste, and dense, and faintly odorous. . . . I have been thinking of soprano, alto, contralto, tenor, and baritone colours. . . .

A few days before this he had exploded in a passionate outburst for this cause:

Recognizing the ugliness of words, however, you must also recognize their physiognomical beauty. . . . For me words have colour, form, character; they have faces, parts, manners, gesticulations; they have moods, humours, eccentricities;—they have tints, tones, personalities. . . .[15]

Further, in an attack on magazine editors who object to such a style, he says they claim:

'The readers do not feel as you do about words. They can't be supposed to know that you think the letter A is blush-crimson, and the letter E pale sky-blue. They can't be supposed to know that you think KH wears a beard and a turban; that initial X is a mature Greek with wrinkles. . . .'

Here Hearn gives his answer to these critics:

Because people cannot see the colour of words, the tints of words, the secret ghostly motions of words:—
Because they cannot hear the whispering of words, the rustling of the procession of letters, the dream-flutes and dream-drums which are thinly and weirdly played by words:—
Because they cannot perceive the pouting of words, the frowning of words and fuming of words, the weeping, the raging and racketing and rioting of words:—
Because they are insensible to the phosphorescing of words, the fragrance of words, the noisesomeness of words, the tenderness or hardness, the dryness or juiciness of words,— the interchange of values in the gold, the silver, the brass and the copper of words:—
Is that any reason why we should not try to make them hear, to make them see, to make them feel? . . .

Elsewhere he speaks of the variability of words:

Long ago I said that words are like lizards in their power of changing colour with position.[1]

This refinement in Hearn is not accidental. It can be partially explained by his near-sightedness, which had sharpened his perceptions in these matters. A fuller explanation lies in his long residence in Japan where the faculty of finding audio-visual correspondence had been developed with especial acuteness.*

Lafcadio Hearn has brought us to the East where audio-visual relationships are not only part of the Chinese educational system, but are actually incorporated into the code of

* Eisenstein's analysis of the Kabuki theatre's sense-appeals appeared in *Zhizn Iskustiva* (Moscow), No. 34, 19th August 1928.

law. They derive from the principles of Yang and Yin, upon which is based the entire system of Chinese world-outlook and philosophy.* According to Sung tradition this law (*ho t'u*) was delivered to the world in the form of a diagram (see below), brought up dripping from the river, in the mouth of a dragon-horse.[17]

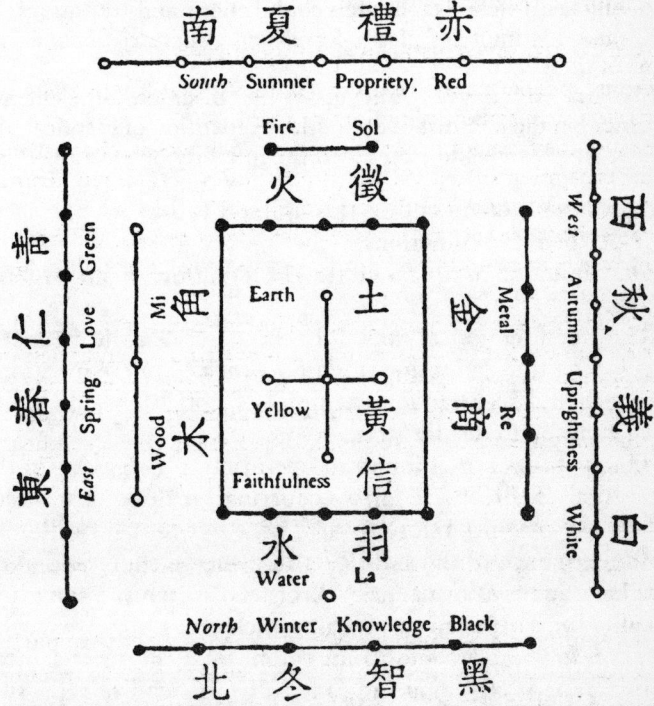

Even more interesting than the correspondence between certain sounds and colours is the analogous reflection of the *artistic tendencies* of certain 'epochs' *in the structure both of music and painting.*

* Yang and Yin—depicted as a circle, locked together within it *yang* and *yin*—*yang*, light; *yin*, dark—each carrying within itself the essence of the other, each shaped to the other—*yang* and *yin*, forever opposed, forever united. An exceptionally pertinent principle for a film-maker to study.

From the increasing and interesting literature in this field, first mapped by Wölfflin, we choose an article by the late René Guilleré on the 'jazz age', *Il n'y a plus de perspective:*

> Formerly the science of esthetics rested content on the principle of fused elements. In music—on the continuous melodic line threaded through harmonic chords; in literature—on the fusion of a sentence's elements through conjunctions and transitions; in art—on a continuity of plastic forms and structures of combinations of these forms.
>
> Modern esthetics is built upon the disunion of elements, heightening the contrast of each other: repetition of identical elements, which serves to strengthen the intensity of contrast. . . .[18]

A necessary comment on this opinion is that *repetition* may well perform two functions.

One function is to facilitate the creation of an organic whole.

Another function of repetition is to serve as a means of developing that mounting intensity which Guilleré mentions. We need not seek far for examples of both these functions. Both may be found in films.

The first function is found in operation in *Potemkin*—in the repetition of 'Brothers!', first occurring on the quarter-deck before the marines refuse to fire; next not as a sub-title but as the sequence of the sail-boats that merge shore and ship, and last, again as a sub-title, 'Brothers!' when the squadron permits the Potemkin to pass unattacked.

Alexander Nevsky contains an example of the second function of repetition—mounting intensity. Instead of repeating a single measure of the music *four* times as written in the score, I multiplied this by three, achieving *twelve* exact repeats of the measure. This occurs in the sequence where the peasant militia cuts into the rear of the German wedge. The resultant effect of growing excitement never fails to win the spectators' approval.

To continue from Guilleré's article:

> . . . in the form of jazz, if we look into its musical element and

into its method of composition—we find a typical expression of this new esthetic.

Its basic parts: syncopation and a dominance of rhythm. This cancels out smoothly curving lines—curlicues, phrases in the form of a lock of curling hair, characteristic of Massenet, and all slow arabesques. Rhythm is stated by angle—protruding edge, sharp profile. It has a rigid structure—firmly constructed. It strives towards plasticity. Jazz seeks volume of sound, volume of phrase. Classical music was based on planes (not on volumes)—planes arranged in layers, planes erected atop one another, planes horizontal and vertical, creating an architecture of truly noble proportions: palaces with terraces, colonnades, flights of monumental steps—all receding into a deep perspective. In jazz all elements are brought to the foreground. This is an important law that can be found in painting, in stage design, in films, and in poetry of this period. Conventional perspective with its fixed focus and its gradual vanishing point has abdicated.

In both art and literature creation proceeds through several perspectives, simultaneously employed. The order of the day is intricate synthesis—bringing together viewpoints of an object from below and viewpoints from above.

Antique perspective presented us with geometrical concepts of objects—as they could be seen only by an ideal eye. Our perspective shows us objects as we see them with both eyes—gropingly. We no longer construct the visual world with an acute angle converging on the horizon. We open up this angle, pulling representation against us, upon us, towards us. . . . We take part in this world. That is why we are not afraid to use close-ups in films: to portray a man as he sometimes seems to us, out of natural proportions, suddenly fifty centimetres away from us; we are not afraid to use metaphors, that leap from the lines of a poem, or to allow the piercing sound of a trombone to swoop out of the orchestra, aggressively.

In antique perspective the planes behaved much like the wings of a stage setting—receding in a funnel towards the depths where the vista closes on a colonnade or on a monumental staircase. Similarly in music the theatre wings formed by the double basses, the cellos and the violins are shaped in like planes, one after the other, like the stairs of a great approach, with the eye carried over terraces towards the triumphant sunset of the brasses. In litera-

ture the same structure dominated the milieu—built in elegant promenades from one tree to the next; each character described minutely—from the colour of his hair. . . .

In our new perspective there are no steps, no promenades. A man enters his environment—the environment is seen through the man. Both function through each other.

In other words, in our new perspective—there is no perspective. Volumes are no longer created through perspective; different intensities, varying colour saturations now create the volumes. Musical volume is no longer created through receding planes, with a sound foreground and appropriate recessions. Its volume is now created by the volume of sound. There are no more great canvases painted with sound in the manner of theatre backdrops. Jazz is volume. It doesn't employ voices with accompaniments, similar to figures against a background. Everything works. Each instrument performs its solo while participating in the whole. The orchestra has even lost its impressionist divisions—with all the violins, for instance, playing the same theme on harmonic notes to create greater richness of sound.

In jazz each man plays for himself in a general ensemble. The same law applies to art: the background is itself a volume. . . .

The above excerpt is interesting for the picture it provides of equivalent structures in musical and graphic arts, particularly that of architecture, although the questions raised here are chiefly concerned with spatial and proportional concepts. However, we have only to glance at a group of cubist paintings to convince ourselves that what takes place in these paintings has already been heard in jazz music.

This relationship is just as evident in the architectural landscape—classic architecture bearing the same relation to the classicists in music composition as the modern urban landscape bears to jazz.

Indeed, Roman squares and villas, Versailles' parks and terraces could be 'prototypes' for the structure of classical music.

The modern urban scene, especially that of a large city at night, is clearly the plastic equivalent of jazz. Particularly noticeable here is that characteristic pointed out by Guilleré, namely, the absence of perspective.

All sense of perspective and of realistic depth is washed away by a nocturnal sea of electric advertising. Far and near, small (in the *foreground*) and large (in the *background*), soaring aloft and dying away, racing and circling, bursting and vanishing—these lights tend to abolish all sense of real space, finally melting into a single plane of coloured light points and neon lines moving over a surface of black velvet sky. It was thus that people used to picture stars—as glittering nails hammered into the sky!

Headlights on speeding cars, highlights on receding rails, shimmering reflections on the wet pavements—all mirrored in puddles that destroy our sense of direction (which is top? which is bottom?), supplementing the mirage above with a mirage beneath us, and rushing between these two worlds of electric signs, we see them no longer on a single plane, but as a system of theatre wings, suspended in the air, through which the night flood of traffic lights is streaming.

This reminds us of another starry sky above and below, for the characters in Gogol's story *A Terrible Revenge*, imagined that the world floated down the Dnieper River between the real starry sky above them and its reflections in the water.

The preceding impressions were those of at least one visitor to the streets of New York during the hours of evening and night.*

Guilleré's article gains added interest through its description, not only of the correspondence between musical and graphic arts, but also through its presentation of the idea that these arts, fused together, correspond to the very *image of an epoch and the image of the reasoning process* of those who are linked

* Similar impressions have been recorded by Antoine de Saint Exupéry in describing an aerial encounter with a storm: 'Horizon? There was no longer a horizon. I was in the wings of a theatre cluttered up with bits of scenery. Vertical, oblique, horizontal, all of plane geometry was awhirl. A hundred transversal valleys were muddle in a jumble of perspectives. . . . For a single second, in a waltzing landscape like this, the flyer had been unable to distinguish between vertical mountainsides and horizontal planes. . . .' (*Wind, Sand and Stars*, Reynal and Hitchcock, 1941, page 83.)

to the epoch. Isn't this picture familiar to us, with that 'absence of perspective', reflecting the lack of historical perspective in a large part of the world to-day, or in the image of an orchestra where each player is on his own, straining to break up this *inorganic* whole of many units by taking an independent course—but bound together in an ensemble only by the *iron necessity* of a common rhythm?

It is interesting to note that all the traits mentioned by Guilleré have been encountered before in the course of art history. Each time these traits reappear in history, one finds them aspiring towards *a unified whole, a higher unity*. It is only in periods of decadence in the arts that this *centripetal movement* changes to a *centrifugal* movement, hurling apart all unifying tendencies—tendencies that are incompatible with an epoch that places an over-emphasis on individualism. We recall Nietzsche:

> ... What is the characteristic of all *literary decadence?* It is that life no longer resides in the whole. The word gets the upper hand and jumps out of the sentence, the sentence stretches too far and obscures the meaning of the page, the page acquires life at the expense of the whole—the whole is no longer a whole. ... The whole has ceased to live altogether; it is composite, summed up, artificial, an unnatural product.[19]

The fundamental and characteristic feature lies precisely here and not in separate particulars. Aren't the Egyptian bas-reliefs valid works even though they were done without a knowledge of linear perspective? Didn't Dürer and Leonardo deliberately make simultaneous use of several perspectives and several vanishing points when it suited their purpose. * And in his painting of Giovanni Arnofini and his wife,[20] Jan van Eyck employed fully *three* vanishing points (see illustration on page 85). In his case this may have been an unconscious method, but what a wonderful *intensity of depth* this painting gains thereby!

* In the familiar *Last Supper* the objects on the table have a vanishing point at variance with that of the room. The Dürer engraving (page 85) is typical of his use of double perspective.

Joseph Kern

Diagram (*left*) of Jan van Eyck's *Giovanni Amolfini and His Wife*, showing three vanishing points (S, F′, F″). Diagram (*right*) of an engraving from *Die Kleine Passion* by Albrecht Dürer, showing his deliberate use of a double horizon line (H) to increase dramatic content. See page 94.

Isn't it perfectly legitimate for Chinese landscape paintings to avoid leading the eye into a single depth, stretching out the viewpoint instead along the entire panorama, so that their mountains and waterfalls all appear to be moving towards us?

Haven't Japanese prints used *super-close-up* foregrounds and effectively disproportionate features in *super-close-up* faces?

One may object that our business has not been to uncover the tendencies of previous epochs towards unity, but simply to demonstrate a less important and merely supplementary diapason in our comparison with a decadent epoch.

Where, for example, can we also find in the past such a degree of simultaneity of viewpoints from above and below, of mixed vertical and horizontal planes, as we found when we looked for the examples of 'intricate synthesis' above?

Modern 'simultaneous' stage settings have their ancestors, too, such as those designed by Yakulov[21] in the 'cubist tradition', cutting through widely separated locales of action, cutting interiors through exteriors. Their exact prototypes can be found in the theatre technique of the sixteenth and seventeenth centuries, where we may see designs of single settings that offered the manager a desert, a palace, a hermit's cave, a king's throne-room, a queen's dressing-room, a sepulchre and various skies—all for the price of one! Such ingenuity immediately recalls certain works of Picasso, both in his cubist and more recent periods, where a face or a figure is presented from multiple viewpoints, and at varying stages of an action.

The copperplate frontispiece to a seventeenth-century Spanish biography of St. John of the Cross shows the saint at the moment he beholds the miraculous appearance of the crucifix. With striking effect, there is incorporated into the same plate a second view in perspective of the same crucifix —as seen from the saint's viewpoint.

If these examples are too special, then let us turn to El Greco. He provides an instance for us of an artist's viewpoint leaping furiously back and forth, fixing on the same canvas

details of a city seen not only from various points outside the city, but even from various streets, alleys, and squares!

All this is done with such a full consciousness of his right to work thus, that he has even recorded, on a map inserted into the landscape for this purpose, a description of this procedure. He probably took this step to avoid any misunderstanding on the part of people who knew the city of Toledo too well to see his work except as a form of capricious 'leftism'.

The painting is his *View and Plan of Toledo*, finished some time between 1604 and 1614, and now in Toledo's Greco Museum. It contains a general view of Toledo from approximately the distance of a kilometre eastwards. At the right a young man displays the map of the city. On this map Greco instructed his son to write these words:

It has been necessary to put the Hospital of Don Juan Tavera in the form of a model [that on the cloud] because it not only so happened as to conceal the Visagra gate, but thrust up its dome or cupola in such a manner that it overtopped the town; once put thus as a model, and removed from its place, I thought it would show the façade before any other part of it; how the rest of it is related to the town will be seen on the map. . . .[22]*

What difference has this made? *Realistic proportions* have been altered, and while part of the city is shown from *one* direction, one detail of it is shown from *exactly the opposite direction*[7]

That is why I insist upon including El Greco among the forefathers of film montage. In this particular instance he appears as a forerunner of the newsreel, for his 're-editing'

* The full text as it appears in the painting:

Ha sido forçoso poner el hospital de Don Joan Tauera en forma de modelo porque no solo venia a cubrir la puerta de visagra mas subia el cimborrios o copula de manera que sobrepujaua la çiudad y asi una vez puesto como modelo y mouido de su lugar me pareçio mostrar la haz antes que otra parte y en lo demas de como viene con la çiudad se vera en la planta.

Tambien en la historia de nra Señora que trahe la casulla a S. Illefonso para su ornato y hazer las figuras grandes me he valido en çierta manera de ser cuerpos çelestiales como vemos en las luçes que vistas de lexos por pequeñas que sean nos pareçen grandes.

is rather more informational here than in his other *View of Toledo* (painted in the same period). [23] In this latter work he accomplished no less radical a *montage revolution* of realistic landscape, but here it has been done through an *emotional* tempest, which has immortalized this painting.

El Greco brings us back to our principal theme, for his painting has a precise musical equivalent in one portion of Spain's many-sided folk music. El Greco walks into our problem of colour-sound montage, for it would have been impossible for him not to have known this music—so close is his painting in spirit to the characteristics of the so-called *cante jondo*.*

This spiritual kinship (naturally without reference to cinematography!) is brought out by Legendre and Hartmann in the introduction to their monumental catalogue of El Greco's works.

They begin by citing Jusepe Martínez' testimony to the effect that El Greco often invited musicians to his home. (Martínez criticized such behaviour as an 'unnecessary luxury'.) We cannot help imagining that an affinity of music to painting would be natural in the work of an artist who had so personal a love for music.

Legendre and Hartmann openly declare:

. . . we readily believe that El Greco loved the *Cante Jondo*, and we shall endeavour to explain how his work represents in painting the counterpart to that which *Cante Jondo* represents in music. [24]

In searching for a description and analysis of *cante jondo*, we find the splendid brochure on this subject, issued anonymously by Manuel de Falla on the occasion of the *cante jondo* festival organized at Granada by the composer and Federico Garcia Lorca. [25] This brochure has been summarized and quoted in J. B. Trend's work on Falla. After tracing elements of the Byzantine chant, the Arabian song, and gipsy music in *cante jondo* . . .

* Or *cante hondo;* literally, 'a deep song'.

. . . Falla finds analogies with certain types of melody found in India and elsewhere in the East. The positions of the smaller intervals in the scale are not invariable; their production depends upon the raising or lowering of the voice due to the expression given to the word which is being sung . . . ; further, each of the notes susceptible of alteration is divided and subdivided, resulting in certain cases in the alteration of the notes of attack and resolution of some fragments of the phrase. To this may be added the *portamento* of the voice—that manner of singing which produces the infinite gradations of pitch existing between two notes, whether next to each other or far apart. 'Summing up what has been said, we may affirm, firstly, that in *cante hondo* (as equally in the primitive melodies of the East) the musical scale is the direct consequence of what might be called the oral scale. . . . Our tempered scale only permits us to change the functions of one note; while in "modulation by enharmonism", properly so-called, that tone is modified according to the natural necessities of its functions. . . .'

Another peculiarity of *cante hondo* is the employment of a compass which rarely exceeds the limits of a sixth. 'The sixth, of course, is not composed solely of nine semitones as is the case with our tempered scale. By the employment of the enharmonic genus, there is a considerable increase in the number of tones which the singer can produce.'

Thirdly, *cante hondo* provides examples of the repetition of the same note—to the point of obsession—frequently accompanied by an appoggiatura from above or below. . . .

Although gipsy melody is rich in ornamental figures, these (as in primitive oriental music) are only employed at determinate moments as lyrical expansion or as passionate outbursts suggested by the strong emotions described in the text. 'They may be considered, therefore, as extended vocal inflexions rather than as ornamental figures, although they assume the latter on being translated into the geometrical intervals of the tempered scale.'[26]

Legendre and Hartmann leave the reader in no doubt as to their analogy between *cante jondo* and El Greco.

. . . when we contemplate those subtly subdivided 'intervals' of colour, where the modulations of essentials prolong themselves into infinity, these violent viewpoints, these explosive gestures, these violent contortions which so shock mediocre and colourless

minds—we hear the *Cante Jondo* of painting—an expression of Spain and the East—of the Occident and the Orient. . . .[27]

Other Greco scholars, such as Maurice Barrès, Meier-Graefe, Kehrer, Willumsen and others, without actually referring to music, have nevertheless described *in almost these exact words* this effect of Greco's paintings. How lucky are those who may confirm these impressions with their own eyes!*

Unsystematized but very curious evidence on this question is provided in Yastrebtzev's memoirs of Rimsky-Korsakov. In the entry for 8th April 1893:

During the course of the evening the conversation turned to the question of tonality and Rimsky told how harmonies in sharps had the personal effect on him of *colours*, while harmonies in *flats* conveyed moods of 'greater or lesser degrees of warmth' to him. C sharp minor followed by D flat major in the 'Egypt' scene of *Mlada* was 'deliberately introduced to convey a *feeling of warmth*, just as the colour red arouses *sensations of heat*, while *blue and purple* suggest *cold and darkness*. 'This is possibly why,' he said, 'the strange tonality (E minor) of Wagner's inspired Prelude of *Das Rheingold* always has such a depressing effect on me. I would have transposed this Prelude in the key of E major.'[28]

In passing, we should remember James McNeill Whistler's 'colour symphonies'—*Harmony in Green and Blue, Nocturne in Blue and Silver, Nocturne in Blue and Gold*, and his *Symphonies in White*.[29]

Audio-colour associations have occupied even so little respected a figure as Böcklin:

To him, who always pondered the secret of colour, all colours spoke—as Floerke reports—and in turn, everything he perceives, both inwardly and outwardly, is translated into colour. I am convinced that to him a trumpet blast, for example, is cinnamon red.[30]

Considering the prevalence of this phenomenon, Novalis' demand is quite relevant:

* American public collections now contain a wealth of El Greco's work. There are paintings of first importance in New York, Chicago, Boston, Washington and Philadelphia.—Editor.

Plastic works of art should never be viewed without music; musical works, on the other hand, should be heard only in beautifully decorated halls.[31]

As for an absolute 'colour alphabet', unfortunately we must agree with François Coppée, that philistine whom I thoroughly despise, when he writes:

> *Rimbaud, fumiste réussi,*
> *—Dans un sonnet que je deploré—*
> *Veut que les lettres O. E. I.*
> *Forment le drapeau tricolore.*
> *En vain le* Décadent *pérore. . . .*[32]

The question must, nevertheless, be undertaken, for the problem of achieving such absolute correspondence is still disturbing many minds, even those of American film producers. Only a few years ago I came across in an American magazine quite serious speculations as to the absolute correspondence of the piccolo's tone to—yellow!

But let this yellow colour, allegedly produced by the piccolo, serve us as a bridge to the problems, not of 'non-objective abstractions' but those problems encountered by the artist in his creative work with colour.

CHAPTER III

COLOUR AND MEANING

Forms, colours, densities, odours—what is it in me that corresponds with them?

<div style="text-align: right">WALT WHITMAN[1]</div>

In the preceding section we gave a rather thorough consideration to that question of *finding* 'absolute' relations between sound and colour. For further clarification let us examine another problem tangent to this, namely: the question of 'absolute' relations between particular emotions and particular colours.

For variety's sake, let us approach this question less through 'authorities' with their reasonings and opinions, and more through the living emotions and impressions that artists have left us in this matter.

And for convenience' sake, let us confine our examples to one colour tonality. Let us compose our own 'rhapsody in yellow'.

Our first example is an extreme case.

When we speak of 'inner tonality' and 'inner harmony of line, form and colour', we have in mind a harmony with *something*, a correspondence with *something*. The inner tonality must contribute to the *meaning* of an inner feeling. As vague as this feeling may be, in its turn it is always directed finally to something concrete, which finds an outer expression in colours, lines and forms.

Nevertheless, there are those who claim that such an approach denies the 'freedom' of feeling. To counter our views and opinions, they propose an aimless, vague, 'absolutely

free' inner tonality (*der innere Klang*), neither as a direction nor as a means, but as *an end in itself*, as the summit of achievement, as finality.

Such a view of 'freedom' only frees us from reason. This is truly a rare, unique freedom, the only one *absolutely* attainable among our fascist neighbours.

A leading exponent and life-long advocate of the above ideal is the painter Kandinsky—the source of the first measure of our 'rhapsody in yellow'.

The following is an excerpt from 'The Yellow Sound',[2] a theatre-composition by Kandinsky, which concludes the volume entitled *Der blaue Reiter*—practically a manifesto of the group of this name—and of considerable influence in the subsequent tendencies of modern European art.

This 'Yellow Sound' is actually a 'programme' for a scenic presentation of its author's feelings regarding the play of colours as of music, of the play of music as of colours, of the play of people in some way or other, and so on.

Within its obscurity and bewildering elusiveness one eventually senses the presence of some mystic 'seed'—although it would be very difficult to arrive at any clear definition of it. Finally, in the sixth scene, it is revealed, almost religiously:

Dull blue background. . . .
In the centre of the stage is a bright yellow giant with a blurred white face and big, round, black eyes. . . .
He slowly raises his arms alongside his body (palms down), growing in height as he does so.
At the moment he attains the full height of the stage, and his figure resembles a cross, the stage is *suddenly* darkened. The music is expressive, following the action on the stage.

The contents of this work cannot be satisfactorily conveyed, due to the total absence of content—as well as theme.

The most we can do for the author is to present a few examples of his feelings, winding around the 'yellow sounds':

Scene 2
The blue haze gradually gives way to the light, which is com-

pletely and harshly white. Upstage a mound, entirely round, as bright green as possible.

The background is violet, rather bright.

The music is harsh, stormy, with constantly recurring *A*'s and *B*'s and *A* flats. These individual notes are finally swallowed up by the loud tempestuousness. Suddenly total stillness ensues. A pause. Again *A* and *B* moan, complainingly, but definite and sure. This lasts for some time. Then again a pause.

At this moment the background suddenly turns dirty brown. The mound turns dirty green. And at the very centre of the mound an indefinite black spot is formed, alternately becoming clearer and then blurry grey. At the left on the mound a *large* yellow flower suddenly becomes visible. It remotely resembles a big crooked cucumber and constantly grows brighter. Its stem is long and thin. A single spiny, narrow leaf grows out of the middle of the stem and is turned toward the side. A long pause.

Later, *in dead silence*, the flower very slowly swings from right to left. Still later the leaf joins in the oscillation, but not in unison with the flower. Later still they both oscillate in uneven tempo. Then they again swing to and fro separately, a very thin *B* sounding with the motion of the flower, and a very deep *A* with the leaf's motion. Then both swing in unison, both notes sound in with them. The flower trembles violently and is still. The two musical notes continue to sound. At the same time many persons enter from the left in garish, long, formless clothes (one all in blue, another in red, the third in green, etc.—only yellow is lacking). They have very large white flowers in their hands, similar to the flower on the mound. . . . They speak a recitative in mixed voices. . . .

First the whole stage suddenly grows blurred in dull red light. Secondly, complete darkness alternates with harsh white light. Thirdly, everything suddenly turns a faded grey (all colours disappear!). Only the yellow flower shines ever brighter!

The orchestra gradually begins and covers the voices. The music grows restless, falling away from fortissimo to pianissimo. . . At the instant that the first figure becomes visible, the yellow flower trembles as if in a cramp. Then it suddenly vanishes. Just as suddenly all the white flowers turn yellow. . . .

Finally they throw away the flowers, which seem to be soaked in blood, and, forcibly freeing themselves from their rigidity, run

toward the footlights, closely packed shoulder to shoulder. They often look about them. Sudden darkness.

Scene 3

Upstage: two big reddish-brown rocks, one of them pointed, the other rounded and larger than the first. Background: black. The giants (of Scene 1) stand between the rocks and silently whisper to one another. Sometimes they whisper in pairs, sometimes they approach with all their heads together. Their bodies remain motionless. In rapid succession fall from all sides harshly coloured beams of light (blue, red, violet, green—alternating several times). These beams meet at the centre of the stage, where they mix. Everything is motionless. The giants are almost wholly invisible. Suddenly all the colours vanish. The stage is black for an instant. Then a dull yellow light floods the stage, gradually growing more intense, until the whole stage is bathed in garish lemon-yellow. As the light increases, the music grows deeper and becomes darker and darker (these movements remind one of a snail forcing itself into its shell). During these two movements nothing but light should be visible on the stage—no objects. . . .

Etc., etc.

The method employed here is clear—to abstract 'inner tonalities' of all 'external' matter.

Such a method *consciously attempts to divorce all formal elements from all content elements;* everything touching theme or subject is dismissed, leaving only those extreme formal elements that in *normal creative work* play only a partial role. (Kandinsky formulates his theory elsewhere in the volume cited.)

We cannot deny that compositions of this kind evoke *obscurely disturbing* sensations—but no more than this.

But to this day attempts continue to be made to arrange these subjective and largely personal sensations into meaningful relationships, that are, frankly, just as vague and remote. *

* Both Remy de Gourmont and Humpty-Dumpty adopted this course. The one claims, 'To erect into laws one's personal impressions, this is the great effort of a man if he is sincere.' The other: 'When *I* use a word, it means just what I choose it to mean—neither more nor less.'

The following will demonstrate how Paul Gauguin dealt with similar 'inner tonalities' in a notebook entitled *Genèse d'un tableau*,[3] concerning his painting 'Manao Tupapau—The Spirit of the Dead Watching'[4]

A young Tahitian girl is lying on her belly, revealing a part of her frightened face. She reposes on a bed covered with a blue *pareo* and a light chrome yellow sheet. There is a background of purple violet, strewn with flowers similar to electric sparks; a somewhat strange figure stands by the bed.

Charmed by a form, a movement, I paint this with no other concern than to do a nude. As it now stands, it is a slightly indecent sketch in the nude. What I want to do, however, is a chaste painting, expressing the Tahitian spirit, its character and its tradition.

I use the *pareo* as a bedspread because it is intimately bound to the life of a Tahitian. The sheet, with a texture of tree-bark, must be yellow—because this colour suggests something unexpected to the beholder; and also because it suggests lamplight which spares me the trouble of producing this effect. I must have a slightly terrifying background. Violet is obviously necessary. The scaffolding of the musical aspect of the picture is now erected.

In this somewhat daring pose, what can a young Tahitian girl be doing stark naked on a bed? Preparing for love?—This would be characteristic for her, but it is indecent, and I don't want it. Sleeping?—The act of love would be ended, which is still indecent. I see only fear. What kind of fear?—Certainly not the fear of some Susanna surprised by the elders. This fear is unknown in Tahiti.

The *tupapau* (Spirit of the Dead) is the answer I am seeking. It is a source of constant fear for the Tahitians. At night, a lamp is always kept alight. When there is no moon, nobody walks along the road without a lantern, and even then they always walk in groups.

Having found my *tupapau*, I become completely attached to it and make it the motif of my picture. The nude takes on a secondary importance.

How does a Tahitian girl imagine a ghost? She has never been to the theatre, nor has she read novels, and when she thinks of a dead person, she can only think of one that she has already seen. My ghost can only be some little old woman. She extends her hand as though to clutch her prey.

A decorative sense leads me to strew flowers over the background. These are *tupapau* flowers, phosphorescences, indicating that the ghost is thinking of you. Tahitian beliefs.

The title *Manao tupapau* has two meanings: she can be thinking of the ghost, or the ghost is thinking about her.

Summing up. The musical element: undulating horizontal lines; harmonies of orange and blue woven together by yellow and violets and their derivatives, all lighted by greenish sparks. The literary element: the Spirit of a living girl bound to the Spirit of the dead. Night and Day.

This genesis is written for those who always insist on knowing the *whys* and *wherefores*.

Otherwise, it is simply a Tahitian nude study.

Here is everything we are seeking: 'the scaffolding of the musical aspect of the picture is now erected'; an appraisal of the psychological values of colours—the 'terrifying use of violet, as well as of our yellow, here calculated to suggest 'something unexpected to the beholder'.

A close associate of Gauguin's has recorded a similar appraisal of our colour. Vincent van Gogh describes his 'Night Café'[5] which he has just finished, to his brother:

In my picture of the 'Night Café' I have tried to express the idea that the café is a place where one can ruin one's self, run mad, or commit a crime. So I have tried to express as it were the powers of darkness in a low drink shop, by soft Louis XV green and malachite, contrasting with yellow green and hard blue greens, and all this in an atmosphere like a devils' furnace, of pale sulphur.[6]

Here is another artist speaking of yellow—Walther Bondy, writing of his designs for a production of Strindberg's *Brott och Brott* in 1912:

In staging the Strindberg play we made an attempt to bring the settings and costumes directly into participation in the action of the play.

To do this it was necessary for every detail of the milieu to express something and to play its own specific role. In many cases, for example, particular colours would be employed for their direct effect on the spectator. There were several leit-motifs, con-

veyed through colour, in order to show a more profound connection between separated moments of the play. Thus in the third scene (Act II, Scene 1) a yellow motif was introduced into the action. Maurice and Henriette are sitting in the 'Auberge des Adrets'; the general tone of the scene is black, with a black cloth almost completely covering an enormous stained-glass window; on the table is a candelabra with three candles. In the necktie and gloves given him by Jeanne, now unwrapped by Maurice, the colour of yellow appears for the first time. Yellow becomes the colour motif of Maurice's 'sinking into sin' (through this gift he is inescapably tied to Jeanne and Adolphe).

In the fifth scene (Act III, Scene 2) when Adolphe leaves the stage and Maurice and Henriette become aware of their crime, great bunches of yellow flowers are brought on to the stage. In the seventh scene (Act IV, Scene 1) Maurice and Henriette are sitting in the Luxembourg Gardens. The sky is brilliant yellow, and silhouetted against it are the thin bare black branches, the bench and the figures of Maurice and Henriette. . . . It should be noted that the treatment of the whole production was on a mystic plane. . . .

The premise here is that 'particular colours exert specific influences' on the spectator. This is 'substantiated' by the connection of yellow with sin, and the influence of this colour on the psyche. Mysticism is also mentioned. . . .

It is interesting to see the same associative use made of this colour by T. S. Eliot, particularly in his early poems:

> *Sitting along the bed's edge, where*
> *You curled the papers from your hair,*
> *Or clasped the yellow soles of feet*
> *In the palms of both soiled hands.* [8]

> *Well! and what if she should die some afternoon,*
> *Afternoon grey and smoky, evening yellow and rose . . .* [9]

> *The yellow fog that rubs its back upon the window-panes,*
> *The yellow smoke that rubs its muzzle on the window-panes*
> *Licked its tongue into the corners of the evening,*
> *Lingered upon the pools that stand in drains. . . .* [10]

Mr. Eliot's pointed use of yellow extends even to substances and objects of this colour. In *Sweeney Among the Nightingales*:

> . . . *the man with heavy eyes*
> *Declines the gambit, shows fatigue,*
>
> *Leaves the room and reappears*
> *Outside the window, leaning in,*
> *Branches of wistaria*
> *Circumscribe a golden grin.* . . .

And *Mr. Apollinax* ends on:

> *I remember a slice of lemon, and a bitten macaroon.*

To make the colour of yellow thoroughly 'frightening' we choose another example.

There are few writers as acutely sensitive to colour as is Gogol. And few also are writers of our time who understand Gogol as acutely as did the late Andrei Belyi.

In his painstaking analysis of Gogol's craftsmanship,[11] Belyi subjects the changes of Gogol's palette throughout his creative career to the most minute examination in the chapter, 'The Spectrum of Gogol'. What is revealed thereby? Following the yellow graph in Belyi's charts, we see our colour increasing steadily from the joyous *Evenings in the Village*. through *Taras Bulba*, and making its greatest quantitative leap upwards in the second volume of *Dead Souls*.

Of all colours employed by Gogol in his first works, the average of yellow references is only 3·5 per cent.

In the second group (of novels and comedies) this average rises to 8·5 per cent, and in the third group (Volume I of *Dead Souls*) reaches 10·3 per cent. And lastly (Volume II of *Dead Souls*), yellow occupies 12·8 per cent of Gogol's colour attention. Being close to yellow, green moves correspondingly: 8·6—7·7—9·6—21·6 per cent. Together, these two colours occupy *more than a third* of Gogol's palette in his last work.

Nor does this include the 12·8 per cent of 'golden' references. Belyi points out:

... the gold of Volume II (of *Dead Souls*) is not the gold of gold-plate and gold thread, but the gold of cathedrals and crosses, heightening the influential role of the Orthodox Church; the ringing of 'gold' is balanced against the 'red ringing' of Cossack glory; with the red graph declining and the yellow and green graphs rising, this second volume moves away to a colour world far removed from the spectrum of *Evenings in the Village*. ...

Even more terrifying seems the 'fateful' tone of yellow, when we recall how this is exactly the chromatic scale that dominates another work of art, created in a tragic twilight—Rembrandt's self-portrait at the age of fifty-five. [12]

To avoid charges of personal prejudice in describing the colour of this painting, I cite here, not my own, but Allen's description of this work, as he wrote of it in his article relating the problems of esthetics to those of psychology: [13]

... the colours are all dark and dull, lightened only in the centre. This centre is a combination of dirty green and yellowed grey, mixed with faded brown; the rest is almost black. ...

This yellow scale, melting into dirty greens and a faded brown, is emphasized by contrast with the lower portion of the canvas:

... only below some reddish tones can be seen; muffled and overlaid upon each other, but, more or less aided by thickness and their comparatively great colour intensity, they create a clearly expressed contrast to the rest of the painting. ...

In this connection it is impossible to forbear any reference to the unfortunate image of the aged Rembrandt presented by Alexander Korda and Charles Laughton in *Rembrandt*. As scrupulously costumed and made-up as Laughton was for these concluding scenes, no attempt was made to mirror this tragic *chromatic scale*, so typical of the late Rembrandt, with an equivalent cinematic *light-scale*.

It becomes apparent that many characteristics we ascribe to the colour yellow derive from its immediate neighbour in the spectrum—green. Green, on the other hand, is directly associated with the symbols of life—young leaf-shoots, foliage

and 'greenery' itself—just as firmly as it is with the symbols of death and decay—leaf-mould, slime, and the shadows on a dead face.

There is no limit to the evidence we could bring in to this court, but have we not enough to make us ask ourselves, 'Perhaps there *is* something sinister in the nature of the colour of yellow?' Does this touch something more profound than mere conventional symbolism and habitual or accidental associations?

For answers to these questions we must turn to the *history of the evolution of symbolic meanings* within certain colours. There is, fortunately, a very thorough work on this subject by Frédéric Portal, first published in 1857: *Des couleurs symboliques dans l'antiquité, le Moyen-Age, et les temps modernes.*

This authority on the 'symbolic meaning' of colour has this to say about the colour that concerns us here—yellow, and how ideas of *perfidy, treason and sin* grew to be connected with it:

Divine and sacred languages designated with the colours of gold and yellow the union of the soul with God and, by opposition, adultery in a spiritual sense. In profane speech, this was a materialized emblem representing legitimate love as well as carnal adultery that breaks the bonds of marriage. . . .

The golden apple was, for the Greeks, the symbol of love and concord and, by opposition, it represented discord and all the evils in its train; the judgment of Paris proves this. Likewise Atalanta, while gathering the golden apples picked in the Garden of the Hesperides, is beaten in the race and becomes the victor's prize.[14]

Of particular interest is Portal's evidence of one feature to be found in all mythological matter attaching to this colour: the *ambivalent* meanings that are read into it. This phenomenon can be explained by the fact that in early stages of evolution *the same concept, meaning or word equally represents two opposites that are mutually exclusive.*

Yellow, he shows, has equally strong connections with both 'loving union' and 'adultery'.

Havelock Ellis provides a convincing explanation of this phenomenon, that is, in the particular instance of *yellow*:

It was clearly the advent of Christianity that introduced a new feeling in regard to yellow. . . . In very large measure, no doubt, this was clearly the outcome of the whole of the Christian revulsion against the classic world and the rejection of everything which stood as the symbol of joy and pride. Red and yellow were the favourite colours of that world. The love of red was too firmly rooted in human nature for even Christianity to overcome it altogether, but yellow was a point of less resistance and here the new religion triumphed. Yellow became the colour of envy.

Yellow became the colour of jealousy, of envy, of treachery. Judas was painted in yellow garments and in some countries Jews were compelled to be so dressed. In France in the sixteenth century the doors of traitors and felons were daubed with yellow. In Spain heretics who recanted were enjoined to wear a yellow cross as a penance and the Inquisition required them to appear at public *autos da fe* in penitential garments and carrying a yellow candle.

There is a special reason why Christianity should have viewed yellow with suspicion. It had been the colour associated with wanton love. In the beginning the association was with legitimate love. . . . But in Greece, and to a still more marked extent in Rome, the courtesan began to take advantage of this association.[15]

In one of the lectures which I happened to hear given by the late academician Marr,[16] he illustrated the basic phenomenon of ambivalence with the word-root 'kon', which is the root for both the Russian word for *end*, 'kon-yetz', and one of the oldest Russian words for *beginning*, 'is-kon-i'.

The ancient Hebrew language contains a similar example in the word 'K°d°sh', which has both 'holy' and 'unholy' significance. The 'clean' and 'unclean' significance of the word *tabu* is already familiar to us. And Gauguin has already mentioned that 'Manao tupapau' holds a dual meaning: '*she is thinking of the ghost*', and '*the ghost is thinking about her*'.

Remaining within the circle of our present interest in ideas of yellow and gold, we can remark another case of ambivalence: gold, a symbol of *highest value*, also serves as a popular

metaphor signifying—filth. This is true not only in a general way, as in the Western European examples below, but in the Russian language which contains the term 'zolotar' ('zoloto', the root—gold), having the specific meaning of 'cess-pool cleaner'.

We will see also that a '*positive*' interpretation (in a 'major key') of this colour's golden or yellow gleam contains a *directly sensual* base, and that into this are woven entirely marginal associations (sun, gold, stars).

Even Picasso has remarked these particular associations:

There are painters who transform the sun into a yellow spot but there are others who with the help of their art and their intelligence transform a yellow spot into a sun.[17]

And van Gogh, for whom the colour of yellow had special vitality, casts aside its evil associations which he exploited in his 'Night Café', and takes the floor for the painters who 'transform a yellow spot into a sun':

. . . instead of trying to reproduce exactly what I have before my eyes, I use colour arbitrarily so as to express myself forcibly. Well, let that be as far as theory goes, but I am going to give you an example of what I mean.

I should like to paint the portrait of an artist friend, a man who dreams great dreams, who works as the nightingale sings, because it is his nature. He'll be a fair man. I want to put into the picture my appreciation, the love I have for him. So I paint him as he is, as faithfully as I can, to begin with.

But the picture is not finished yet. To finish it I am now going to be the arbitrary colourist. I exaggerate the fairness of the hair, I come even to orange tones, chromes and pale lemon-yellow.

Beyond the head, instead of painting the ordinary wall of the mean room, I paint infinity, a plain background of the richest, intensest blue that I can contrive, and by the simple combination of the bright head against the rich blue background, I get a mysterious effect, like a star in the depths of an azure sky. . . .[18]

The positive source of yellow in the first instance was the *sun* (Picasso), and in the second—a *star* (van Gogh).

Let us take another image of the golden hue of yellow—

finding it in 'a man who dreams great dreams'—Walt Whitman himself, 'speeding through space, speeding through heaven and the stars':

Painters have painted their swarming groups and the centre-figure of all,
From the head of the centre-figure spreading a nimbus of gold-colour'd light,
But I paint myriads of heads, but paint no head without its nimbus of gold-
colour'd light,
From my hand from the brain of every man and woman it streams, efful-
gently flowing forever. [19]

Whitman must have loved the colour, but loved it enough not to restrict its application to one use alone. His nature descriptions are full of a 'positive' use of yellow, growing into great, warm, 'positive' landscapes:

Sprouts take and accumulate, stand by the curb prolific and vital,
Landscapes projected masculine, full-sized and golden. [20]

I see the highlands of Abyssinia,
I see flocks of goats feeding, and see the fig-tree, tamarind, date,
And see fields of teff-wheat and places of verdure and gold. [21]

California gets special 'golden' attention:

Always California's golden hills and hollows, and the silver mountains of
New Mexico. . . . [22]

The flashing and golden pageant of California,
The sudden and gorgeous drama, the sunny and ample lands. . . . [23]

Among the important positive associations that Whitman makes with yellow is with a theme that concerned him even more than nature—the theme of work:

By the curb toward the edge of the flagging,
A knife-grinder works at his wheel sharpening a great knife,
Bending over he carefully holds it to the stone, by foot and knee,
With measur'd tread he turns rapidly, as he presses with light but firm hand,
Forth issue then in copious golden jets,
Sparkles from the wheel. [24]

and from the *Song of the Broad-Axe*:

The butter-coloured chips flying off in great flakes and slivers. . . .

Despite the powerful major key in which these yellow references are sounded, there is also a minor key—first heard in the rural sunset passages, from which the transition to death and old age stems through direct images:

Ray'd in the limpid yellow slanting sundown,
Music, Italian music in Dakota.[25]

Pictures of growing spring and farms and homes,
With the Fourth-month eve at sundown, and the grey smoke lucid and bright,
With floods of the yellow gold of the gorgeous, indolent sinking sun, burning expanding the air. . . .[26]

Passing the yellow-speared wheat, every grain from its shroud in the dark-brown fields uprisen,
Passing the apple-tree blows of white and pink in the orchards,
Carrying a corpse to where it shall rest in the grave,[7]
Night and day journeys a coffin.[2]

and from *Old Age's Lambent Peaks*:

> *The calmer sight—the golden setting, clear and broad. . . .*

And finally yellow becomes the colour of the faces of wounded men, of old women—and is added to the colour-scale of deathly decay:

I dress a wound in the side, deep, deep,
But a day or two more, for see the frame all wasted and sinking,
And the yellow-blue countenance see.[28]

It is my face yellow and wrinkled instead of the old woman's,
I sit low in a straw-bottom chair and carefully darn my grandson's stockings.[29]

and in *The Pallid Wreath*:

Somehow I cannot let it go yet, funereal though it is,
Let it remain back there on its nail suspended,
With pink, blue, yellow, all blanched, and the white now grey and ashy. . . .

But one can detect even among Whitman's broad, varied uses of this colour that he does make some distinctions in his

use of subtle differences of *shades* of yellow —ranging all the way from golden to 'yellow, all blanched'.

Returning to our authority, Portal tells us of a stage in the evolution of 'yellow traditions' in the Middle Ages. The single colour which in antiquity had been a *token of two* opposites simultaneously, underwent a 'rationalizing process' and emerged as *two distinct tones*, each representing *one half* of the former *double-significance*:

> . . . the Moors differentiated the two symbols by using two different shades: golden yellow signified *wise and good counsel*, and pale yellow signified treachery and deceit. . . .[30]

The learned rabbis of medieval Spain gave an interpretation of added interest for us:

> . . . the rabbis held that the fruit of the forbidden tree was a lemon, by opposing its pale colour and its acidity to the golden colour and sweetness of the orange or golden apple, according to the Latin term.

This subdivision is carried further:

> In heraldry, gold is the emblem of love, of constancy and of wisdom and, by opposition, yellow still denotes, in our time, inconstancy, jealousy and adultery.

Thus came into existence the French tradition mentioned by Ellis of smearing yellow paint on the doors of traitors (such as Charles de Bourbon for his treason during the reign of Francis I). The official garment for an executioner in medieval Spain was prescribed as of two colours, yellow and red: yellow to symbolize the accused's treachery; red, retribution.

These are the 'mystic' sources from which the symbolists tried to extract 'eternal' colour meanings, and determine the irrevocable influences of colours on the human psyche.

But what tenacity there has been in preserving traditions in this matter!

It is precisely these meanings that are preserved, for example, in Parisian 'argot'—a language full of wit and folk imagery.

Open one of the many dictionaries of this argot to the word 'jaune':

YELLOW—the colour assigned to deceived husbands: cf. *Sa femme le peignait en jaune de la tête aux pieds*—his wife cuckolded him tremendously; *un bal jaune*—a ball where all the men are cuckolds.[31]

This is not all. The interpretation of treachery spreads further than this.

(*c*) YELLOW—a member of an anti-socialist trade union.

This use of the term is to be found in many countries. We often hear the Second International referred to as the 'yellow international'. 'Yellow trade unions' is a familiar term in many places while America knows the 'yellow dog contract'. Yellow as the colour of treachery has been preserved to the point of stigmatizing traitors to the working class! Through the medium of films Alberto Cavalcanti has brought into common usage an epithet for one of the most despicable of these traitors—*Yellow Caesar*.*

Close cousins of the Paris argot, the slang and 'cant' of America and England have preserved the same associations for yellow.

A New Canting Dictionary of 1725 asserts that yellow, meaning *jealous*, was originally a term of the London underworld.[32]

In *Slang and Its Analogues Past and Present*, the parent of all modern slang dictionaries, the authors found older, broader interpretations for this colour:

YELLOW, subs. (old colloquial). (1) Generic for jealousy, envy, melancholy. . . . Also in frequent proverbial phrase: e.g., *to wear yellow hose (breeches or stockings)*—to be jealous; . . . *to wear yellow stockings*—to be cuckolded. . . .[33]

The authors bring Shakespeare to testify:

. . . civil as an orange, and something of that jealous complexion.
(*Much Ado About Nothing*, Act II, Scene 1)

* A two-reel satire produced for Michael Balcon, 1941.

. . . with a green and yellow melancholy . . .

> (*Twelfth Night*, Act II, Scene 4)

. . . 'mongst all colours
No yellow isn't, lest she suspect, as he does,
Her children not her husband's!

> (*Winter's Tale*, Act II, Scene 3)

American slang is particularly colourful in this respect:

> Yellow-livered—Cowardly.
> Yellow streak—Cowardice, undependableness.
> Yaller dog—A treacherous person, a cowardly person.[34]

Another meaning is found for yellow in the term 'yellow stuff'—money (or, sometimes, counterfeit money). A fusion of this meaning and of the more 'traditional' meaning gave birth to that inspired phrase, formed from 'bought' and 'treachery'—'the yellow press'.

However, the most interesting light cast on these 'symbolic meanings' of yellow comes from the fact that, essentially it was not yellow, as a colour, that determined them.

We have shown that in antiquity this interpretation arose as an automatic antipode to the sun-motivated positive tone of yellow.

Its negative 'reputation' in the Middle Ages was formed of the sum of *associative and no longer narrowly colour indications*. The Arabs found 'wanness' rather than 'brilliance' in this colour. The rabbis saw yellow as 'pallor' rather than as 'vividness', and gave first place to taste associations: the 'treacherous' taste of the lemon as distinct from the sweetness of the orange!

This use was also preserved in the argot. There is a popular French expression—*rire jaune* (yellow laughter). In Balzac's *Paris Marié*, Chapter III is entitled 'Les risettes jaunes'. Pierre MacOrlan gives the title of *Le Rire Jaune* to a novel. The expression can also be found in the dictionary (*Parisisms*) quoted above. What is its meaning?

An exact counterpart can be found in both the English and Russian languages: a sour smile. (In German also: *ein*

saures Lächeln.) The interesting fact here is that where the French use a *colour* identification, these other languages use a corresponding designation of *taste*. That lemon of the Spanish rabbis furnishes us with a key to the code.

The tradition of dividing the meanings of yellow according to associations was continued by Goethe. Most of his concrete associations are with textures, but he introduces a psychological approach with a new pair of concepts: 'noble' (*edel*) and 'coarse' (*unedel*), which even ring of social motives!

In Part IV, entitled 'Effect of colour with reference to moral associations', of Goethe's *Farbenlehre*, we read:

Yellow

765. This is the colour nearest the light. . . .

766. In its highest purity it always carries with it the nature of brightness, and has a serene, gay, softly exciting character.

767. In this state, applied to dress, hangings, carpeting, &c., it is agreeable. Gold in its perfectly unmixed state, especially when the effect of polish is superadded, gives us a new and high idea of this colour; in like manner, a strong yellow, as it appear on satin, has a magnificent and noble effect. . . .

770. If, however, this colour in its pure and bright state is agreeable and gladdening, and in its utmost power is serene and noble, it is, on the other hand, extremely liable to contamination, and produces a very disagreeable effect if it is sullied, or in some degree tends to the *minus* side. Thus, the colour of sulphur, which inclines to green, has something unpleasant in it.

771. When a yellow colour is communicated to dull and coarse surfaces, such as common cloth, felt, or the like, on which it does not appear with full energy, the disagreeable effect alluded to is apparent. By a slight and scarcely perceptible change, the beautiful impression of fire and gold is transformed into one not undeserving the epithet foul; and the colour of honour and joy reversed to that of ignominy and aversion. To this impression the yellow hats of bankrupts and the yellow circles on the mantles of Jews, may have owed their origin. . . .[35]

Before proceeding further on our 'yellow path' (which seems to have landed us among Nazi revivals of medieval darkness!) let us note some facts about the colour of green,

the spectrum neighbour of yellow. The same picture appears here, too. If green, in its positive interpretation, fully coincides with the initial image which is presupposed above, then its 'sinister' interpretation is also determined, like the 'negative' side of yellow, not by direct associations, but with the same ambivalence.

In its first interpretation, green is a symbol of life, regeneration, spring, hope. In this the Christian, the Chinese and the Moslem religions agree. Mohammed is believed to have been attended in all critical moments of his life by 'angels in green turbans', and so a *green banner* became the *Prophet's banner*.

Along with this a number of contradictory interpretations evolved. The colour of hope was also the colour of hopelessness and despair: in the Greek theatre the dark green colour of the sea conveyed a sinister meaning under certain conditions.

This tone of green contains a strong blue. And it is interesting that in the Japanese theatre, where colour symbolism is so 'tightly' attached to particular imagery, blue is the colour worn by sinister figures.

In a letter to me (31st October 1931) Masaru Kobayashi, author of the definitive work on 'kumadori' (make-up in the Kabuki theatre) wrote:

> . . . the basic colours employed in kumadori are red and blue. Red is warm and attractive. Blue, the opposite, is the colour of villains, and among supernatural creatures, the colour of ghosts and fiends. . . .

And Portal has this to say of green:

> Green, like other colours, had a nefarious meaning; as it had been the symbol of the soul's regeneration and of wisdom, it also signified, by opposition, moral degradation and madness.

The Swedish theosophist, Swedenborg, gives green eyes to the madmen in hell. A window in Chartres Cathedral depicts the temptation of Jesus—Satan has a green skin and great green eyes. . . .

The eye, in the lore of symbolism, signifies intelligence, the light of the mind; man may turn it towards good or evil; Satan

and Minerva, folly and wisdom, were both represented with green eyes.[36]

Abstracting green from green objects or the colour of yellow from objects of this colour, elevating green to an 'eternal green' or yellow to a 'symbolic yellow', the symbolist who performs this feat is remarkably akin to the madman of whom Diderot wrote to Madame Volland:

> . . . a single physical quality can lead the mind preoccupied with it to an infinite variety of things. Let us take a colour, yellow, for instance: gold is yellow, silk is yellow, anxiety is yellow, bile is yellow, straw is yellow; with how many other threads does not this thread connect? Insanity, dreams, rambling conversations consist in passing from one subject to the next by means of some common quality.
>
> The madman is unaware of the transition. He holds a blade of shiny yellow straw in his hand, and he shouts that he has caught a sunbeam.[37]

This madman was an ultra-formalist, seeing as he did only the *form* of the sunbeam and the *yellowness* of the colour, seeing *line and colour*. And to this colour and line, completely independent of the *concrete content of the object*, he gives a meaning, determined by himself alone.

In this he resembles his ancestor of the period of magic beliefs. Then, too, meanings were determined for yellow 'of itself'.

The ancient Hindoos performed an elaborate ceremony, based on homeopathic magic, for the cure of jaundice. Its main drift was to banish the yellow colour to yellow creatures and yellow things, such as the sun, to which it properly belongs, and to procure for the patient a healthy red colour from a living, vigorous source, namely a red bull. With this intention, a priest recited the following spell: 'Up to the sun shall go thy heart-ache and thy jaundice: in the colour of the red bull do we envelop thee! We envelop thee in red tints, unto long life. May this person go unscathed and be free of yellow colour! . . .' Then in order to improve his colour by thoroughly eradicating the yellow taint, he proceeded thus. He first daubed him from head to foot with a

yellow porridge made of turmeric or curcuma (a yellow plant), set him on a bed, tied three birds, to wit, a parrot, a thrush, and a yellow wagtail, by means of a yellow string to the foot of the bed; then pouring water over the patient, he washed off the yellow porridge, and with it no doubt the jaundice, from him to the birds. . . . The ancients held that if a person suffering from jaundice looked sharply at a stone-curlew, and the bird looked steadily at him, he was cured of the disease. 'Such is the creature,' says Plutarch, 'and such the temperament of the creature that it draws out and receives the malady which issues, like a stream, through the eyesight.' . . . The virtue of the bird lay not in its colour but in its large golden eye, which naturally drew out the yellow jaundice. Pliny . . . mentions also a stone which was supposed to cure jaundice because its hue resembled that of a jaundiced skin. In modern Greece jaundice goes by the name of the Golden Disease, and very naturally it can be healed by gold.[38]

We must not fall into the error either of the madman or the Hindu magician, who see the sinister power of disease or the great power of the sun as solely reposing in the golden colour.

Ascribing to a colour such independent and self-sufficient meanings,

abstracting colour from the *concrete phenomenon, which was its sole source for the attendant complex of concepts and associations,*

seeking absolute correlations of colour and sound, colour and emotion,

abstracting the concreteness of colour into a system of colours that act 'for their own sakes',

we will get nowhere, or worse, we will arrive at the same destination as that of the French symbolists of the latter half of the nineteenth century, about whom Gorky wrote:

. . . We must, they tell us, attach to every letter a particular, specific sensation,—A with cold, O with longing, U with fear etc.: then we are to paint these letters with colours, as Rimbaud has done, then give them sounds, bringing them to life, making out of each letter a tiny, living organism. This done, we can begin to combine these into words. . . .[39]

The harm consequent on such a method of playing with absolute correspondences is self-evident.

But if we look more carefully at the schemes for 'absolute' relationships cited in the previous section, we will discover that in almost each citation, its author speaks not of 'absolute correspondences', but of *images* to which he has attached *personal* colour concepts. It is from these various image concepts that the various 'meanings' have evolved, ascribed by these different authors to the same colour.

Rimbaud begins very decidedly: '*A*, black; *E*, white,' and so on. But in the following line he promises:

> *Someday I shall name the birth from which you rise.* . . .

And in going further, he does reveal this 'secret', not only the secret of the formation of his own *personal* sound-colour correspondences, but of the very *principle* of any author's determination of such relationships.

Every vowel, as a result of his personal life and his private emotional experiences, belongs, for Rimbaud, to a definite group of image complexes, each of which has a colour source.

'I' is not merely coloured red. But:

> I, *purples, blood spit out, laugh of lips so*
> *Lovely in anger or penitent ecstasies.* . . .

'U' is not merely green. But:

> U, *cycles, divine vibrations of green seas;*
> *The peace of animal pastures, peace of these*
> *Lines printed by alchemy on the great*
> *brows of the wise.* . . .

(We recall that, according to Lafcadio Hearn, above, a similar figure, of 'a mature Greek with wrinkles', is indicated by the initial 'X', and so on.)

Here colour acts as nothing more than a stimulus, as in a conditioned reflex, which recalls a whole complex, in which it had once played a part, to the memory and the senses.

However, one opinion is that Rimbaud's *Voyelles* was inspired by his memories of the primer which he had used as a

child. Such primers, familiar to all of us, consist of great letters of the alphabet, next to which appears the picture of some object or animal whose name begins with the same letter. Its purpose is to fasten the letter to the memory through the object or animal. Rimbaud's 'vowels' very possibly grew according to this 'image and likeness'. With each letter Rimbaud associated the 'picture' which, for him, was bound to the letter. These pictures are of various colours, so that these colours are therefore bound to particular letters.

This is exactly what takes place with other writers.

In general the 'psychological' interpretation of colour *qua* colour is a very slippery business. It becomes even more absurd when this system of interpretation begins to claim social 'associations'.

How gratifying it would be, for example, to find in the fading colours and powdered wigs of the eighteenth-century French aristocracy a reflection 'so to speak' of 'the ebb of life force from the highest group in the social structure whose place in history the middle classes and the third estate are about to assume'. How perfectly this fading scale of delicate (super-delicate!) colours of aristocratic costumes echoes this formulation! However, there is a much simpler explanation of this pastel colour-scale: the powder that fell from the wigs on to costumes that were actually vivid in colour. Thus this 'scale of fading colours' penetrates the intelligence, becoming understood almost as 'functional'. This is 'protective colouration' in significance as much as is khaki; * the fallen powder is no longer a 'dissonance' but is simply unnoticed.

The colours of red and white have long been posed as traditional opposites (and long before the Wars of the Roses). Later these colours move in the direction of *social* tendencies (along with the representation of divisions in parliamentary situations as 'right' and 'left'). Whites have been the émigrés and legitimists in both the French and Russian Revolutions. Red (the favourite colour of Marx and Zola) is associated

* *The Oxford Dictionary*: KHAKI. Dust-coloured, dull-yellow . . . (Hindustani, dusty).

with revolution. But even in this case there are 'temporary violations'. Towards the end of the French Revolution, the survivors of the aristocracy, the most violent representatives of reaction, started a vogue for wearing red handkerchiefs and cravats. It was also at this time that the French aristocracy adopted a hair-dress exposing the nape of the neck. This hair-dress, remotely resembling that of the Emperor Titus, was called 'à la Titus', but its actual origin had nothing to do with Titus, aside from the accidental resemblance. Essentially it was a symbol of implacable counter-revolutionary hatred, for it was intended to be a constant reminder of the shaving of the necks of those aristocrats condemned to the guillotine. Hence also the red kerchiefs, in memory of the neckerchiefs which wiped the blood from the 'victims of the guillotine'—creating a relic that cried aloud for vengeance to every sympathetic beholder.

Thus when any segment of the colour spectrum achieves a special vogue, we can look behind it for the *anecdote*, the concrete episode that binds a colour to specifically associated ideas.

It may be rewarding to recall other colour terminology of pre-revolutionary France—particularly that shade of brown that enjoyed a vogue at the time of the birth of one of the last Louis'—that shade that leaves no doubt as to its origin: 'caca Dauphin'. A variant of this was called 'caca d'oie'. Another self-revealing colour-word is 'puce'. The popularity among Marie Antoinette's courtiers of the combination of yellow and red bore little relation to the Spanish executioner's robes that we mentioned above. This combination was called 'cardinal sur la paille', and was a sign of the French aristocracy's protest over the imprisonment in the Bastille of Cardinal de Rohan in connection with the famous case of the Queen's Necklace.

In such examples, which are innumerable, lies this 'anecdotal origin' which is at the base of those 'special' interpretation of colour meanings in which so many authors have indulged themselves. The anecdotes are so much more graphic

and expressive than the mystic meanings given these colours!

Can we, on the basis of all this presented evidence, deny altogether the existence of relationships between emotions, timbres, sounds and colours? If not convincing relationships to all men, can they at least be established as common to special groups?

It would be impossible to deny such relationships. Pure statistics themselves would prevent such a mechanical conclusion. Without referring to the special statistical literature in this field, we can quote again from Gorky's article:

> . . . It is strange and difficult to understand [Rimbaud's attitude], until one remembers the research conducted in 1885 by an eminent oculist among the students of Oxford University. 526 of these students painted sounds as colours and vice versa—and they unanimously decided an equivalent between brown and the note of the trombone, between green and the tone of the hunting-horn. Perhaps this sonnet by Rimbaud has some psychiatric base. . . .[40]

It is clear that in purely 'psychiatric' states these phenomena would be far more heightened and evident.

Within these bounds it is possible to speak of the connections between certain colours and certain 'definite' emotions. In Havelock Ellis's colour investigations he mentions certain colour predilections established to his satisfaction:

> . . . in the achromatopsia of the hysterical, as Charcot showed and as Parinaud has since confirmed, the order in which the colours usually disappear is violet, green, blue, red: . . . this persistence of red vision in the hysterical is only one instance of a predilection for red which has often been noted as very marked among the hysterical.[41]

These colour reactions of hysterical persons have interested other experimenters, whose results concern us despite the antiquated terminology:

> The experiments of Binet have established that the impressions conveyed to the brain by the sensory nerves exercise an important influence on the species and strength of the excitation distributed by the brain to the motor nerves. Many sense-impressions operate

enervatingly and inhibitively on the movements; others, on the contrary, make these more powerful, rapid and active; they are 'dynamogenous', or 'force-producing'. As a feeling of pleasure is always connected with dynamogeny, or the production of force, every living thing, therefore, instinctively seeks for dynamogenous sense-impressions, and avoids enervating and inhibitive ones. Now, red is especially dynamogenous. 'When', says Binet, in a report of an experiment on a female hysterical subject who was paralysed in one half of her body, 'we place a dynamometer in the anaesthetically insensible right hand of Amélie Cle—the pressure of the hand amounts to 12 kilogrammes. If at the same time she is made to look at a red disc, the number indicating the pressure in kilogrammes is at once doubled. . . .'

If red is dynamogenous, violet is conversely enervating and inhibitive. It was not by accident that violet was chosen by many nations as the exclusive colour for mourning. . . . The sight of this colour has a depressing effect, and the unpleasant feeling awakened by it induces dejection in a sorrowfully-disposed mind. . . .[42]

Similar qualities are ascribed by Goethe to the colour of red. These qualities led him to divide all colours into active and passive groups (*plus* and *minus*). Such a division is connected with the popular grouping of 'warm' and 'cold' colours.

When William Blake sought ironical instructions for his *Advice to the Popes who succeeded the Age of Rafael*,[43] he employed such a grouping:

> Hire Idiots to Paint with cold light & hot shade . . .

If this data is perhaps insufficient for the formulation of a convincing 'scientific code', nevertheless art has long since adopted this in a purely empirical manner, and employed it flawlessly.

Even though the reactions of a normal person are of course far less intense than those of Amélie Cle— while facing a red disc, the artist is quite confident of the effects he can expect to shape with his palette. For the *dynamic tempest* of his painting of 'Peasant Women', Malyavin[44] didn't just *happen* to flood his canvas with a riot of *vivid red*.

Goethe has something to say on this score, too. He divides red into three shades: red, red-yellow and yellow-red. To this last shade, our *orange*, he ascribes an 'ability' to exert psychic influence:

YELLOW-RED

775. The active side is here in its highest energy, and it is not to be wondered at that impetuous, robust, uneducated men should be especially pleased with this colour. Among savage nations the inclination for it had been universally remarked, and when children, left to themselves, begin to use tints, they never spare vermilion and minium.

776. In looking steadfast at a perfectly yellow-red surface, the colour seems actually to penetrate the organ. . . . A yellow-red cloth disturbs and enrages animals. I have known men of education to whom its effect was intolerable if they chanced to see a person dressed in scarlet cloak on a grey, cloudy day. . . .[45]

As regards our primary interest, the correspondence of sounds and feelings not only to emotions, but also to each other, I had occasion to come upon an interesting fact outside the scientific or semi-scientific works.

Its source may not be exactly 'legal', but it was direct and quite logically convincing to me.

I have an acquaintance, S., to whom I had been introduced by the late Professor Vygotsky and by Professor Luriya.[46] S., failing to find any other use for his unusual faculties, had worked for several years on the vaudeville stage, astonishing audiences with feats of memory. While a man of perfectly normal development, he had retained till his maturity all those traits of primary sensual processes which human beings ordinarily lose in their evolution of logical thought. In this case, particularly, was that boundless capacity for *memorizing* concrete objects through the visualization of their surroundings as well as *what is said* about them (in the evolution of the ability to *generalize*, this early form of thought, assisted by accumulated *single factors*, retained by the *memory*, becomes atrophied).

Thus S. could *at the same time* remember *any number* of

figures or meaninglessly strung together words. He could then recite these from beginning to end—from end to beginning —skipping every second or third word, and so on. In addition to this, he would, upon meeting you a year and a half later, repeat the entire feat, and just as flawlessly. He could duplicate all the details of any conversation that he had ever overheard, and he could recite from memory all the experiments in which he had taken part (and the tables used in these experiments often contained several hundred words!). In short, he was a living, and naturally more amazing thereby, prototype of Mr. Memory in Hitchcock's *Thirty-Nine Steps*. 'Eidetics' also figured in his talents—that is, an ability to make an exact reproduction, not consciously, but automatically, of any drawing of any complexity (this ability normally disappears with the evolution of an *understanding of relationships* in drawings or pictures, and of conscious examination of the objects depicted in them).

I repeat that all these traits and abilities were preserved in S. alongside the absolutely normal traits acquired through a full development of active consciousness and of thought processes.

S. was, of course, endowed far beyond any other being within my experience, with the power of *synesthesia*, or the production from one sense-impression of one kind of an associated mental image of a sense-impression of another kind. The particular examples of this cited above were limited to the ability *to see sounds in terms of colour and to hear colours as sounds*. I once had an opportunity to discuss this with him. The most interesting fact to appear, for the authenticity of which I would be glad to vouch, was that the *scale of vowels* was seen by him *not as colours*, but as a scale of varying *light values*. Colour, for him, *is summoned only* by the consonants. This seems much more convincing to me than all the calculations cited above.

We may say without fear of contradiction that purely physical relations do exist between sound and colour vibrations.

But it can also be said, just as categorically, *that art has*

extremely little in common with such purely physical relationships.

Even if an absolute correspondence between colours and sounds were to be revealed to us, such a control over our making of films would bring us, under the most perfect conditions, to the same curious destination as that of the jeweller described by Jean d'Udine:

I know a goldsmith who, while very intelligent and cultivated, is certainly a mediocre artist. He is determined to design *original* vases and jewelry at any cost. Because he is empty of genuine creative impulse, he has come to believe that all natural forms are beautiful (which, by the way, is not true). In order to obtain the purest forms, he is content to copy exactly the curves produced by instruments in the study of physics, intended for the analysis of natural phenomena. His principal patterns are the light curves produced on a screen by the vibrations on a perpendicular plane of the mirror-tipped tuning forks used in physics to study the relative complexity of the various musical intervals. For instance he will copy on a belt buckle the figure eight, more or less elegant in contour, produced by two forks tuned to the octave. I think it would be difficult to convince him that the consonant octave tones which in music form a perfectly simple chord do not transmit a comparable emotion through the eye. When he designs a brooch by chiselling the particular curve produced by two tuning forks sounding at nine intervals from each other, he firmly believes that he is creating through plastic art an emotion which corresponds to the harmonies that M. Debussy has introduced into the art of music.[47]

In art it is not the *absolute* relationships that are decisive, but those *arbitrary* relationships within a system of images dictated by the particular work of art.

The problem is not, nor ever will be, solved by a fixed catalogue of colour-symbols, but *the emotional intelligibility and function of colour will rise from the natural order of establishing the colour imagery of the work, coincidental with the process of shaping the living movement of the whole work.*

Even within the limitations of a colour-range of black and white, in which most films are still produced, one of these tones not only evades being given a single 'value' as an *abso-*

lute image, but can even assume absolutely *contradictory* meanings, *dependent only upon the general system of imagery that has been decided upon for the particular film.*

It will be enough to note the thematic role played by the colours of black and white in *Old and New* and in *Alexander Nevsky*. In the former film black was associated with everything reactionary, criminal and out-dated, while white was the colour representative of happiness, life, new forms of management.

In *Nevsky*, the white robes of the Teuton *Ritter* were associated with the themes of cruelty, oppression and death, while the colour black, attached to the Russian warriors, conveyed the positive themes of heroism and patriotism. This deviation from the generally accepted image for these colours would have been less surprising to the critics and press abroad (whose objections were very interesting in themselves) if they had recalled an astonishing and powerful passage of literature which I have since found for myself—the chapter called 'The Whiteness of the Whale', in Melville's *Moby Dick*.

A long time ago* I introduced this subject of *imagery relationships with colour*, in analysing the question of *relationships within the montage-image in general.*

If we have even a *sequence* of montage pieces:

> A grey old man,
> A grey old woman,
> A white horse,
> A snow-covered roof,

we are still far from certain whether this sequence is working towards 'old age' or towards 'whiteness'.

Such a sequence of film-strips might proceed for some time before we would finally discover that guiding piece of film which immediately 'identifies' the *whole* sequence in one way or another.

That is why it is advisable to place this 'identifying' piece as near as possible to the beginning of the sequence (in an 'orthodox' construction). Sometimes it even becomes necessary to do this with a sub-title.

* See Bibliography, No. 15.

This means that *we do not obey some 'all-pervading law' of absolute 'meanings' and correspondences between colours and sounds— and absolute relations between these and specific emotions*, but it does mean that *we ourselves decide which colours and sounds will best serve the given assignment or emotion as we need them.*

Of course, the 'generally accepted' interpretation may serve as an impetus, and an effective one at that, in the construction of the colour-imagery of the drama.

But the law laid down here will not legalize any absolute correspondence 'in general', but will demand that consistency in a definite tone-colour key, running through the whole work, must be given by an imagery structure in strict harmony with the work's theme and idea.

CHAPTER IV

FORM AND CONTENT: PRACTICE

... If, to a composition which is already interesting through the choice of subject, you add a disposition of lines which augments the impression, if you add chiaroscuro which seizes the imagination, and colour adapted to the characters, you have solved a more difficult problem—you have entered a realm of superior ideas, doing what the musician does when, to a single theme, he adds the resources of harmony and its combinations.

EUGÈNE DELACROIX[1]

I always took the score and read it carefully during the performance, so that, in time, I got to know the sound—the voice, as it were—of each instrument and the part it filled. . . . Listening so closely, I also found out for myself the intangible bond between each instrument and true musical expression.

HECTOR BERLIOZ[2]

A song by Shakespeare or Verlaine, which seems so free and living and as remote from any conscious purpose as rain that falls in a garden or the lights of evening, is discovered to be the rhythmic speech of an emotion otherwise incommunicable, at least so fitly.

JAMES JOYCE[3]

In Part II we discussed the new question posed by audio-visual combinations—that of solving a wholly new compositional problem. The solution to this compositional problem lies in finding *a key to the measured matching* of a strip of music and a strip of picture; such measured matching as would enable us to unite both strips '*vertically*' or *simultaneously*: matching each continuing musical phrase with *each phase* of the continuing parallel picture strips—our shots. This will be conditioned by our adherence to the letter of that law allowing us to *combine* '*horizontally*' or *continuously*: shot after shot in the silent film—phrase after phrase of a developing theme in music. We have brought to this question an analysis

of existing theories on general correlations of aural and visual phenomena. We have also examined the question of correlating visual and aural phenomena with specific emotions.

With these problems in mind we discussed the question of correlating music and colour. And we concluded that the existence of 'absolute' sound-colour equivalents—even if found in nature—cannot play a decisive role in creative work, except in an occasional 'supplementary' way.

The decisive role is played by the *image structure* of the work, not so much by *employing* generally accepted correlations, but by *establishing* in our images of a *specific creative work* whatever correlations (of sound and picture, sound and colour, etc.) are dictated by the *idea and theme of the particular work*.

We turn now from all the preceding *general premises* to *concrete methods* of constructing relations between music and picture. These methods will not vary basically no matter how varying the circumstances: it makes no difference whether the composer writes music for the 'general idea' of a sequence, or for a rough or final cutting of the sequence; or, if procedure has been organized in an opposite direction, with the director building the visual cutting to music that has already been written and recorded on sound-track.

I should like to point out that in *Alexander Nevsky* literally all these possible approaches were employed. There are sequences in which the shots were cut to a previously recorded music-track. There are sequences for which the entire piece of music was written to a final cutting of the picture. There are sequences that contain both approaches. There are even sequences that furnish material for the anecdotists. One such example occurs in the battle scene where pipes and drums are played for the victorious Russian soldiers. I couldn't find a way to explain to Prokofiev what precise effect should be 'seen' in his music for this joyful moment. Seeing that we were getting nowhere, I ordered some 'prop' instruments constructed, shot these being played (without sound) *visually*, and projected the results for Prokofiev—who almost immediately handed me an exact 'musical equivalent' to that visual

image of pipers and drummers which I had shown him.

With similar means were produced the sounds of the great horns blown from the German lines. In the same way, but inversely, completed sections of the score sometimes suggested plastic visual solutions, which neither he nor I had foreseen in advance. Often these fitted so perfectly into the unified 'inner sounding' of the sequence that now they seem 'conceived that way in advance'. Such was the case with the scene of Vaska and Gavrilo Olexich embracing before leaving for their posts, as well as a great part of the sequence of knights galloping to the attack—both of which sequences had effects that we were totally unprepared for.

These examples are cited to confirm the statement that the 'method' we are proposing here has been tested 'backwards and forwards' to check all its possible variations and nuances.

What then is this method of building audio-visual correspondences?

One answer, a naïve one, to this problem would be to find equivalents to the *purely representational elements in music*.

Such an answer would be not only naive, but childish and senseless as well, inevitably leading to the confusions of Shershavin in Pavlenko's novel *Red Planes Fly East*:

Out of his wallet he pulled an exercise-book in a peeling oilcloth binding, inscribed *Music*. . . .

'What is it?' she asked.

'My impressions of music. At one time I tried to reduce everything I heard to a system, to understand the logic of music before I understood the music itself. I took a fancy to a certain old man, a movie pianist, a former colonel of the Guards. What do instruments sound like? "That's courage,' said the old man. "Why courage?" I asked. He shrugged his shoulders. "C major, B flat major, F flat major are firm, resolute, noble tones," he explained. I made a habit of seeing him before the film began and treated him to my ration cigarettes—since I didn't smoke—and asked how music was to be understood. . . .

'I continued visiting him at the theatre, and on candy-wrappers he wrote down the names of the works he played and their emo-

tional effect. Open the note-book and we'll laugh together.' . . .
She read:

' "Song of Maidens" from Rubinstein's *Demon*: sadness.

'Schumann's *Fantasiestuecke*, No. 2: inspiration.

'Barcarolle from Offenbach's *Tales of Hoffman*: love.

'Overture to Chaikovsky's *Pique Dame*: sickness.'

She closed the book.

'I can't read any more,' she said. 'I'm ashamed of you.'

He flushed, but did not yield.

'And, you know, I wrote and wrote, I listened and made notes, compared, collated. One day the old man was playing something great, inspired, joyous, encouraging, and I guessed at once what it connoted: it meant rapture. He finished the piece and threw me a note. It appeared that he had been playing Saint-Saëns' *Danse Macabre*, a theme of terror and horror. And I realized three things: first, that my colonel didn't understand a thing about music, second that he was as stupid as a cork, and third that only by smithing does one become a smith.'[4]

Besides such patently absurd definitions as these, any definitions that even touch this approach of a *narrowly representational comprehension of music* inevitably lead to visualizations of a most platitudinous character—if for any reason visualizations should be required:

'Love': a couple embracing.

'Illness': an old woman with a warming pad on her stomach.

If we also add to the pictures evoked by the 'Barcarolle' a series of Venetian scenes, and to the *Pique Dame* Overture various St. Petersburg vistas—what then? The 'illustration' of the lovers and the 'illustration' of the old woman are blotted out.

But take from these Venetian 'scenes' only the *approaching and receding* movements of the water combined with the reflected *scampering and retreating play of light* over the surface of the canals, and you immediately remove yourself, by at least one degree, from the series of 'illustration' fragments, and you are closer to finding a response to the *sensed inner movement* of a barcarolle.

The number of 'personal' images arising from this inner movement is unlimited.

And they will all reflect this inner movement, for all will be based upon the same sensation. This even includes the ingenious embodiment of the Offenbach 'Barcarolle' in the hands of Walt Disney* where the visual solution is a peacock whose tail shimmers 'musically', and who looks into the pool to find there the identical contours of its opalescent tail feathers, shimmering upside down.

All the approachings, recedings, ripples, reflections and opalescence that came to mind as a suitable essence to be drawn from the Venetian scenes have been preserved by Disney in the same relation to the music's movement: the spreading tail and its reflection approach each other and recede according to the nearness of the flourished tail to the pool—the tail feathers are themselves waving and shimmering—and so on.

What is important here is that this imagery in no way contradicts the 'love theme' of the 'Barcarolle'. Only here there is a substitution for 'pictured' lovers by a characteristic trait of lovers—an ever-changing opalescence of approaches and retreats from one another. Instead of a literal picture, this trait afforded a *compositional foundation*, both for Disney's style of drawing in this sequence and for the movement of the music.

Bach, for example, built his music on this same foundation, eternally searching for those *movement* means that gave expression to the fundamental movement characterizing his theme. In his work on Bach, Albert Schweitzer provides innumerable musical quotations to evidence this, including the curious circumstance to be found in the Christmas cantata No. 121:[5]

How far he will venture to go in music is shewn in the Christmas cantata *Christum wir sollen loben schon* (no. 121). The text of the aria 'Johannis freudenvolles Springen erkannte dich mein Jesu schon' refers to the passage from the Gospel of St. Luke, 'And it came to

* *Birds of a Feather* (a Silly Symphony, 1931).

pass that when Elisabeth heard the salutation of Mary, the babe leaped in the womb.' Bach's music is simply a long series of violent convulsions:

A similar but less willing search was confessed by a quite different type of composer, Giuseppe Verdi, in a letter to Léon Escudier:

To-day I have sent off to Ricordi the last act of *Macbeth* finished and complete. . . .

When you hear it you will observe that I have written a *fugue* for the battle! ! ! A *fugue*? I, who detest everything that smacks of the schools and who have not done such a thing for nearly thirty years! ! ! But I'll tell you that in this instance that musical form is to the point. The repetition of subject and counter-subject, the jar of dissonances, the clashing sounds express a battle well enough. . . .[6]

Musical and visual imagery are actually not commensurable through narrowly 'representational' elements. If one speaks of genuine and profound relations and proportions between the music and the picture, it can only be in reference to the relations between the *fundamental movements* of the music and the picture, i.e., compositional and structural elements, since the relations between the 'pictures', and the 'pictures' produced by the musical images, are usually so individual in perception and so lacking in concreteness that they cannot be fitted into any strictly methodological 'regulations'. The Bach example is eloquent proof of this.

We can speak only of what is actually 'commensurable' i.e., the movement lying at the base of both the structural law of the given piece of music and the structural law of the given pictorial representation.

Here an understanding of the structural laws of the pro-

cess and rhythm underlying the stabilization and development of both provides the only firm foundation for establishing a unity between the two.

This is not only because this understanding of regulated movement is 'materialized' in equal measure through the particular specifics of any art, but is mainly because such a structural law is generally the first step towards the embodiment of a theme through an image or form of the creative work, regardless of the material in which the theme is cast.

This remains clear as long as we deal with theory. But what happens to this in practice?

Practice reveals this principle with even greater simplicity and clarity.

Practice is built somewhat along the following lines:

We all speak of particular pieces of music as 'transparent', or as 'dynamic', or as having a 'definite pattern', or as having 'indistinct outlines'.

We do this because most of us, while hearing music, visualize some sort of plastic images, vague or clear, concrete or abstract, but somehow peculiarly related and corresponding to our own *perceptions* of the given music.

In the more rare circumstance of an abstract rather than a concrete or a dynamic visualization, someone's recollection of Gounod is significant. While listening to a Bach concert, Gounod suddenly and thoughtfully remarked, 'I find something octagonal in this music. . . .'

This observation is less surprising when we remember that Gounod's father was 'a painter of distinguished merit' and his mother's mother 'a musician and poetess as well'.[7] Both streams of impressions were so vivid throughout his childhood that he recorded in his memoirs his equally attractive opportunities for working in the plastic arts as well as in music.

But in a final analysis such 'geometrism' may not be so exceptional.

Tolstoy, for example, made Natasha's imagination picture a much more intricate complex—a complete image of a man

—by means of such a geometrical figure: Natasha describes Pierre Bezukhov to her mother as a 'blue quadrant'.[8]

Dickens, another great realist, occasionally shows the images of his characters by exactly this 'geometrical means', and it is quite likely that in such cases it is only through such means that the full depth of the character may be revealed.

Look at Mr. Gradgrind on the opening page of *Hard Times* —a man of paragraphs, figures and facts, facts, facts:

> The scene was a plain, bare, monotonous vault of a schoolroom, and the speaker's square forefinger emphasized his observations by underscoring every sentence with a line on the schoolmaster's sleeve. The emphasis was helped by the speaker's square wall of a forehead, which had his eyebrows for its base, while his eyes found commodious cellarage in two dark caves, overshadowed by the wall. . . . The speaker's obstinate carriage, square coat, square legs, square shoulders—nay, his very neckcloth, trained to take him by the throat with an unaccommodating grasp, like a stubborn fact, as it was—all helped the emphasis.
>
> 'In this life, we want nothing but Facts, sir; nothing but Facts!'

Another illustration of our normal visualization of music is the ability of each of us, naturally with individual variations and to a greater or lesser degree of expressiveness, to 'depict' with the movement of our hands that movement sensed by us in some nuance of music.

The same is true of poetry where rhythm and metre are sensed by the poet primarily as images of movement.

How the poet feels about this identification between metre and movement has been keenly expressed by Pushkin in his ironic sixth stanza of *The Cottage in Kolomna*:

> *Pentameters demand caesural rest*
> *After the second foot, I do agree.*
> *If not, you oscillate 'twixt ditch and crest.*
> *Reclining on a sofa though I may be,*
> *I feel as though a driver with a jag on*
> *Were jolting me o'er cornfields in a wagon.*[9]

And it is Pushkin who provides some of the best examples

of translating the movement of a phenomenon into verse.

For example, the splashing of a wave. The Russian language lacks a word that adequately and tersely describes the whole action of a wave, rising in a curve and splashing as it falls. The German language is more fortunate: it has a compound word—*wellenschlag*—that conveys this dynamic picture with absolute accuracy. Somewhere Dumas *père* bewails the fact that the French language compels its authors to write: 'the sound of water striking against the surface', while an English author has at his disposal the single rich word, 'splash'.

However, I doubt if any nation's literature contains a more brilliant *translation of the dynamics of splashing waves into the movement of poetry* than the flood passage of Pushkin's *Bronze Horseman*. Following the well-known couplet,

> *Behold Petropol floating lie*
> *Like Triton in the deep, waist-high!*

the flood surges in:

> *A siege! the wicked waves, attacking*
> *Climb thief-like through the windows; backing,*
> *The boats stern-foremost smite the glass;*
> *Trays with their soaking wrappage pass;*
> *And timbers, roofs, and huts all shattered,*
> *The wares of thrifty traders scattered,*
> *And the pale beggar's chattels small,*
> *Bridges swept off beneath the squall,*
> *Coffins from sodden graveyards—all*
> *Swim in the streets!*[10]*

From the material presented above we can formulate a simple, practical approach to a method of audio-visual combinations.

We must know how to grasp the movement of a given piece of music, locating its path (its line or form) as our foundation for the plastic composition that is to correspond to the music.

* Elsewhere I have described the exact 'reconstruction' in these lines of the splashing, the rolling and breaking of a wave, in terms that would lose their point entirely with *any* English translation.

There are already instances of this approach, building a plastic composition upon firmly determined musical lines, in the case of ballet choreography, where there is a full correspondence between the movement of the score and of the *mise-en-scène*.

However, when we have before us a number of shots of equal 'independence', * at least in so far as their original flexibility was concerned, but differing in composition, we must, keeping the music before us, select and arrange only those shots that prove their correspondence to the music according to the above conditions.

A composer must proceed in the same way when he takes up a previously cut film sequence: he is obliged to analyse the visual movement both through its overall montage construction and the compositional line carried from individual shot to shot—even the compositions *within* the shots. He will have to base his musical imagery composition on these elements.

The movement which lies at the base of a work of art is not abstract or isolated from the theme, but is the generalized plastic embodiment of that image through which the theme is expressed.

'Striving upwards', 'expanding', 'broken', 'well-knit', 'limping', 'smoothly developing', 'patchy', 'zig-zagging'—are terms used to define this movement in the more abstract and generalized instances. We will see in our example how such a line can contain not only dynamic characteristics but also a whole complex of fundamental elements and meanings peculiar to *that* theme and *that* image. Sometimes the primary embodiment of the future image will be found in *intonation*. But this won't affect the basic conditions—for intonation is the *movement of the voice* flowing fom the same *movement of*

* 'Independent' only in the sense that *thematically* they can be arranged in any sequence. The twelve shots of the 'waiting sequence' developed below, were precisely of this sort. In their purely *thematic and narrative-informational* nature they might have been arranged in any order. Their final arrangement was determined by purely interpretive and emotional requirements of construction.

emotion which must serve as a fundamental factor in outlining the whole image.

It is precisely this fact that makes it so easy to describe an intonation with a gesture as well as a movement of the music itself. From the base of the music's movement all these manifestations spring with equal force—the intonation of the voice, the gesture, and the movement of the man who makes the music. Elsewhere we will consider this point in more detail.

Here we want to emphasize that *pure line*, that is, the specifically 'graphic' outline of a composition, is only *one of the many* means of visualizing the character of a movement.

This 'line'—the path of the movement—under differing conditions and in differing works of plastic art—can be drawn in other ways besides purely linear ones.

For example, movement can be drawn with the same success by means of changing nuances within the light- or the colour-imagery structure, or by the successive unfolding of volumes and distances.

In Rembrandt the 'movement line' is described by the shifting densities of his chiaroscuro.

Delacroix found this line through that path followed by the spectator's eye in moving from form to form, as the forms are distributed throughout the volume of the painting. He has recorded in his *Journal* his admiration for Leonardo's use of 'le système antique du dessin par boules', [11] a method which his contemporaries tell us Delacroix himself used all his life.

In a remarkably close echo of Delacroix's thoughts on line and form, Balzac's Frenhofer (in *Le Chef-d'œuvre Inconnu*) says that the human body is not made up of lines and, strictly speaking, 'Il n'y a pas de lignes dans la nature ou tout est plein'.

In opposition to such a view, we can call upon that 'contour' enthusiast—William Blake, whose pathetic plea,

O dear Mother outline, of knowledge most sage . . . [12]

can be found among his bitter polemics against Sir Joshua Reynolds, and against Sir Joshua's insufficient regard for the firmness of outline.

It should be clear that our argument is not over the *fact of movement* in the work of art, but over the *means* by which that movement is *embodied*, which is what characterizes and distinguishes the work of different painters.

In the work of Dürer, such movement is often expressed by the *alternation of mathematically precise formulae through the proportions* within his figures.

This is not very remote from the expression of other painters, Michelangelo in particular, whose rhythm flows dynamically through the undulating and swelling muscles of his figures, serving thus to voice not only the movement and position of these figures, but primarily to voice the whole flight of the artist's emotions. *

Piranesi reveals no less emotional a flight with his particular line—a line built from the movements and variations of '*counter-volumes*'—the broken arcs and vaults of his *Carceri*, with their intertwined lines of movement woven with the lines of his endless stairs—breaking the accumulated *spatial fugue* with a *linear fugue*.

Van Gogh similarly expresses the movement of his line with thick running slashes of colour, as though in a desperate effort to weld the flight of his line with a flying explosion of colour. In his own way he was carrying out a law of Cézanne's which he could not have known—a law carried out in an entirely different aspect by Cézanne himself:

> Le dessin et la couleur ne sont point distincts . . .[18]

Moreover, any 'communicator' realizes the existence of such a 'line'. A practitioner in any medium of communication has to build his line, if not from plastic elements, then certainly from 'dramatic' and thematic elements.

In this we must bear in mind that in cinema, the selection of 'correspondences' between picture and music must not be

* We can recall what Gogol said of him: 'For Michelangelo, the body served only as a revelation of the strength of the soul, of its suffering, of its cry aloud, of its invincible nature—and for him mere plastics were discarded, and man's contour assumed gigantic proportions in its function as a symbol; the result is not man, but man's passions.'[18]

satisfied with any one of these 'lines', or even with a harmony of several employed together. Aside from these general formal elements the same law has to determine the selection of *the right people, the right faces, the right objects, the right actions, and the right sequences*, out of all the equally possible selections within the circumstances of a given situation.

Back in the days of the silent film, we spoke of the 'orchestration' of *typage* faces * in repeated instances (for example, in producing the mounting 'line' of grief by means of intensified close-ups in the sequence of 'mourning for Vakulinchuk' in *Potemkin*).

Similarly, in sound-films there arise such moments as that mentioned above: the *farewell embrace* between Vaska and Gavrilo Olexich in *Alexander Nevsky*. This could occur only at one *precise* point in the musical score, in the same way that the close-up shots of the German knights' helmets could not be used before the point where they were finally employed in the attack sequence, for only at that point does the music change its character from one that can be expressed in long shots and medium shots of the attack to one that demands rhythmic visual beats, close-ups of galloping and the like.

Alongside this, we cannot deny the fact that the most *striking* and immediate impression will be gained, of course, from *a congruence of the movement of the music with the movement of the visual contour*—with the graphic composition of the frame; for this contour or this outline, or this line is the most vivid 'emphasizer' of the very idea of the movement.

But let us turn to the object of our analysis and try, through one fragment from the beginning of Reel 7 of *Alexander Nevsky*, to demonstrate how and why a certain series of shots in a certain order and of a certain length was related in a specific way, rather than any other way, with a certain piece of the musical score.

* *Typage*, as a term and as a method, might be defined as 'typecasting' (of non-actors), elevated by Eisenstein to the level of a conscious creative instrument, just as *montage*, a simple term for a physical process of film editing, has been transformed to a broader term and a deeper process by the Russian film-makers.—Editor.

We will try to discover here that 'secret' of those sequential *vertical correspondences* which, step by step, relate the music to the shots *through an identical motion* that lies at the base of the musical as well as the pictorial movement.

Of particular interest in this case is the fact that the music was composed to a completely finished editing of the pictorial element. The visual movement of the theme was fully grasped by the composer to the same degree that the completed musical movement was caught by the director in the subsequent scene of the attack, where the shots were matched to the previously recorded music-track.

However, it is an exactly identical method of binding organically *through movement* that is used in either case. Therefore, methodologically, it is absolutely immaterial from which element the process of determining audio-visual combinations begins.

The audio-visual aspect of *Alexander Nevsky* achieves its most complete fusion in the sequence of the 'Battle on the Ice' —particularly in the 'attack of the knights' and the 'punishment of the knights'. This aspect becomes a decisive factor also, because of all the sequences of *Alexander Nevsky*, the attack seemed the most impressive and memorable to critics and spectators. The method used in it of audio-visual correspondence is that used for any sequence in the film. So for our analysis we will choose a fragment which can be somewhat satisfactorily reproduced on a printed page—some fragment where a whole complex is resolved by almost *motionless* frames, in which a minimum would be lost by showing its shots on a page rather than on a screen. It is such a fragment that we have chosen for analysis.

These are the twelve shots of that 'dawn of anxious waiting' which precedes the beginning of the attack and battle, and which follows a night full of trouble and anxiety, on the eve of the 'Battle on the Ice'. The thematic content of these twelve frames has a simple unity: Alexander on Raven Rock and the Russian troops at the foot of the Rock on the shore

of the frozen Lake Chudskoye, peering into the distance from which the enemy is to appear.

A diagram inserted in the back of this book shows four divisions. The first two describe the succession of shot-frames and musical measures which together express the situation. XII frames; 17 measures. (This particular disposition of the pictures and the measures will be clarified in the process of analysis; this disposition is connected with the chief inner components of music and picture.)

Let us imagine these XII shots and these 17 measures of music—not as we see them in the diagram, but as we experienced them from the screen. What part of this audio-visual continuity exerted the greatest pull on our attention?

The strongest impression seems to come from Shot III followed by Shot IV. We must keep in mind that such an impression does not come from the photographed shots alone, but is an *audio-visual impression* which is created by the combination of these two shots together with the corresponding music—which is what one experiences in the auditorium. These two shots, III and IV, correspond to these measures of music—5, 6 and 7, 8.

That this is the most immediate and most impressive audio-visual group can be checked by playing the four measures on the piano 'to the accompaniment' of the reproduced corresponding two shots. This impression was confirmed in the appraisal of this excerpt during the students' screening at the State Institute of Cinematography.

Take these four measures and try to describe in the air with your hand that line of movement suggested by the movement of the music.

The first chord can be visualized as a 'starting platform'.

The following five quarter-notes, proceeding in a scale upwards, would find a natural gesture-visualization in a *tensely rising line*. Therefore, instead of describing this passage with a simple climbing line, we will tend slightly to arch our corresponding gesture—*ab*:

The next chord (at the beginning of measure 7), preceded

by a sharply accented sixteenth, will in these circumstances create an impression of an abrupt fall—*bc*.* The following row of four repeats on a single note—in eighths, separated by rests—can be described naturally by a *horizontal gesture*, in which the eighths are indicated by even accents between *c* and *d*.

FIGURE I

Draw this line (on Figure 1: *bc* and *cd*) and place this graph of the music's movement over the corresponding measures of the score.

Now let us describe the *graph of the eye's movement* over the main lines of Shots III and IV which 'correspond' to this music.

This can also be described by a gesture of your hand,

FIGURE 2

* Melodically the sensation of the 'fall' is achieved by a leap from B to G sharp.

138

which will present us with the following drawing representing the *motion* within the linear composition of the two frames:

From *a* to *b* the gesture 'arches' upwards—drawing an arc through the outlined dark cloud, hanging over the lighter lower part of the sky.

From *b* to *c*—an abrupt *fall of the eye downwards*: from the upper frame-line of Shot III almost to the lower frame-line of Shot IV—the maximum fall possible in this vertical position.

From *c* to *d*—*evenly horizontal*—with neither an ascending nor a descending movement, but twice interrupted by the points of the flags that stand over the horizontal line of the troops.

Now let us collate the two graphs. What do we find? Both graphs of movement correspond absolutely, that is, we find a *complete correspondence between the movement of the music and the movement of the eye over the lines of the plastic composition.*

In other words, *exactly the same motion lies at the base of both the musical and the plastic structures.*

I believe that this motion can also be linked with the emotional movement. The rising tremolo of the cellos in the scale of C minor clearly accompanies the increasingly tense excitement as well as the increasing atmosphere of watching. The chord seems to break this atmosphere. The series of eighth-notes seems to describe the motionless line of the troops: the feelings of the troops spread along the entire front; a feeling which grows again in Shot V, with renewed tenseness in Shot VI.

It is interesting to note that Shot IV, which corresponds to measures 7 and 8, contains two flags, while the music contains four eighth-notes. The eye appears to pass over these two flags twice, so that the front seems twice as broad as that which we actually see before us in the frame. Passing from left to right, the eye 'taps off' the eighth-notes with flags, and the two remaining notes lead the perception away beyond the frame-line to the right, where the imagination continues indefinitely the front-line of the troops.

Now it becomes clear why these two shots in juxtaposition

arrested our attention particularly. The plastic element of movement and the musical movement coincide here, with a maximum of descriptiveness.

Let us, however, proceed further, to find what catches our 'second' attention. Running over this sequence again, we are attracted by Shots I, VI–VII, IX–X.

Looking more closely at the music with these shots, we will find a structure similar to the music of Shot III. (Generally speaking, the music for this entire fragment consists, actually, of two two-measure phrases A and B, alternating with each other in a certain way. The distinguishing factor here is that while they belong structurally to the same A phrase, they vary in tonality: the music with Shots I and III belong to one tonality [C minor], while the music of Shots VI–VIII and IX–X belong to another [C sharp minor]. The relation of this tonal change to the thematic meaning of the sequence will be brought out in the analysis of Shot V.)

Thus the music for Shots I, VI–VII and IX–X will duplicate the graph of movement that we found in Shot III (see Figure 1).

But in looking at the shot-frames themselves, do we find the same graph of linear composition, which with the line of musical movement 'welded' together Shots III and IV with their music (measures 5, 6, 7, 8)?

No.

And yet the sensation of an audio-visual unity seems just as powerful in these combinations.

Why?

The explanation can be found in our previous discussion of the various possible expressions of the line of movement. The graph of movement that we found for Shots III and IV need not be confined to the line *a-b-c alone*, but may be expressed *through any* plastic means at our disposal. Thus we encounter in practice the hypothetical cases suggested above.

Let us supplement our previous discussion with the aid of our three new cases—I, VI–VII, IX–X.

CASE 1. Photography cannot convey the full sensation of

Shot I, for this shot *fades into sight*: appearing from the darkness we first see on the left a dark group of men with a banner, and then gradually revealed is a mottled sky, irregularly spotted with clouds.

We can see that the movement inside this shot is absolutely identical with our description of the movement within Shot III. The lone difference lies in the fact that the movement of Shot I is not linear, but is a movement of gradual lighting of the frame—a movement of increasing degree of lightness.

So that our 'starting platform' *a*, which corresponded to the initial chord of Shot III, is here found in the darkness before the fade-in begins—a 'water-line' of darkness from which the degrees of gradual lightening of the frame can be counted. The 'arching' here is formed from the progressive chain of differing frames—each of which is lighter than the preceding frame. The *arching* of Shot III is reflected here by the curve of gradual lightening of the full frame. The individual stages are marked by the appearance of more and clearer cloud spots. In the mergence of the fully lit frame, the darkest spot (the one in the centre of the frame) appears first. This is followed by a somewhat lighter one above. Then we grow aware of the whole sky of a general light tone—with a darker 'fleece' in the lower right centre and in the upper left corner.

We see that the curved line of movement is duplicated here, down to a detail, but not expressed through the *contour* of the plastic composition, but through a 'line' of *light tonality*.

We can thus declare a correspondence between Shot I and Shot III, in their identical basic motion, a correspondence, in the former case, in *tone*.

CASE 2. Examine the pair of shots—VI–VII. These should be examined as a pair, for the musical phrase *A* which falls entirely within Shot I (over *one picture*), here covers fully *two pictures*. The variation of phrase *A* that is over Shots VI–VII can be identified as *A1*. (See the general diagram of the whole fragment.)

Let us check this combination according to our perception of the music.

This is what we see in the first of the two shots: four warriors with shields and upright spears stand at the left; behind them, further to the left edge, the contour of the high rock can be seen; into the further distance, but towards the right edge—ranks of warriors stretching into the distance.

Without checking the reactions of others, the impression always made upon me by the first chord of measure 10 is of a heavy mass of sound, rolling down along the lines of spears from the top of the frame to the bottom:

FIGURE 3

(Subjective as this impression may have been, it was precisely due to it that I felt the need for giving this shot its particular place in the montage.)

Behind the group of four spearmen the line of warriors stretches out in stages of depth, to the right. The most prominent 'stage' is the transition from the entirety of Shot VI to the entirety of Shot VII, which continues the line of warriors in the same direction, further into the distance. The dimensions of the warriors in Shot VII are somewhat greater, but the general movement into depth (in stages) carries on the movement of Shot VI. In the second shot there is another clearly defined stage: the white line of empty horizon on the

right edge of the frame. This element in Shot VII breaks the continuous line of warriors and introduces us to a new sphere —towards the horizon where the sky merges with the frozen surface of Lake Chudskoye.

Let us graph this basic movement through both frames by means of stages:

<center>FIGURE 4</center>

We have diagrammed the troop groupings as though they were the receding wings of a theatre set—1, 2, 3, 4—inwards. Our *starting surface* is formed by the four spearmen of Shot VI. These coincide with our screen's surface, from which all the *inward* movement stems. Drawing a line to unify these 'theatre wings', we obtain a certain curve a, 1, 2, 3, 4. Where have we seen a strikingly similar curve? This is still the same curved line of our 'arc', but now found not along the *vertical surface* of the frame, as in Shot III, but moving in *horizontal* perspective into the depth of the frame.

This curve has exactly the same *starting surface*, our wing of four standing warriors. In addition to this, the several phases have defined limits, giving sharp edges to the succeeding wings, that can be enclosed by four vertical lines: the three warrior figures that stand away from the troop-line in Shot VII (x, y, z)—and the line that separates Shot VI from Shot VII.

Can we find a correspondence in the music to that glimpsed cut of horizon in VII?

A fact to be considered in this connection: the music of

<center></center>

phrase $A1$ does not extend over the entirety of Shots VI and VII, so that the phrase $B1$ begins to be heard during Shot VII. This beginning includes three-quarters of measure 12.

What do these three-quarters contain?

Exactly that chord preceded by a sharply accented sixteenth, which in Shot III corresponded to the feeling of an abrupt fall downward from Shot III into Shot IV.

In the former case the whole movement was placed along a vertical surface, and the abrupt musical break was visualized as a fall (from the upper right corner of frame III to the lower left corner of frame IV). Here the whole movement is horizontal—into the depth of the frame. The plastic equivalent to such a sharp break in the music can be assumed under these conditions to appear as an analogous jolt—now not from top to bottom, but perspectively, inwards. *The 'jolt' in Shot VII from the line of warriors to the horizon line is exactly such a jolt.* Again we attain a 'maximum break', since in landscape the horizon represents the limit of depth!

We are justified in considering this strip of horizon to the right of Shot VII as a visual equivalent to the musical 'jolt' between measure 11 and three-quarters of measure 12.

We should add that from a purely psychological viewpoint, this audio-visual correspondence conveys a full and precise feeling to the audience, whose attention is pulled beyond the horizon to some unseen point from which they are expecting the foe to attack.

Thus we see that like strips of music—such as the 'jolt' at the beginning of measures 7 and 12—can be plastically solved by varying the means of the *plastic break*.

In one case it is a break along a vertical line during the transition from shot to shot—III–IV. In the other case—a break along *a horizontal line, within the frame of Shot VII* at point *M*. (See Figure 4.)

But this is not all that can be found in these two pairs of shots. In III our 'arc' sprang across the *surface*. In VI–VII it sprang inwards in perspective, that is, spatially. Along this second 'arc' was strung our system of theatre wings, unfolding

into space itself. This recession from the surface of the screen (wing *a*) into the space of the screen, accompanies the scale of upward climbing sounds.

Thus, in the case of VI–VII, we can point to another kind of correspondence between music and picture—solved through the same graph—and with the same motion. This is—*spatial* correspondence.

Let us draw a general graph of this new variant of corresponding music and pictorial representation. To complete our picture we should finish phrase *B* in the score (by adding one measure and a quarter-note). This will give us a full repeat of the musical phrase that we examined with Shots III and IV. But our pictorial line will demand the addition of Shot VIII to VI–VII—for this repeat of phrase *B* (actually *B*1 here) closes with the completion of Shot VIII.

So Shot VIII demands our inspection at this point.

Plastically it can be divided into three parts. In the foreground our attention is caught by the first *close-up* to appear thus far in the sequence of eight shots—Vasilisa in a helmet. This occupies only a part of the frame, leaving the rest to the front-line of troops, placed in the frame in much the same way as in the preceding frames. Shot VIII serves as a transition shot, since it contains, first, a plastic completion of the motif in VI–VII. (We should not forget that the further recession inwards of Shot VII has the effect of an *enlargement*, in relative size to Shot VI, providing an opportunity for a further change in Shot VII to a close-up.) The three shots— VI–VII–VIII—are further tied together organically, by their correspondence with the musical sequence *A*1–*B*1. The *furthest* margins of these four measures 10, 11, 12, 13 coincide with the furthest edges of the pair of shots—VI–VIII, although within this grouping, the divisions between Shots VII and VIII do not coincide with the divisions between measures 11 and 12. (See the general diagram.)

Shot VIII completes the phrase of *medium shots* of troops (VI–VII–VIII) and introduces the phrase of *close-ups* (VIII– IX–X) which now appears.

In this same way the phrase of *the prince on the rock* was carried through Shots I–II–III, and was followed by a new phrase of *long shots of warriors at the foot of the rock*. This second phrase was introduced not by a *crossing* in a single shot, but through a *montage crossing*.

Following Shot III comes the phrase 'the troops', shown in a long shot (IV), followed by 'the prince on the rock' *again*—also shown in a long shot (V).

This *essential* transition from 'prince' to 'troops' is marked by an *essential* musical change—a transition from one tonality to another (C minor to C sharp minor).

A less important transition—not *from one theme* (prince) *to another theme* (troops), but *within* a theme—from a middle shot of warriors to close-ups of them—is not solved through a *montage crossing* (as in III–IV–V–VI) but *within one shot*—Shot VIII.

This solution is by means of a composition containing *two planes*: the new theme is shown in close-up, emerging in the foreground, while the fading theme (the long shot of the front-line) recedes into the background. One may note, besides this fact, that the 'fading' of the preceding theme is also expressed by filming the troops (in the second plane of distance) with a deliberate avoidance of depth of focus, so that this slightly out-of-focus receding line provides a background for Vasilisa's close-up.

This close-up of Vasilisa introduces the other close-ups—of Ignat and Savka (IX–X) which, joined to the last two shots of this fragment (XI–XII), will give us a *new plastic interpretation* for our graph of motion.

But this part of our analysis has to wait for our next step.

On our examination of Shot VIII depends the completion of our graph for the group of shots (VI–VII–VIII).

The three divisions of Shot VIII can be described thus:

In the foreground—Vasilisa's face in close-up. Further to the right in the frame is a long row of troops—photographed without sharply defined focus, which results in emphasizing the high-lights on their helmets. In the narrow section between Vasilisa's head and the left edge of the frame can

be seen part of the line of troops, topped by a banner. What corresponds to this in the musical score?

This shot is covered by one whole musical measure and a quarter-note—the end of measure 12 and the whole of measure 13. This musical fragment contains three distinct elements, of which the middle one—the chord that opens measure 13—comes to the foreground. This chord has the 'impact' of a full fusion with the close-up in our shot.

From the middle of this measure start four eighth-notes, interrupted by rests. Just as this even horizontal musical movement was accompanied by the tiny flags of Shot IV, the slightly shifting highlights on the helmets of the troop-line in Shot VIII accompany these notes like little stars.

Only our left edge lacks its musical 'correspondence'. But —we have forgotten the eighth-note, remaining over from the preceding measure 12, and which 'on the left' precedes the opening chord of measure 13; it is this eighth-note that 'corresponds' to the narrow strip of frame to the left of Vasilisa's head.

This analysis of Shot VIII and its corresponding musical movement can be diagrammed thus:

FIGURE 5

At this point I expect to hear a quite natural exclamation —'Hold on there! Isn't it a little far-fetched to match a line of music so exactly to a pictorial representation? Doesn't the *left* of a measure of music and the *left* of a picture signify absolutely *different* things?'

A *motionless* picture exists *spatially*, that is, *simultaneously*, and neither its left, nor its right, nor its centre can be thought of as occupying *any order of time*, while the musical staff contains a definite *order moving in time*. In the staff the left always signifies '*before*', while the right signifies '*after*'.

All the above objections would carry weight if our shot contained elements that *appeared in succession*, as indicated by the diagram (Figure 6) opposite.

The objections at first sound quite reasonable.

And then we realize that an extremely important factor has been ignored, namely, that *the motionless whole of a picture and its parts do not enter the perception simultaneously* (with the exception of those cases where the composition is calculated to create just such an effect).

The art of plastic composition consists in leading the spectator's attention through the exact path and with the exact sequence prescribed by the author of the composition. This applies to the eye's movement over the surface of a canvas if the composition is expressed in painting, or over the surface of the screen if we are dealing with a film-frame.

It is interesting to note here that at an earlier stage of graphic art, when the conception of 'the path of the eye' was still difficult to separate from a physical image—that paths were introduced into pictures *as paths of the eye, concrete picturizations of roads* along which were distributed the events that the artist wished to portray in particular sequence. One of the most dramatic (and cinematic) of all illuminated manuscripts is the Greek manuscript of the sixth century known as the Vienna Genesis[15]—in which this device is employed repeatedly. There it was solely concerned with a sequence of scenes which, often in this period, were depicted in one painting. Development of this device continued into the era of

FIGURE 6

perspective, where the scenes were placed in the different planes of a painting, similar to the effect of a path. Thus, Dirk Bouts' painting of *The Dream of Elijah in the Desert* shows Elijah sleeping in the foreground, while another Elijah departs on a path that winds into the depth of the picture. In *The Adoration of the Shepherds* by Domenico Ghirlandaio, the Infant surrounded by shepherds occupies the foreground, and on a road that twists forward from the background appear the Magi; so that the road ties together events which are, in subject, thirteen days apart (December 24th—January 6th).

Memling used this same device, but in a far more complex (and exciting) composition, in distributing all the consecutive Stations of the Cross through the streets of a city, in his *Passion of Christ*, now in Turin.

Later on, when such jumps in time disappear, the physical road, as one of the means of plotting the spectator's view of a painting, also disappears.

The *road* is transformed into the *path of the eye*, transferred from a sphere of *representation* to one of *composition*.

The means employed in this further stage of development are varied, although they have one characteristic in common: there is usually something in a painting which attracts attention before all other elements. From this point the attention moves along that path desired by the artist. This path can be described either by a movement-line, or as a path of graduated tones, or even by grouping or the 'play' of personages in the picture. A classic case of deciphering in this regard is Rodin's analysis of Watteau's *L'Embarquement pour Cythère* which I cannot forbear quoting here:

In this masterpiece the action, if you will notice, begins in the foreground to the right and ends in the background to the left.

What you first notice in the front of the picture, in the cool shade, near a sculptured bust of Cypris garlanded with roses, is a group composed of a young woman and her adorer. The man wears a cape embroidered with a pierced heart, a gracious symbol of the voyage that he would undertake.

Kneeling at her side, he ardently beseeches his lady to yield. But she meets his entreaties with an indifference perhaps feigned, and appears absorbed in the study of the decorations on her fan. Close to them is a little cupid, sitting half-naked upon his quiver. He thinks that the young woman delays too long, and he pulls her skirt to induce her to be less hard-hearted. But still the pilgrim's staff and the script of love lie upon the ground. This is the first scene.

Here is the second: To the left of the group of which I have spoken is another couple. The lady accepts the hand of her lover, who helps her to arise. She has her back to us, and has one of those blonde napes which Watteau painted with such voluptuous grace.

A little further away is a third scene. The lover puts his arm around his mistress's waist to draw her with him. She turns towards her companions, whose lingering confuses her, but she allows herself to be led passively away.

Now the lovers descend to the shore and all push laughing towards the barque; the men no longer need to entreat, the women cling to their arms.

Finally the pilgrims help their sweethearts on board the little ship, which, decked with flowers and floating pennons of red silk, rocks like a golden dream upon the water. The sailors, leaning on their oars, are ready to row away. And already, borne by the breezes, little cupids fly ahead to guide the travellers towards that azure isle which lies upon the horizon.[16]

Have we any right to claim that our film-frames also can gauge the movement of the eye over a determined path?

We can give an affirmative answer to this, and add further —that in the twelve shots we are analysing that this movement proceeds precisely *from left to right* through *each* of the *twelve shots identically*, and *fully corresponds* in its pictorial character with the character of the *music's movement*.

We have said the music has two phrases—*A* and *B*—alternating throughout the length of the entire fragment.

A is constructed thus:

FIGURE 7

B is constructed thus:

FIGURE 8

First, a chord. Then against the background of the resonance of the chord, is an ascending scale,* moving in an 'arc', or else, a recurrence of one note in a *horizontal* movement.

Plastically all the frames are constructed in the same way (except IV and XII, which do not really function as independent shots, but as continuations of the movement of preceding shots).

Actually they each have on the left a darker, more solid heavy plastic 'chord' which commands the eye's attention first.

In Shots I–II–III this 'chord' is a group of dark figures, placed on the heavy mass of the rock. These attract our attention for another reason: they are the only living people in the frame.

* For example, along with Shot III is a *tremulous* movement of the cellos, rising in a C minor scale.

In Shot V—these figures, but with a greater mass of rock.

In Shot VI—the four spearmen in the foreground.

In Shot VII—the mass of the troops, and so on.

And in each of these shots there is something to the right of the frame which occupies the secondary attention: something light, airy, consecutively 'moving' which compels the eye to follow it.

In Shot III—the *upward* 'arc'.

In Shots VI–VII—the 'theatre wings' of the troops, *inward*.

So that for the entire plastic system of frames the left side is 'before', while the right is 'later', for the eye has been directed in a particular way from left to right through each of these motionless frames.

In the process of dividing up the frame compositions along a vertical line, this gives us the right to mark our musical beats and measures among the various plastic elements that make up these frames.

It was upon our perception of this circumstance that we based our montage of this particular sequence—and made our audio-visual correspondences more precise. This analysis, certainly as painstaking for the reader as it was for its writer, could only be done, of course, *post factum*, but it is worth doing to prove to what degree compositional 'intuition' is responsible for correct audio-visual structures—and how those senses of 'instinct' and 'feeling' can materialize sound-picture montage. It hardly seems necessary to point out that this is premised wholly on a wish for truth in the choice of theme, and a desire for vitality in its treatment.

From frame to frame in our sequence, the eye becomes accustomed to 'read' the picture from left to right.

Moreover, this continuous horizontal reading of the sequence induces horizontal reading in general, so that frames are *psychologically* perceived as placed side by side *upon a horizontal line* in the same left-to-right direction.

This is what allows us not only to divide each frame 'in time' upon our vertical line, but also *to place frame after frame* .

upon a horizontal line, and describe their correspondence to the music in this precise way.

Let us continue to take advantage of this circumstance by describing in one gesture the succession of Shots VI–VII–VIII, along with the movement of the music that is fused with these shots, and the movement of that total plastic motion upon which both picture and music are based. (See general diagram.) This is the same motion that goes through the combination of Shots III–IV. An interesting distinction here between the motion through two shots and the same motion through three shots, is that the effect of a 'fall' is, in the latter case, placed *within* the frame (Shot VII), rather than at the *transition* between two shots (Shot III to IV). *

Upon this graph and with the addition of the remaining frames, we can construct the general graphic diagram for the whole fragment. Comparing the III–IV graph with the VI–VII-VIII graph, we can see how much more complicated in the case of the latter is the audio-visual development of 'variations' on a basic line of movement.

We have noted that the movement from left to right through each frame has given a psychological suggestion that the frames are actually set next to one another upon a horizontal line running in one direction—to the right. This peculiarity permitted the arrangement of our diagram in the way you see it.

In connection with this, another much more important factor of a different type is now revealed. The psychological effect of left-to-right combines the total sequence into a focused shaping of the attention, directed from somewhere at the left towards somewhere at the right.

This underlines our dramatic 'indicator'—which is a direction of the eyes of all personages in these shots towards one point—with only one exception, the close-up of Ignat in IX.

* The differing diagrammed lengths of the musical measures (10 and 12, for example) bear no relation to the content, either of the music or of the frames. This, and the occasional stretching of the notes within the frame limits have been conditioned exclusively by the exigencies of diagramming.

In Shot IX Ignat looks to the left, but precisely because of this our general direction of attention towards the right is thereby strengthened.

This close-up emphasizes our general direction, which is developed by the 'triple-sounding' of close-ups VIII–IX–X, where it holds a middle position for the shortest period of time—only three-quarters of a measure—while Shots VIII and X occupy a measure plus an eighth and a measure plus a quarter respectively.

This turn towards the left replaces what would have been a monotonous series.

FIGURE 9

with a nervous series:

FIGURE 10

in which the third close-up (Shot X) acquires, instead of a general, vaguely expressive direction, which the first arrangement would have produced, even sharper emphasis for its rightward direction by being photographed with a 180° lens.

Examples can be found of Pushkin's adherence to a similar construction. In *Ruslan and Ludmila* he tells of those who were killed in battle against the Pechenegs: one struck by an arrow, another smitten by a mace, and a third trampled by a horse.

A sequence of *arrow, mace, horse* would have corresponded with a direct crescendo.

Pushkin, however, gives a different arrangement. He distributes the 'weight' of the blow, not in a simple ascending line, but with a 'recoil' in the middle link in the chain:

not: arrow—mace—horse,

but: mace—arrow—horse.

That one, felled by a mace's blow;
And that—struck by an arrow;
Another, pressed to his shield,
Crushed by a frenzied horse. . . .[17]

So these separate movements of the eye from left to right throughout the sequence add up to a feeling of something on the left, striving 'with all its soul' in a direction somewhere to the right.

This is precisely the feeling that the entire complex of twelve shots was seeking: the prince on the rock, the army at the foot of the rock, the general air of expectation—all directed to that point, to the right, into the distance, somewhere beyond the lake, from which the as yet invisible enemy will appear.

At this point the enemy is shown only through the Russian army's expectation of it.

Following these twelve shots are three empty frames of the deserted icy surface of the lake.

In the middle of the second of these three shots the enemy appears 'in a new quality'—through the sounding of his horn. The sound of the horn ends upon a shot of Alexander's group—to give a feeling that the sound 'came from afar' (the series of deserted landscapes) and finally 'reached' Alexander (or 'fell upon the picture of the Russians').

The entrance of the sound is *in the middle* of a shot of empty landscape, so that the sound is heard as if from the middle of the picture—*head on*. It is then heard *head on* in the shot of the group of Russians (facing the enemy).

The following shot discloses the distant cavalry line of German knights, moving *head on*, appearing to flow from the horizon with which it at first seemed to be merged. (This theme of a *head on* attack is prepared long in advance by Shots IV and XII—both *head on* shots—which was their chief role in the sequence, apart from their function as plastic equivalents of the music at these points).

To all that has been said a basic reservation must be added.

It is perfectly obvious that a horizontal reading of a se-

quence of frames, attached to each other in a horizontal conception, is not always pertinent. As we have shown, in this case it flows entirely from the total image sensation that is required of the sequence: a sensation bound to a direction of the attention from left to right.

This particular feature of our desired image is achieved fully by both picture and music, and by genuine inner synchronization of both. (Even the music seems to expand, moving away from the heavy chords of the 'left' side. Try to imagine for a moment the effect that would result from these chords being placed to the 'right', i.e., *ending* the phrases with chords; there could be no sensation of 'flight' to beyond the spaces of Lake Chudskoye, such as is now achieved.)

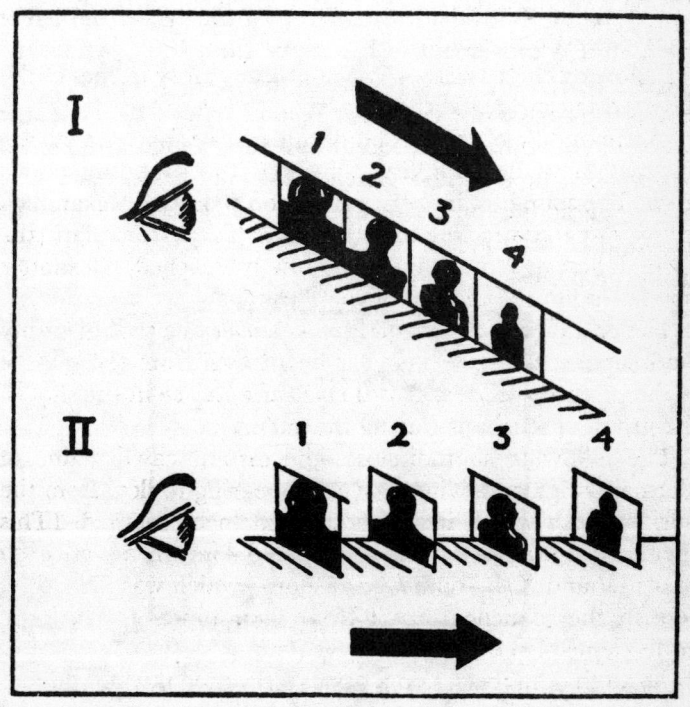

FIGURE 11

In working to achieve *other images*—in other cases—the composition of the frames can 'train' the eye for an entirely different plastic reading.

The eye may be trained, not to attach one frame to another as in our fragment, but to place frame upon frame—as layers.

This would produce either a sensation of being drawn into a depth or a sensation of pictures rushing towards the spectator.

Imagine, for instance, a sequence of four close-ups of increasing size, each of a different person, each placed centrally in its frame. A natural perception of this series of shots would not be as diagrammed in the upper drawing, but as in the lower:

This would not be a movement past the eye—from left to right, but a movement either away from the eye in a sequence of 1, 2, 3, 4—or towards the eye, 4, 3, 2, 1.

What we have just noted is a second type of movement in our analysis of the horn-sound and the change to a *head on* movement into a depth—which follows our first sequence.

The sound falls on a shot similar to Shot XII—such a shot as could be read just as well ('by inertia') from left to right, as into a depth:

FIGURE 12

But two things help us to switch attention to a depth.

First, the sound bursts from the *temporal* centre of the shot,

so that our perception, guided by analogy and a sense of space, places the sound in the *spatial* centre of the shot.

Second, a step-like movement of the greyish-white streaks of snow, moving upward from the bottom frame-line.

This 'ladder' carries the eye upward, but this upward movement over the surface is at the same time an approach to the horizon; it can thus be read psychologically as a spatial movement towards the horizon, or into the depth, which is exactly what we need here. This movement is further strengthened by the following shot, which has an almost identical composition, but with a lowered horizon-line—so that the increased expanse of sky induces the eye to perceive an even greater distance. Later this conditioned direction of the eye is materialized—first audibly (with an approaching sound), and then concretely (with the galloping riders) as the moment of the attack draws nearer.

With a systematic distribution of forms, lines or movements, it is just as possible to train the eye for vertical reading, or in any desired direction.

There is a little more to add to our analysis of Shots IX–X and XI–XII. As already mentioned, Shots IX–X fall on phrase A_1 (equal to A, but in a new tonality). We may note that Shots XI–XII fall on phrase B_1 in the same way.

The general diagram shows that, unlike Shots III and IV where one picture covers each two measures of the phrases A and B, two pictures cover each two measures of the phrases A_1 and B_1.

Let us see whether Shots IX–X–XI–XII repeat the graph of motion that we determined for Shots III–IV. If so, in what new aspect? The first three-quarters of the first measure fall on the close up, IX. These three-quarters include the introductory chord—'the starting platform', as we called it on other occasions. The picture that accompanies this chord seems almost like an enlargement of part of Shot VI: the close-up of a bearded man (Ignat) against a background thick with spears might have been a closer camera set-up on the four spearmen of Shot VI. The remaining five-quarters of the phrase fall over Shot X—the background of which is relatively free of spears, compared to the background of Shot IX. This 'simplification' resembles that of Shot VI, if you compare the left side of that frame with its right side. Our 'jolt' also can be found in this close-up —but here expressed in an entirely new manner—as puffs of breath in the cold air, exhaled from a nervously tense throat. The 'arc' in this instance is built upon a main element of growing suspense, now 'acted'—increasing the excitement.

A new embodiment of our 'motion' is revealed—a psychological factor of play, of acting—woven into the rising emotion.

Along with this factor, we may visualize Shot X as having volume. In the transition from Shot X to Shot XI, analogous to the 'fall' of III–IV, we have no less sharp a jolt from a rounded volume—Savka's young face in close-up—to a long shot of small figures, with their backs to the camera, peering into the distance. This jolt is produced not only through an abrupt decrease of dimensions, but also through the full about-face of the personages.

These two shots—X and XI—are analogous to the right and left sides of Shot VII. Each half of Shot VII is given here a whole frame, producing its own effect. Naturally these are enriched and given more weight (compare VII and XI, or the strip of horizon in VII with the whole frame of deserted frozen lake in Shot XII).

Echoes of the other elements can be found here, also. The tapping off of flags that we remarked in Shot IV, and the moving high-lights of Shot VIII here appear as vertical streaks, alternating white and grey, stretching across the icy surface.

Thus we can find the same graph of motion that determined the synchronization of the inner movement of music and picture, reappearing in varying plastic means:

Tonally (Shot I).

Lineally (Shot III).

Spatially (the wings of Shots VI–VII).

Dramatically and substantially (by the acting in Shots IX–X and by the plastic transition from the close-up volume of Shot X to the reduced volumes of Shot XI).

And, too, the anxious awaiting of the enemy was itself expressed through several kinds of variations: by vague, 'general' half-uttered means through the light of Shot I, then the line of Shot III, then by *mise-en-scène* and the grouping of Shots VI–VII, and finally by a fully edited integration of Shots VIII–IX–X.

There is also one shot that we have not yet touched in our analysis—Shot V. In referring to it above we called it a 'transitional' shot. Thematically this is an exact description: a transition from the prince on the rock to the troops at its foot.

This shot contains a musical transition—and its change from one tonality to another is consistent with its thematic function, and with the plastic character of the shot. This is the only frame in the sequence where the 'arc' is transposed from the right of the frame to the left side. Here it serves to outline, not the airy part of the frame, but the heavy, solid part: here the arc does not move upward, but downward—

all of which is in full correspondence with the music: a clarinet in the bass expressing a movement downward against a background of violins, tremolo.

Despite these differences this frame cannot be freed completely from its responsibilities to the whole sequence. In theme this shot is completely linked with the other shots.

The different character of this shot could be explained without any hesitation if it contained some antagonistic element—if, for example, the German knights appeared, in any aspect, in this shot. Such a sharp cut, deliberately breaking up the general texture of the sequence, would have been in such a case not only 'desirable', but actually necessary. The enemy theme does break in thus, with a harsh, new sound, a few shots later, as described above. Later the 'clashing' themes of the two foes cross in a combat of clashing shots: in a clash of montage strips, sharply differing in composition and structure—white German knights—black Russian troops; immobile Russian troops—galloping riders; open, living emotional Russian faces—German faces hidden by the visors of iron masks.

This clashing of the two foes is first shown as a clash of shots assembled by means of contrast—solving the introductory phase of the battle without as yet bringing the troops into contact. A filmic battle has already begun, however, by means of this clash of the plastic elements that characterize the antagonists for us.

But no such full clash takes place between Shot V and the other shots. Despite the fact of a difference between the features of Shot V and the features of the other shots, V does not break away from their unity.

How is this achieved?

Since we have seen that the features of Shot V are torn away from the features of the other shots in almost every respect, we will, apparently, have to look beyond the limits of this frame alone for the answer.

Examining the entire series of pictures, we shall quickly discover two frames which, to a lesser degree, describe the

same inverted curved arc that characterizes the descending line of the rock in Shot V.

We find that Shot V is placed roughly half-way between these two.

One shot prepares for the appearance of Shot V. The other cancels it out.

These two shots, so to speak, 'amortize' the appearance and disappearance of Shot V, whose coming and going without them would have been too abrupt.

These two shots are II and VIII.

In fact, if we draw a directional line of their two main masses, we can see a coincidence with the rock contour of Shot V:

SHOT II SHOT VIII

FIGURE 14

Shot V differs from Shots II and VIII in that this line is not *physically* drawn, but functions as a construction line along which the main shapes of II and VIII arise.

In addition to this more fundamental welding of Shot V to the other shots, there are also curious 'clamps' that hold V to its immediate neighbours—IV and VI.

It is tied to Shot IV by the tiny banner fluttering above the rock, continuing the play of flags over the troop-line in Shot IV; the last musical accent of the flags actually coincides with the appearance of the banner in Shot V.

163

Shot V is tied to Shot VI by the black contour of the rock, whose base occupies the left of frame VI.

This rock base has an importance other than the considerations of its plastic-compositional elements. It conveys topographical information—proving that the army is really at the foot of Raven Rock. The lack of such 'information trifles' too often leads to a lack of definite topographical and strategic logic, allowing most film battles to melt into an hysterical chaos of skirmishes through which it is impossible to discern the general picture of the whole developing event.

Aside from these elements, we should note here another means of achieving compositional unity—through a mirror type of contrast. The same unity can be felt in Shot V that can be felt *quantitatively* by representing the same quantity with a *plus* and with a *minus* sign.

Our perception of this shot would be entirely different if, for example, Shot V had contained not only the same (though *inverted*) curve of the arc, but also a *broken* or a *straight* line. Then we would have sought its relationships among such opposites as black-white, immobile-moving, etc., where we would be dealing with *qualities* that are diametrically opposite rather than with equal quantities equipped with differing *indications*.

However, such general considerations could lead us very far afield.

Let us instead exploit our established fact—that we may draw a general diagram of audio-visual correspondence and a motion graph of this correspondence through our entire analysed sequence. (During this résumé of the analysis it is advisable to follow the argument while keeping an eye on the general diagram.)

For this stage of the discussion we will overlook the details of how the repeats and variations are interwoven harmoniously. In this respect the diagram is quite clear in itself, both through its spacing and its figures.

There is another question that has not yet been touched in the analysis.

At the beginning of Part II we laid down a general principle, according to which audio-visual unity and correspondence is to be achieved. We defined this as a unity of both elements in an 'image', i.e., through a unifying image.

We have just discovered that the 'unifier' of the plastic and the music elements is the impulse of a movement that frequently and repeatedly passes through an entire sequence construction. Isn't there a contradiction here? Or may we, on the other hand, maintain that within our typical linear figure (that is, typical for a certain part of the work) there is a definite 'imagery', and that that imagery is firmly connected with the 'theme' of the part?

Does this appear in our general graph of motion, as shown in Figure 1?

If we try to read this graph emotionally in conjunction with the thematic matter of the sequence, checking one against the other, we can find a 'seismographical' curve of a certain process and rhythm of *uneasy expectation*.

Beginning with a state of relative calm, it develops into an increasing upward movement—which can be read as a period of tenseness—waiting.

Near the summit of this tension, there is a sudden discharge, a complete fall—like an escaping sigh.

This similarity cannot really be considered accidental, because the apparently similar structure of the emotional graph is actually the prototype of the motion graph itself, which, like every living compositional graph, is a fragment of the activity of man, coloured in a certain emotional way—a fragment of the regularity and the rhythm of this activity.

The line *a-b-c* on Figure 1 very clearly reproduces the state of 'holding one's breath', holding in the exhalation until the chest is ready to burst—to burst not only with the increasing intake of air, but also with the increasing emotion that is bound to the physical act —'Any moment now the enemy will appear on the horizon.' And then, 'No, he is not yet in sight.' And you sigh with relief: the expanding chest suddenly collapsing with the deep exhalation. . . . Even here, in a

simple description, one involuntarily places after this action
. . .—three dots: the three dots of a pulsing anti-climax re-
acting to the previously increased tension.

Here something else catches our attention in the graph. A
repeated stationary feeling matched to the introductory chord
of the new musical phrase before again climbing to suspense
—then a fall—and so on. And so the entire process moves
ahead, rhythmically, invariably repeating itself with the very
monotony that makes suspense so unbearable for those who
are experiencing it.

Deciphered in this way, our graph of curved ascensions,
falls and horizontal resonances may be rightly considered as
the limits to be reached by a graphic *embodiment* of that image
which fuses the process of a certain state of excited suspense. *

Such a construction can obtain realistic fullness, and the
full imagery of 'suspense' only through the fullness of the shot-
frames—only when these frames are filled with a plastic *repre-
sentation* that is composed according to the most *generalized*
graph of our theme.

Along with a firm *generalized graph* of the sequence's emo-
tional content sounded several times in the musical score, the
element of the changing *pictorial representations* carries the
responsibility for increasing the theme of suspense.

In our sequence we see a growing intensity of varying
representations passing consecutively through a series of varying
dimensions:

1. Tonal I.
2. Linear III–IV.
3. Spatial VI–VII–VIII.

* '. . . as Osmin's rage gradually increases, there comes (just when the
aria seems to be at an end) the allegro assai, which is in a totally different
measure and in a different key; this is bound to be very effective. For just
as a man in such a towering rage oversteps all the bounds of order,
moderation and propriety and completely forgets himself, so must the
music too forget itself. But as music . . . must never cease to be *music*, I
have gone from F (the key in which the aria is written), not into a remote
key, but into a related one, not, however, into its nearest relative D
minor, but into the more remote A minor.' Mozart, in a letter to his
father, 26th September 1781, regarding *Die Entführung aus dem Serail*.[18]

4. Substantial (the masses of the close-ups) and, at the same time Dramatic (the playing of these close-ups on through IX–X–XI–XII).

The very order in which these dimensions change forms a definitely growing line—from unsubstantial, vaguely alarming 'play of light' (the fade-in) up to the clear, concrete *human action*, the activity of realistic characters, realistically awaiting a realistic foe.

One question remains to be answered—a question asked by every listener or reader for whom any picture of the regularity of compositional structures is laid out for the first time: 'Did you know all this *beforehand?* Did you anticipate it *beforehand?* Did you really calculate this in such detail *beforehand?*'

This sort of question usually betrays an ignorance in the questioner as to the true manner in which the creative process proceeds.

It is a mistake to think that with the composition of a shooting-script, no matter how 'ironclad' or 'foolproof' it might be judged, the creative process is ended. Unfortunately this is an opinion I very often hear expressed—that the creative job is ended as soon as the compositional formulae are drawn up, and that it is thus that all the subtleties of construction are pre-determined.

This is far from a true picture of the process—and at the most, only to a certain degree is it even a possible picture.

It is especially far from the truth in respect to those scenes and sequences of a 'symphonic' construction, where the shots are connected by a dynamic process, developing a broad emotional theme, rather than by some sequence of the plot's phases, which may develop only in that definite order and that definite sequence dictated by common sense.

This is connected with another circumstance—that during the period of work one rarely *formulates* these 'hows' and 'whys' which determine this or that choice of 'correspondence'. In the work period the basic selection is transmuted, not into *logical evaluation*, as in a post-analysis of this sort, but into *direct action*.

Build your thought not through inference, but lay it out directly in frames and in the course of composition.

I involuntarily recall Oscar Wilde's denial that an artist's ideas are born 'naked', and only later dressed in marble, paint and sound.

The artist thinks directly in terms of manipulating his resources and materials. His thoughts is transmuted into direct action, formulated not by a formula, but by a form.

Even in this 'spontaneity' the necessary laws, bases, motivations for *precisely such and no other* distribution of one's elements pass through the consciousness (and are sometimes even uttered aloud), but *consciousness does not stop to explain these motivations*—it hurries on *towards completion of the structure itself.* The pleasure of deciphering these 'bases' remains to post-analysis, which sometimes occurs years after the 'fever' of the creative 'act' has passed—that 'act' which Wagner, at the height of his creative rise in 1853, referred to in refusing to contribute to a review devoted to musical theory which was being organized by his friends: 'When you create—you do not explain.'[19]

The laws governing the fruits of the creative 'act' are in no sense relaxed or reduced thereby—as we have endeavoured to demonstrate in the above analysis.

THE WORK OF EISENSTEIN
(1920–47)

(*Note to Revised Edition:* This list has been corrected and supplemented by Ivor Montagu.)

This record has been compiled with the intention of providing a fully rounded picture of Eisenstein's creative career, beginning with his work as designer in the theatre. The list includes not only his six finished films, but also the unrealized projects and unachieved dreams without which the record of any artist's career is incomplete. The titles in **bold-face** are those of the six completed films.

Sergei Mikhailovich Eisenstein was born in 1898 and educated in St. Petersburg. A student of engineering and architecture, his interest in the theatre did not become active until the Civil War, when as an engineer attached to a Red Army fortification corps he organized an amateur theatre group. After demobilization, he found work as a theatre designer in Moscow.

THE MEXICAN (1920–1)

An adaptation of a story by Jack London, prepared by B. Arbatov for the First Workers' Theatre of the Proletkult. Directed by Valeri Smishlayev and Eisenstein. Designed by Eisenstein. An 'agit-poster', staged in the Central Arena of Proletkult, Moscow.

KING HUNGER (1921)

A play by Leonid Andreyev. Directed by V. Tikhonovich. Designed by Eisenstein. Staged in the Central Arena of Proletkult, Moscow.

MACBETH (1921)

A play by Shakespeare. Directed by V. Tikhonovich. Designed by Eisenstein. Produced in the Polenov Theatre, Moscow.

VAUDEVILLES (1921-2)

Including *A Good Relation to Horses* (V. Mass), *Thieving Children* (Dennery), and *The Phenomenal Tragedy of Phetra* (a parody by Foregger of Tairov's production of Racine's *Phedra*). Directed by N. Foregger for his Free Studio, Moscow. Designed by Eisenstein.

HEARTBREAK HOUSE (1922)

A play by Bernard Shaw. Directed by Vsevolod Meyerhold. Designed by Eisenstein. This production was prepared, but not staged.

PRECIPICE (1922)

A play by Valeri Pletnyov. Directed by M. Altman. Designed by Eisenstein. Staged in the Proletkult Theatre, Moscow.

THE WISE MAN (1922-3)

Première March 1923. An adaptation by Eisenstein for the Proletkult Theatre of Ostrovsky's play, *Enough Simplicity in Every Wise Man*. Directed and designed by Eisenstein. Cast:

Glumov	Gregori Alexandrov
Mamayev	Maxim Shtraukh
Mamayeva	Vera Yanukova

A short comic film representing Glumov's diary and photographed by B. Frantzisson, was especially produced for incorporation into this first of Eisenstein's independent theatrical productions.

LISTEN, MOSCOW! (1923)

Première in the summer of 1923. An 'agit-Guignole' by Sergei Tretiakov, written for the Proletkult Theatre. Directed and designed by Eisenstein.

GAS MASKS (1923-4)

A play by Serge Tretiakov. Directed and designed by Eisenstein. Staged in the Moscow Gas Factory.

For detailed analysis of role played by his theatre work in Eisenstein's development, see item 47, Bibliography.

STRIKE (1924)

Produced by Goskino (1st Studio), Moscow. Released 1st February 1925; 8 reels, 1,969 metres. Scenario by Valeri Pletnyov, Eisenstein and the Proletkult Collective. Directed by Eisenstein. Photographed by Edward Tisse. Settings by Vasili Rakhals. Cast:

Organizer	A. Antonov
Worker	Mikhail Gomarov
Spy	Maxim Shtraukh
Foreman	Gregori Alexandrov
Lumpenproletariat	Judith Glizer, Boris Yurtzev
	and other Proletkult actors

The first of a proposed series of films on pre-revolutionary working-class activities. Its original intent was almost purely educational, but the finished film was as dynamic and experimental as might be expected of Eisenstein's first film. It was one of the prize-winning Soviet films at the 1925 Exposition des Arts Décoratifs in Paris, and it was commercially exhibited in Germany, but it has not been seen in America or England.

1905 (1925)

Produced by Goskino (1st Studio), Moscow. Scenario by Nina Agadzhanova-Shutko. Directed by Eisenstein. Photographed by Edward Tisse.

A large panoramic film in celebration of the 1905 Revolution, half-completed in shooting before Eisenstein decided to concentrate on the expansion of one episode in it—the mutiny of the sailors on the Battleship *Potemkin*. The other episodes were never edited or released.

POTEMKIN [*The Battleship 'Potemkin'*] (1925)

Produced by Goskino, Moscow. Première in the Bolshoi Theatre, Moscow, 1st January 1926; 5 reels, 1,740 metres. Scenario by Eisenstein, from an outline by Nina Agadzhanova-Shutko. Directed by

Eisenstein, assisted by Gregori Alexandrov. Photographed by Edward Tisse. Direction assistants: A. Antonov, Mikhail Gomarov, A. Levshin, Maxim Shtraukh. Group manager: Yakov Bliokh. Sub-titles by Nikolai Aseyev. Cast: Sailors of the Black Sea Fleet of the Red Navy, citizens of Odessa, members of the Proletkult Theatre; and

Vakulinchuk	A. Antonov
Chief Officer Giliarovsky	Gregori Alexandrov
Captain Golikov	Vladimir Barsky
Petty Officer	A. Levshin
A sailor	Mikhail Gomarov

Filmed in the city and port of Odessa and in Sevastopol. The only American prints of *Potemkin* that reproduce exactly its original state are available through the Museum of Modern Art Film Library, New York.

FIRST CAVALRY ARMY

A proposed film which was to celebrate the role played in the Civil War by Budyonny's cavalry division. Material was also to be drawn from Isaac Babel's stories published under a similar title.

THE GENERAL LINE

Produced by Sovkino, Moscow. Scenario and direction by Eisenstein and Gregori Alexandrov. Photography by Edward Tisse.

A detailed film on the changes in Russia's agricultural scene as a result of the policy of collectivization. Its production was interrupted by Eisenstein's assignment to the largest of the several films being made in celebration of the October Revolution. On the crew's return to the subject a year later, it was completely reorganized, rewritten and rephotographed as *Old and New*.

OCTOBER [*Ten Days That Shook the World*] (1928)

Produced by Sovkino, Moscow. Released 20th January 1928; 7 reels, 2,800 metres. Scenario and direction by Eisenstein and Gregori Alexandrov. Photography by Edward Tisse. Direction assistants: Maxim Shtraukh, Mikhail Gomarov, Ilya Trauberg. Camera assistants: Vladi-

mir Nilsen, Vladimir Popov. The cast, drawn largely from the people of Leningrad, included:

Lenin	Nikandrov
Kerensky	N. Popov
A Cabinet Minister	Boris Livanov

A reconstruction of the critical days between February and October, 1917, ending on the fall of the Provisional Government. Photographed almost entirely in Leningrad. Known abroad and in America as *Ten Days That Shook the World*.

OLD AND NEW (1929)

Produced by Sovkino, Moscow. Released September 1929; 6 reels, 2,469 metres. Scenario and direction by Eisenstein and Gregori Alexandrov. Photography by Edward Tisse. Direction assistants: Maxim Shtraukh, Mikhail Gomarov. Camera assistants: Vladimir Nilsen, Vladimir Popov. Settings by V. Kovrigin; architecture by Andrei Burov. Cast:

The Woman	Marfa Lapkina
Komsomol	Vasya Buzenkov
Tractor Driver	Kostya Vasiliev
The Kulak	Chukhmarev
The Priest	Father Matevei
The Peasant	Khurtin
The Witch	Sukhareva

A film entirely different from the half-completed *General Line*, employing a more concentrated and personal story than originally proposed. See treatment in item 38 of Bibliography. Shown in England as *The General Line*.

CAPITAL

A planned film-dramatization of Karl Marx's analysis. See item 9 in Bibliography.

THE STORMING OF LA SARRAZ

This unfinished film was the result of Eisenstein, Tisse and Alexandrov attending an international film congress held in the ancient château of La Sarraz in Switzerland. One of the delegates (Jeannine Bhoussinousse, clad in a white robe with

two empty film-reels for breastplates) was suspended with ropes from the topmost tower where, as 'the spirit of the artistic film', she was the object for contention of two armies: that of Commerce, led by Bela Balasz in full armour, and that of Independence, led by Eisenstein, mounted on a projection table and tilting with both lance and projection apparatus. Other remembered warriors were Léon Moussinac as Wallenstein, Hans Richter as General Tilly, and Walter Ruttman as St. George. This riot was 'directed' by Eisenstein, Richter and Montagu, and Richter is credited with most of the improvised script. Tisse had to shoot the entire allegorical jest in a single day, because the outraged hostess demanded a stop to the congress's eccentricities. The short but uncut film was lost in some Berlin film vault.

THE ROAD TO BUENOS AIRES

The reportage by Albert Londres was proposed to a French company by Eisenstein and he worked over it for a while with Montagu before the project evaporated. Eisenstein privately explained his choice of the subject by his belief in type-casting, for he would not have been able to make a film in France without employing the lady friends of the film's financiers.

ZAHAROFF

Eisenstein was attracted by a currently published biography of Sir Basil Zaharoff, and suggested it to French and English companies at this time as well as, later, to Paramount and to other American firms.

[*Romance Sentimentale*]

A musical short film made by Alexandrov and Tisse in Paris. Its producer would only put up the money for the production (which included salaries for three) if Eisenstein would agree to be named as co-director on it. Eisenstein did agree, in

174

advance. He also later wrote defending the production from criticism as though it were indeed one of his own, although his actual participation was not more than as an occasional consultant.

ARMS AND THE MAN

George Bernard Shaw offered his plan to Eisenstein if he could get an American producer to do it and it was later mentioned to Paramount, though without interest.

THE WAR OF THE WORLDS

When Eisenstein signed the contract with Paramount in Paris, Jesse Lasky proposed to him the H. G. Wells novel, but the project was soon dropped as too costly.

GLASS HOUSE

Possibly suggested by Eugene Zamiatin's novel *We*. Eisenstein outlined the idea to Lasky, who was interested, but the combined efforts of Eisenstein, Alexandrov and Montagu, plus some writers from the Paramount lot (including Oliver Garrett), to find a story to express the idea, produced nothing.

SUTTER'S GOLD

The next project submitted to Paramount. Along with a treatment by Eisenstein, Alexandrov and Montagu (see Appendix 5) a detailed production schedule to demonstrate how economically the film could be made (now in the Eisenstein Collection at the Museum of Modern Art Film Library) was turned in to Lasky.

AN AMERICAN TRAGEDY

The most completely developed of the several projects submitted to Paramount. This adaptation and treatment of Theodore Dreiser's novel was approved by the author but

rejected by Paramount. See Appendix 4 and item 34 in Bibliography. Ivor Montagu thus ascribes the authorship of this and the previous *Sutter's Gold* scripts: 'The scripts of both these subjects should be ascribed to S.M.E., G.V.A. and I.M. After a lot of research, of which E. of course did overwhelmingly the most and initiated everything, he and A. got out the first draft, which we then had translated, whereupon he and I got out the second, the actual writing of this being my job (as the writing of the first had been A.'s), the actual planning—general and detail—of both being E.'s.'

BLACK MAJESTY

A film of the Haitian Revolution was considered at various times, and as early as Paris, before the Paramount contract was signed. In addition to the John Vandercook novel of this name, material was also to be drawn from Anatoli Vinogradov's *The Black Consul* and Otten's play *Der Schwarze Napoleon*. The idea of starring Paul Robeson was also absorbed into the continuing project.

ONCE IN A LIFETIME

Eisenstein obtained the Russian theatrical rights from Sam H. Harris to the play by Moss Hart and George S. Kaufman, with a view to staging it on his return to Moscow.

'A FILM IN JAPAN'

As the return home was first planned via Japan, a production there was contracted by letter exchange. This was cancelled by the change in travelling plans and the Mexican film.

QUE VIVA MEXICO!

Independently produced, through Upton Sinclair. Scenario and direction by Eisenstein and Gregori Alexandrov. Photographed by Edward Tisse.

The footage shot for this film was utilized in 1933 by Sol

Lesser to make *Thunder Over Mexico* (based on one episode of the complete plan) and two short films, *Death Day* and *Eisenstein in Mexico*. In 1939 Marie Seton used additional footage to release *Time in the Sun* (edited by Roger Burnford from extant outlines for *Que Viva Mexico!*). Eisenstein himself has never seen his full footage nor any uses that others have made of sections of it. See Appendix 6 and item 39 in Bibliography.

'A TRAVEL FILM OF RUSSIA'

A project mentioned on Eisenstein's journey back to Moscow.

'A MODERN *GÖTTERDÄMMERUNG*'

Another mentioned project, to be centred around the story of Ivar Kreuger.

MMM

A comedy prepared by Eisenstein immediately upon his return to Moscow. Although tentatively cast with Maxim Shtraukh and Judith Glizer, this did not get beyond the scenario stage.

MOSCOW

An ambitious historical film, planned to cover four centuries of Moscow's existence as a leading Russian city. Coincidental with this plan was to be Eisenstein's return to the stage, as director of a play by his co-scenarist, Natan Zarkhi—*Moscow the Second*. Both film and play were halted by Zarkhi's death in 1934. See item 37 in Bibliography.

LA CONDITION HUMAINE

This proposed film was to be based on Malraux's own adaptation of his novel.

BEZHIN MEADOW

Produced by Mosfilm, Moscow. Original scenario by Alexander Rzhe-shevsky, based on Turgenev's short story of this name, and on the life of Pavel Morozov; later revisions by Eisenstein and Isaac Babel. Direction by Eisenstein. Photographed by Edward Tisse. Cast included Vity Kartashov, Boris Zakhava, Elena Telesheva.

After several delays and revisions, the uncompleted film was shelved. See item 52 in Bibliography.

'A FILM OF THE CIVIL WAR IN SPAIN'

Mentioned by Vishnevsky in his pamphlet on Eisenstein.

'A FILM ON THE ORGANIZATION OF THE RED ARMY IN 1917'

Also mentioned by Vishnevsky. This may be identified with a scenario written by Vishnevsky, *We, the Russian People*.

ALEXANDER NEVSKY (1938)

Produced by Mosfilm, Moscow. Released 23 November 1938; 12 reels, 3,044 metres. Scenario by Eisenstein and Piotr Pavlenko. Directed by Eisenstein, with the collaboration of D. I. Vasiliev. Photographed by Edward Tisse. Music by Sergei Prokofiev. Lyrics by Vladimir Lugov-sky. Settings and costumes executed from Eisenstein's sketches by Isaac Shpinel, Nikolai Soloviov, K. Yeliseyev. Sound: B. Volsky, V. Popov. Direction assistants: B. Ivanov, Nikolai Maslov. Camera assistants: S. Uralov, A. Astafiev, N. Bolshakov. Consultant on work with actors: Elena Telesheva. Cast:

Prince Alexander Yaroslavich Nevsky	Nikolai Cherkasov
Vasili Buslai	Nikolai Okhlopkov
Gavrilo Olexich	Alexander Abrikosov
Ignat, master armourer	Dmitri Orlov
Pavsha, Governor of Pskov	Vasili Novikov
Domash Tverdislavich	Nikolai Arsky
Amelfa Timofeyevna, mother of Buslai	Varvara Massalitinova
Olga, a Novgorod girl	Vera Ivasheva
Vasilisa, a girl of Pskov	Anna Danilova
Von Balk, Grand Master of the Livonian Order	Vladimir Yershov
Tverdilo, traitorous mayor of Pskov	Sergei Blinnikov
Ananias	Ivan Lagutin
The Bishop	Lev Fenin
The Black-robed monk	Naum Rogozhin

Work on the scenario was begun in the summer of 1937, and the shooting was completed during the summer of 1938. Prokofiev has written a cantata based on his score, also entitled *Alexander Nevsky*.

PEREKOP

A film-project to reconstruct Frunze's drive on the White Guard forces of Baron Wrangel from the Crimean Peninsula in 1920. Script by Eisenstein and Fadeyev.

FERGHANA CANAL

A planned history of Central Asia from antiquity to the present day. There was one exploratory filming expedition to the chief location before the project was dropped. This footage was edited into a short documentary film on the opening of the Canal. The full script was by Pavlenko and Eisenstein (see Appendix 7). The preliminary photography was by Tisse, and a score was sketched by Sergei Prokofiev.

DIE WALKÜRE

The second opera of Richard Wagner's *Ring of the Nibelung*. Staged at the Bolshoi Opera Theatre, Moscow. Directed by Eisenstein. Settings and costumes designed by Peter Williams after sketches by Eisenstein. Conducted by Vasili Nebolsin. Première 21st November 1940. Cast:

Sieglinde	N. D. Schpiller
Brünnhilde	Marguerite Butenina
Fricka	Elena Slivinskaya
Siegmund	Alexander Khanayev
Hunding	Vasili Lubentzov
Wotan	Innocent Redikultzev

MOSCOW FIGHTS BACK

The preparation of *Ivan the Terrible* was interrupted to work on a newsreel feature-length with the collaboration of Quentin Reynolds. This project was variously called *War Against the Nazis* and *The Face of Fascism*, and was halted by the removal of Reynolds to Kuibyshev with the other correspondents at the end of 1941.

IVAN THE TERRIBLE: Part I (1944)

Produced by the Central Cinema Studio, Alma-Ata. Released 30th December 1944; 12 reels, 2,745 metres. Scenario and direction by Eisenstein. Photographed by Edward Tisse (exteriors) and Andrei Mosvin (interiors). Music by Sergei Prokofiev. Lyrics by Vladimir Lugovsky. Settings and costumes executed from Eisenstein's sketches by Isaac Shpinel, L. Naumov, V. Goryunov. Sound: V. Bogdankevich, B. Volsky. Direction assistants: B. Sveshnikov, L. Indenbom. Camera assistant: V. Dombrovsky.

Ivan IV	Nikolai Cherkasov
Anastasia, his bride	Ludmila Tzelikovskaya
The Boyarina Staritzkaya	Seraphima Birman
Vladimir Andreyevich, her son	Piotr Kadochnikov
Prince Andrei Kurbsky	M. Nazvanov
Prince Fyodor Kolychov	Alexander Abrikosov
Archbishop Pimen	A. Mgebrov
Nikola, the fanatic	Vsevolod Pudovkin
Malyuta Skuratov	Mikhail Zharov
Alexei Basmanov	Alexei Buchma
Fyodor, his son	Mikhail Kuznetzov

This is the first of a projected series of three films, planned before the Nazi invasion, but not begun until after the evacuation of the Mosfilm Studio to Alma-Ata. The full treatment (then in two parts) was published in 1944, and thereupon translated into English (see item 67 in Bibliography).

IVAN THE TERRIBLE (Part II)

Most of this Part II of the projected trilogy was shot during the production of Part I, but its cutting (including sequences in colour) was not completed until the beginning of 1946. Immediately upon the completion of the cutting, Eisenstein suffered an almost fatal heart-attack, confining him to a hospital for the remainder of the year. During this time screenings of his work-print aroused considerable critical controversy, of which he was unaware until his release from the hospital. At present he is completing Part II for release in 1948.

MONTAGE OF ATTRACTIONS

This is an excerpt from Eisenstein's first published article, printed in the magazine *Lef* in 1923. This statement was made in connection with the preparation of his production of Ostrovsky's play *Enough Simplicity in Every Wise Man*, staged in the Proletkult Arena. Of particular interest in the article is its formulation of a direction in Eisenstein's theatre work that was not to find complete realization until practised in the film medium. This direction has developed so consistently since Eisenstein entered films that a comparison between this and his latest work in this volume reveals no fundamental contradiction.

THE basic materials of the theatre arise from the spectator himself—and from our guiding of the spectator into a desired direction (or a desired mood), which is the main task of every functional theatre (agit, poster, health education, etc.). The weapons for this purpose are to be found in all the left-over apparatus of the theatre (the 'chatter' of Ostuzhev no more than the pink tights of the prima-donna, a roll on the kettledrums as much as Romeo's soliloquy, the cricket on the hearth no less than the cannon fired over the heads of the audience). For all, in their individual ways, bring us to a single ideal—from their individual laws to their common quality of *attraction*.

The attraction (in our diagnosis of the theatre) is every aggressive moment in it, i.e., every element of it that brings to light in the spectator those senses or that psychology that influence his experience—every element that can be verified and mathematically calculated to produce certain emotional shocks in a proper order within the totality—the only means by which it is possible to make the final ideological conclusion perceptible. The way

*to knowledge—'Through the living play of the passions'—applies specific-
ally to the theatre (perceptually).*

Sensual and psychological, of course, in the sense of efficient
action—as directly active as in the Theatre Guignole, where an
eye is gouged out, an arm or leg amputated before the very eyes
of the audience; or a telephone communication is incorporated
into the action to describe a horrible event that is taking place
ten miles away; or a situation in which a drunkard, sensing his
approaching end, seeks relief in madness. Rather in this sense than
in that branch of the psychological theatre where the attraction
rests in the theme only, and exists and operates *beneath* the action,
although the theme may be an extremely urgent one. (The mis-
take made by most agit-theatres is in their satisfaction with those
attractions that already exist in their scripts.)

I establish attraction as normally being an independent and
primary element in the construction of a theatrical production—
a molecular (i.e. compound) unity of the *efficiency* of the theatre
and of *theatre in general*. This is fully analogous with the 'pictorial
storehouse' employed by George Gorsz, or the elements of photo-
graphic illustration (photo-montage) employed by Rodchenko.

As difficult as 'compound' may be to limit, it certainly ends
with that fascinating noble hero (the psychological moment) and
begins with the concentrated moment of his personal charm
(i.e., his erotic activity), for the lyric effect of certain Chaplin
scenes does not in the least detract from the attractions com-
municated by the specific mechanics of his movement; it is just
as difficult to fix the boundary line where religious pathos moves
into sadist satisfaction during the torture scenes of the miracle
plays.

The attraction has nothing in common with the trick. Tricks
are accomplished and completed on a plane of pure craftsman-
ship (acrobatic tricks, for example) and include that kind of
attraction linked to the process of giving (or in circus slang, 'sell-
ing') one's self. As the circus term indicates, inasmuch as it is
clearly from the viewpoint of the performer himself, it is absolutely
opposite to the attraction—which is based exclusively on the
reaction of the audience.

*Approached genuinely, this basically determines the possible principles
of construction as 'an action construction' (of the whole production). Instead
of a static 'reflection' of an event with all possibilities for activity within the*

limits of the event's logical action, we advance to a new plane—free montage of arbitrarily selected, independent (within the given composition and the subject links that hold the influencing actions together) attractions—all from the stand of establishing certain final thematic effects—this is montage of attractions.

The theatre is confronted with the problem of transforming its 'illusory pictures' and its 'presentations' into a montage of 'real matters' while at the same time weaving into the montage full 'pieces of representation' tied to the plot development of the subject, but now not as self-enforced and all-determining, but as consciously contributing to the whole production and selected for their pure strength as active attractions.

It is not in a 'revelation' of the playwright's purpose, or the 'correct interpretation of the author', or a 'true reflection of an epoch' that a production can base itself. The only true and solid base for the action of a production can be found in attractions and in a system of attractions. With all details gathered together in the hand of the director, the attraction is always, in some way, intuitively employed, but not on a plane of montage or construction, but as part of a 'harmonic composition' (from which derives a whole jargon—'effective curtains', 'a rich exit', 'a good stunt' etc.), but this exists solely within the frame of the subject's plausibility, chiefly unconsciously and in the pursuit of something entirely different (usually something that is present in the rehearsals from the beginning). What remains to us in reworking the system of staging is to shift the centre of attention to that which is necessary, scrutinizing everything for its value as a transitional, clarifying or factual exposition of the basic intentional line of the staging, rather than for its ties to logical, natural and literary traditional piety. *Our job is to establish this way as a production method* (which has been the work of the Proletkult Workshop since the autumn of 1922).

Schooling for the *montageur* can be found in the cinema, and chiefly in the music-hall and circus, which invariably (substantially speaking) puts on a good show—from the spectator's viewpoint. This schooling is necessary in order to build a strong music-hall-circus programme, resulting from the situation found at the base of a play. . . .

<p align="right">(<i>Lef</i>, No. 3, 1923)</p>

A SEQUENCE FROM *STRIKE*

The following list of shots is a record* made of the completed final sequence of Eisenstein's first film. This oft-quoted example of an early montage conception has never been seen on American or English screens, and its publication in this form may be of interest. Technical abbreviations used here and in the subsequent script fragments: Close-up (*c.u.*), Medium Shot (*m.s.*), and Long Shot (*l.s.*).

1 The head of a bull jerks out of the shot, beyond the upper frame-line, avoiding the aimed butcher's knife.

2 (*c.u.*) The hand holding the knife strikes sharply—beyond the lower frame-line.

3 (*l.s.*) 1,500 persons roll down a slope—in profile.

4 50 persons raise themselves from the ground, arms outstretched.

5 Face of a soldier taking aim.

6 (*m.s.*) A volley of gun-fire.

7 The shuddering body of the bull (*head outside the frame*) rolls over.

8 (*c.u.*) Legs of the bull jerk convulsively. The hooves beat in a pool of blood.

9 (*c.u.*) The bolts of a rifle.

10 The bull's head is fastened with rope to a bench.

11 1,000 persons rush past the camera.

12 From behind bushes, a chain of soldiers appears.

13 (*c.u.*) The bull's head dies under unseen blows (the eyes glaze).

* As published by Alexander Belenson in his *Cinema To-day* (Moscow 1925), p. 59.

14 A volley (*l.s.*) seen from behind the soldiers' backs.

15 (*m.s.*) The bull's legs are bound together, in preparation for the slicing of meat.

16 (*c.u.*) People roll over a cliff.

17 The bull's throat is slit—the blood gushes out.

18 (*m.c.u.*) People lift themselves into the frame, arms outstretched.

19 The butcher moves past the camera (*panning*) swinging his bloody rope.

20 A crowd runs to a fence, breaks through it, and hides behind it (*in two or three shots*).

21 Arms fall into the frame.

22 The head of the bull is severed from the trunk.

23 A volley.

24 The crowd rolls down a slope into the water.

25 A volley.

26 (*c.u.*) The bullets can be seen leaving the gun-barrels.

27 Soldiers' feet walk away from the camera.

28 Blood floats on the water, discolouring it.

29 (*c.u.*) Blood gushes from the slit throat of the bull.

30 Blood is poured from a basin (held by hands) into a pail.

31 Dissolve from a truck loaded with pails of blood—to a passing truck loaded with scrap-iron.

32 The bull's tongue is pulled through the slit throat (to prevent the convulsions from damaging the teeth).

33 The soldiers' feet walk away from the camera (*seen at a further distance than previously*).

34 The bull's skin is stripped off.

35 1,500 bodies at the foot of the cliff.

36 Two skinned bulls' heads.

37 A hand lying in a pool of blood.

38 (*c.u.*) Filling the entire screen: the eye of the dead bull.

39 (*title*) THE END.

A SEQUENCE FROM *AN AMERICAN TRAGEDY*

A copy of the 'first treatment' of this script, dated 9th October 1930, and signed S. M. Eisenstein and Ivor Montagu is in the Eisenstein Collection at the Museum of Modern Art Film Library, New York. The following sequence is from Reel 10 of this script.

17 The surface of Big Bittern Lake.

Pools of the inky black surface of the silent water. The dark reflection of the pines.

Boats trembling on the motionless surface of the silent water. Their gunwales against a rude landing stage at the foot of steps rising to the small hotel. The beautiful panorama of the lake.

18 Standing by the landing stage are Clyde and Roberta. They have just descended from the auto bus.

'How pretty—how beautiful it is!' exclaims Roberta.

Suddenly the hotel proprietor appears from behind the bus. Sprung up as if by magic, he busily praises the weather, greets his guests.

Clyde notices that there are few people about and none to be seen upon the lake. Too late, he notices that the proprietor, praising his kitchen, has taken the grip from him and that Roberta is following him into the hotel. He makes a movement as if to get the grip back, but thinks better of it, and with a strange, hypnotized step, follows them.

19 Open, the white pages of the hotel register stare threateningly at him.

Clyde grows paler; settling himself, he signs a fictitious name —'Carl Golden'—keeping his initials (C.G.) and adding 'and wife'. Roberta, noting this, feels a pang of joy that she hides before those in the hotel.

'It's very hot. I'll leave my hat and jacket here—we'll be coming back early,' says Roberta and she leaves both on a hanger in the hall.

20 Losing his head and ignoring these incidents, Clyde takes his grip from the surprised proprietor and goes towards the boat stand. As he places the grip in a boat, he explains to the man: 'We have our lunch in it.'

Too preoccupied to note a remark by the boatman, he helps Roberta in and, taking hold of the oars, pulls off from the shore.

21 Thick pine forests line the shore, and behind them are to be seen the tops of the hills.

The water of the lake is calm and dark.

'What peace, what tranquillity'—says Roberta.

Rowing, then stopping, Clyde listens to this silence, looks about him. There is no one around.

22 As the boat glides into the darkness of the lake, so Clyde glides into the darkness of his thoughts. Two voices struggle within him—one: 'Kill—kill!' the echo of his dark resolve, the frantic cry of all his hopes of Sondra and society; the other: 'Don't—don't kill!' the expression of his weakness and his fears, of his sadness for Roberta and his shame before her. In the scenes that follow, these voices ripple in the waves that lap from the oars against the boat; they whisper in the beating of his heart; they comment, underscoring, upon the memories and alarums that pass through his mind; each ever struggling with the other for mastery, first one dominating then weakening before the onset of its rival.

They continue to murmur as he pauses on his oars to ask: 'Did you speak to anyone in the hotel?'

'No. Why do you ask?'

'Nothing. I thought you might have met someone.'

23 The voices shudder as Roberta smiles and shakes her head in

answer, playfully letting her hand fall into the water.
'It isn't cold,' she says.

Clyde stops rowing and also feels the water. But his hand springs back as though it had received an electric shock.

24 As he photographs her, the voices preoccupy him. While they picnic, or pick water-lilies, they possess him. As he jumps ashore a moment to put down his grip, the voices rise and torment him.

25 'Kill—kill,' and Roberta happy, freshened by her faith in him, is radiant with the joy of living. 'Don't kill—don't kill,' and as the boat drifts almost soundlessly by the dark pines and Clyde's face is racked by the struggle within him, there rises the long-drawn-out booming cry of a waterbird.

26 'Kill—kill' triumphs, and there passes through his mind the memory of his mother. 'Baby—baby' comes the voice of his childhood and as 'Don't kill—don't kill' rises he hears 'Baby boy—baby boy' in the so different voice of Sondra, and at the image of Sondra and the thought of all that surrounds her 'Kill—kill' grows harder and insistent, and with the thought of Roberta importunate it grows still harsher and shriller, and then the face of Roberta now, aglow with faith in him and her great relief, and the sight of the hair he has so loved to caress and 'Don't—don't kill' grows and tenderly supplants the other and now is calm and firm and final. Ending the conflict. Sondra is lost forever. Never, never now will he have the courage to kill Roberta.

27 And we see Clyde as he sits in blank despair and the misery of renunciation. He raises his face from his hands.

An oar drags in the water. In his left hand he holds the camera.

And Clyde's face is so wild with misery and so stricken by the struggle that has passed behind it that Roberta crawls anxiously towards him and takes his hand in hers.

28 Clyde opens his eyes suddenly and sees near him her anxious, tender face. With an involuntary movement of revulsion he pulls back his hand and jumps up quickly. As he does so the camera, quite accidentally, strikes her in the face. Roberta's lip is cut; she cries out and falls back in the stern of the boat.

'I'm sorry, Roberta, I didn't mean to,' and he makes a natural movement towards her. Roberta is afraid. She tries to get up, loses her balance, and the boat overturns.

29 Once more rings out the long-drawn booming cry of the bird. The overset boat floats on the surface of the water.

Roberta's head appears above the surface.

Clyde comes up. His face showing terrible fright, he makes a movement to help Roberta.

Roberta, terrified by his face, gives a piercing cry and, splashing frantically, disappears under the water. Clyde is about to dive down after her, but he stops, and hesitates.

30 And a third time the long-drawn booming cry of the far-away bird.

On the mirror-like calmness of the water floats a straw hat. The wilderness of forest, the motionless hills. Dark water barely lapping against the shore.

31 A noise of water is heard and Clyde is seen swimming to the shore. Reaching it, he first lies upon the earth, then slowly sits up, forgetting to lift one foot out of the water.

Gradually be begins to shiver, the shivering increases, he pales and makes a familiar gesture, that gesture that he makes when frightened or suffering. He shrinks into himself and hides his head in his shoulders. He notices the foot in the water and lifts it out. He begins to think, and with that, stops trembling. And the voice of his thought.

'Well, Roberta is gone—as you desired—and you didn't kill her—an accident—liberty—life——'

And then very low, tenderly, as if whispering into his ear, the voice says:

'Sondra.'

And Clyde closes his eyes. And in the darkness:

'Sondra.'

Her laughter and her tender voice.

'Sondra.'

32 Clyde is feverishly clothing himself in the dry suit from his grip. Into the grip he packs the soaked suit, and then, getting up from his knees, he stretches to his full height, standing in the rays of the setting sun.

33 The sun vanishes behind the hills, behind the forest. The reflection vanishes from the lake, and all becomes darker and darker.

34 Through the increasing dread of the darkling forest, Clyde is making his way, his grip in his hand. He starts, alarmed by every noise, he is frightened by the cries of the night birds, he fears the moonlight penetrating between the thick branches of the trees, he fears his own shadows and the shadows of the fantastic forest.

He desires to see the time on his watch in the moonlight, but, when the lid is opened, water falls from it and he finds out that it has stopped. . . .

A working sketch by Eisenstein in connection with his development of the 'inner monologue' in the foregoing sequence from *An American Tragedy*. The sketch specifically relates to a breakdown of the material included in nos. 22 and 23

A SEQUENCE FROM *SUTTER'S GOLD*

The following fragment is Reel 4 of a synopsis or a draft treatment of this proposed subject. This manuscript and a detailed production plan for the film are both in the above-mentioned Eisenstein Collection.

Title: FRIDAY
Rain beats mercilessly and ceaselessly upon the ground.
Title: JANUARY 28
The deluge continues.
Title: 1848
The deluge.
Sutter is seated, working, at an old writing desk.
The rain beats hopelessly on the windows.
Galloping horse's hooves are heard through the beat of the rain.
Sutter lifts his head, gets up and, gun in hand, goes to the window.
The sound of galloping hooves comes closer.
The door is flung open and, along with a gust of rain, a man soaked by the downpour rushes into the room, overturning two chairs.
'Marshall!'
—shouts Sutter, and runs to meet him.
Marshall is in a frenzy of excitement—and out of breath. Exhausted by his furious ride, he cannot speak at first.
But through his broken and choked sounds, it becomes clear that his news is secret—he motions for the door to be shut.

Sutter closes the door.

Marshall manages to take a package from his pocket, and tries to unfold it with his trembling fingers.

The door is opened—by one of Sutter's clerks in search of something.

Marshall hastily thrusts the package back into his pocket—glaring at the man.

Innocently and unhurriedly the clerk finds what he needs and leaves.

Marshall shuts the door after him, comes close to Sutter and again takes out the little package, starting to unfold it.

A servant girl comes into the room.

Marshall hides the package.

This time he thrusts the girl out of the room, slamming the door.

Failing to find a key, Marshall shoves a table against the door.

Marshall's trembling fingers are holding the unfolded paper, showing some tiny grains of metal.

Title: GOLD?

Title: GOLD?

Title: GOLD?

As hands complete a chemical test on the grains, Sutter's voice answers quietly and certainly:

'Gold.'

Sutter stands at the table—the gold and reagent are in his hands, and grief fills his face. He repeats—even more quietly:

'Gold.'

Title: GOLD. As the word zooms forward, filling the screen, we hear in a parallel rising inhuman roar—'Gold!'

'Gold!'

—shrieks Marshall at the top of his voice—overturning the table, he flings the door open and rushes into the yard.

Sutter rushes to the window, opens it, and into the rain that drives in, shouts after Marshall:

'Stop. Stop!'

Unheeding, Marshall gallops away through the downpour.

In the centre of the room—with its overturned table, its leaning cupboard, its scattered papers tossed by the wind that is blowing in the rain through the open window and the door swinging on its hinges—stands Sutter, staring with foreboding at the gold on the table.

A gust of wind blows out the light. The dim outlines of the wind-swept room slowly fade out.

In a long fade-in——

—a grey and misty morning.

Sutter dismounts from horseback near his Coloma sawmill at the spot where the first gold was discovered.

At the mill the Indian workers are in the grip of superstitious horror.

They say that the gold belongs to the devil—they have always known of it, and avoided it—and they implore Sutter not to touch it.

Sutter replies that the first job is to complete the construction of his sawmill—no matter what happens.

He urges them to keep the discovery secret.

They all pledge secrecy.

And Sutter, on his way home——

—passes through the prosperous landscapes of a happy country-side.

Wealth, fertility and contentment can be sensed everywhere.

The rain has ceased, nature's garment is soft and sparkling. Myriads of raindrops shimmer in the sunshine.

Suddenly he meets a group of working people with picks, and pans for gold-washing.

Astonished, Sutter follows them with his eyes, then turns his horse and gallops towards the fort.

The storekeeper from near the fort comes up to Sutter to show him gold dust in the palm of his hand.

He asks Sutter if this is really gold or not.

Sutter nods slowly.

The man shouts: 'Gold! Gold!'—and runs into his store.

Sutter, nervous and shaken, rides through the gate of the fort.

The storekeeper nails up the door of his store.

Everything he owns is flung into a wagon.

His helper steals two of Sutter's horses from the corral.

The storekeeper drives off furiously towards the Gold.

Two Indians have stopped their work in the fields to listen to a woman who, with much gesticulation, is telling them the news.

Flinging down their hoes, the Indians follow the storekeeper.

The herdsman deserts his animals.

A husband abandons his wife and children. They weep and plead, but he abandons them.

The schoolmaster leaves his school and his pupils.

Whole groups of Sutter's workers set out on the road.

More and more people stop working to join the human flood.

Fields and homes are empty, deserted.

Sutter places on his finger a ring with the inscription: FIRST GOLD FOUND 1848.

Engraved upon the ring is the coat-of-arms of his native town.

Picks, shovels and crowbars begin to bite into the earth.

The sound of sand moving in the wooden working-pans, the swash of the swinging water, begins to be heard through the forests and fields.

The noise of picks, and of stones cast from the working-pans, grows louder and louder, ever more and more insistent.

These sounds pervade the whole land.

And beneath this tearing sound, the dominion of Sutter falls to waste and rot from its own fertility and luxuriance.

The boughs of fruit-trees are cracking with their burden of ripe fruit.

Barrels are exploding with an over-fermentation of their wine and beer.

Horses, untended and unfoddered, break down the bars of their corrals and rush into the wheat-fields.

Cows fill the air with their lowings of pain, and maddened by their unrelieved udders, burst through the walls of the stables, trampling flowers and vegetables.

High-piled sacks of grain burst with the tension of their stacked weight, and the spilt running grain scatters in the wind.

The dams are taut with their heavy loads, the canal locks are shattered, and the waters rush through their old courses.

Sutter wanders alone through this desolation, listening to the incessant sound of the gold-seekers.

'Gold.' The word rings through the forest, and echoes through the hills and canyons.

And then, from the depths of these canyons, a new theme of the noise symphony can be heard.

The sounds of thousands of feet trampling over stones.

The sounds of endless trails of creaking wagons.

The mixed sounds of horses' hooves and screeching wagon wheels.

And the murmur of limitless crowds.

The first of the wagons appear near the fort.

A savage-looking man tears out some flowers by the roots, and stabs his sharpened tent-pole into the earth.

The sound of the approaching procession grows louder and nearer.

Sutter sits on a hill.

His old dog is huddled against him.

The sounds are nearer—he can distinguish human voices.

They tell of the great distances that they have come—and he realizes that there is no end to this human flood.

Through these sounds can be heard the chopping of axes, falling trees, the whistling of saws, crashing trees.

Pigs are screaming, and frightened ducks quack frantically as they are pursued by the invaders.

Sutter is driven wild by these sounds. The picks grow louder, and now the sound of stone striking stone—stones piled high from out of the river-bed, stones burying the fertile fields. Stones growing into mountains that crush all the fertility that preceded this terrible symphony of sounds.

Darkness, and the crackling of a little fire that lights the silent face of Sutter.

The sounds of destruction swell to colossal proportions.

Sutter is in an agony of despair.

And the saws continue to whine, and the axes to chop, and the trees to crash and the picks to hammer upon the stones.

The gold-diggers curse in the fever of their hunt.

These things madden Sutter, and he takes refuge in the darkness of the forest. . . .

FIRST OUTLINE OF *QUE VIVA MEXICO!*

This incomplete autograph draft of an outline sent to Upton Sinclair before beginning the production of *Que Viva Mexico!* is now in the Eisenstein Collection at the Museum of Modern Art Film Library. Compare with item 39 of the Bibliography.

ROUGH OUTLINE OF THE MEXICAN PICTURE
(and '*plausum date*' for style, orthography, etc.!)

DO you know what a 'Serape' is? A Serape is the striped blanket that the Mexican indio, the Mexican charro—every Mexican wears. And the Serape could be the symbol of Mexico. So striped and violently contrasting are the cultures in Mexico running next to each other and at the same time being centuries away. No plot, no whole story could run through this Serape without being false or artificial. And we took the contrasting independent adjacence of its violent colours as the motif for constructing our film: 6 episodes following each other—different in character, different in people, different in animals, trees and flowers. And still held together by the unity of the weave—a rhythmic and musical construction and an unrolling of the Mexican spirit and character.

Death. Skulls of people. And skulls of stone. The horrible Aztec gods and the terrifying Yucatan deities. Huge ruins. Pyramids. A word that was and is no more. Endless rows of stones and columns. And faces. Faces of stone. And faces and flesh. The man of Yucatan to-day. The same man who lived thousands of years ago. Unmovable. Unchanging. Eternal. And the great wisdom of Mexico about death. The unity of death and life. The passing of one and the birth of the next one. The eternal circle. And the still greater wisdom of Mexico: the *enjoying* of this eternal circle. Death-Day in Mexico. Day of the greatest fun and merriment. The day when Mexico provokes death and makes fun of it—death is but

a step to another cycle of life —why then fear it! Hat stores display skulls wearing top and straw hats. Candy takes the shape of skulls in sugar and coffins of confectionery. Parties go to the cemetery, taking food to the dead. Parties play and sing on the graves. And the food of the dead is eaten by the living. The drinking and the singing grow louder. And night covers Death-Day. Death-Day that is becoming birth day for new lives, for new arrivals. And from beneath the terrifying skull of the grotesque death masquerade and fiesta peeps the smiling face of a new baby establishing the unmovable law of death following life and life following death.

Life. . . . The moist, muddy, sleepy tropics. Heavy branches of fruits. Dreamy waters. And the dreamy eyelids of girls. Of girls. Of future mothers. Of the fore-mother. Like the queen-bee, the mother rules in Tehuantepec. The female tribal system has been miraculously preserved here for hundreds of years till our time. Like serpents are the branches of strange trees. And like serpents are the waves of black and heavy hair around the big dreamy eyes of the female waiting for the male. Activity is on the side of the woman in Tehuantepec. And from girlhood the woman starts the building of a new cell of a new family. Weaving. Cutting fruits. Selling. Sitting hours and hours in the market. The overflowing, slowly moving market of Tehuantepec. Day after day. Coin after coin. Until the neck of the girl bends under the weight· of a golden chain. A golden chain with hanging golden coins. Coins of the States. Coins of Guatemala. Coins with the Mexican eagle. Dowry and bank. Fortune and liberty. New home and wedding. Wedding called in Spanish 'casamiento' in its highest biological meaning—foundation of a new casa. New home. New family. Through picturesque fiestas. With survivals of most ancient customs—like marking the face with red colonial irons—in memory of the Spanish invaders who branded cattle and Indians. Through dances in ancient fashioned robes, gold, silk and embroidery—follows the love story of the young woman. Through customs and rites the story moves from love to wedding. And from the wedding 'Sandunga' (dance) to the lucky palm-shaded new home. A new home overshadowed by the snowy white 'weepeel' —the mountain-like head-dress of the triumphant mother and wife.

The snowy serenity.

Snowy like the grey-haired Popocatepetl.

But harsh, rough, cruel and thorny is the vegetation at his feet. Cruel, rough and harsh like the male tribe of 'charros', farmers, Mexican cowboys and hacendados who live among it. The endless field of maguey—the prickling sharp-leaved cactus. Leaves through which in an endless effort the indio sucks the sap of the earth's heart—the sweet honey-like 'aguamiel'—which when treated becomes 'pulque'. Relief of sorrows—the Mexican brandy. And sorrows are abundant. There is nothing of the aguamiel's sweetness in the tall and bony hacendado, his guards and his major-domos. And lower bends the back of the indio with his little donkey that all day drags the precious load of aguamiel from the boundless fields to the fortress-like hacienda. These are the days of Diaz (before the Revolution of 1910—which changed entirely the living conditions of the indio. We give a glimpse of his state of pure slavery in about 1905–6 to explain why there were always revolutionary 'troubles' in Mexico). Living in the twentieth century but medieval in ways and habits. *Jus prima noctis*. The right of the landowner to the wife of him who works on his fields. And the first conflict in the male tribe. One woman. The bride of a hacienda indio. One woman. And the tribe around her. The right of the landowner, the outburst of protest and the cruelty of repression. And the triangular shadows of indios repeating the shape of the eternal triangle of Teotihuacan. The great pyramid of the Sun, near Mexico City. Waiting for better days. Days of Obregôn.

Controlling their hate under the grimly smiling pagan faces of stone tigers and serpents, worshipped by their ancestors—the Aztecs. (N.B. Quite different from the Yucatan sculpture, people and edifices in part one. And quite different in handling and treatment.)

But the grotesque laughing of the stone heads becomes still more grotesque in the cardboard 'piñata' faces—Christmas dolls. And then becomes voluptuous in the suffering smile of the Catholic polychrome saints. Statues of saints that were erected on the sites of pagan altars. Bleeding and distorted like the human sacrifices that were made on the top of these pyramids. Here, like imported and anæmic flowers bloom the iron and fire of the Catholicism that Cortes brought. Catholicism and paganism. The Virgin of Guadalupe worshipped by wild dances and bloody bull-fights. By tower-high Indian hair-dresses and Spanish mantillas.

By exhausting hours-long dances in sunshine and dust, by miles of knee-creeping penitence, and the golden ballets of bull-fighting cuadrillas. . . .

A typical sketched breakdown, into particular frame-compositions, in Eisenstein's preparation of the shooting-script for *Que Viva Mexico!* This page of sketches is a development of the transition passage noted on page 198 from the luxuriant tropical matriarchy of Tehuantepec to the harsh landscape and male dominion of the plateau at the fleet of Popocatepetl.

FERGHANA CANAL

A shooting-script by Eisenstein, from a treatment by Piotr Pavlenko and Eisenstein. This first draft of the unproduced script is dated 1st, 2nd and 3rd August 1939. Of the published 657 shot indications, only the first 145 are reproduced below, forming a fourteenth-century prologue to the modern drama of Soviet Uzbekistan's reclamation of its desert wastes. In the film's Tamerlane will be found more resemblance to Adolf Hitler than to the heroic figure of Marlowe's tragedy.

1 *(m.s.)* The singer Tokhtasin sings, gazing into the desert . . .

2 *(m.s.)* . . . singing a song of a flowering land, such as was known in the days of the ancient land of Kharesm. . . .

3 *(l.s.)* Before Tokhtasin spreads the endless desert . . .

4 *(l.s.)* The infinite sands of the desert . . . Over the words of the song, *dissolve to* . . .

4a *(c.u.)* . . . a spray of a delicately flowering bush . . .

5 *(m.s.)* . . . surrounded by young trees, clipped and blossoming . . .

6 *(l.s.)* And lo! before us a whole shady oasis is disclosed . . .

7 *(m.s.)* . . . its trees reflected in a broad artificial lake . . .

8 *(c.u.)* . . . an aqueduct flows into the lake . . .

9 *(l.s.)* . . . and irrigation-canals are filled from the lake, carrying away the water in a network of little channels.

10 *(l.s.)* Intricate patterns of silvery channels irrigate fertile fields.

11 *(t.s.)* Again we see the aqueduct flowing into the lake. And this time we see in the lake the inverted reflection of a sky-blue cupola . . .

12 (*l.s.*) The lake reflects the domes of the mosque, the shrine, the academy . . . And Tokhasin, sings of the great city of Urganj, whose beauty surpassed all the cities of Asia, and whose riches were uncounted.

13 (*m.s.*) The intricate pattern of silvery channels dissolves into the complex arabesques of the ornamental tiles on the façade of a magnificent mosque, and before us . . .

14 (*l.s.*) . . . is the square of the rich ancient city—busy in its many-coloured movement . . .

15 (*l.s.*) Water pours from huge reservoirs. It is caught in jars . .

16 (*m.s.*) . . . and from these jars it is poured into large vessels . . .

17 (*l.s.*) Streams of people pour over the monumental staircase of the ancient city.

18 (*m.s.*) Suspended in the sky are the pale blue domes of the academy, the mosque, the shrine . . .

19 (*m.s.*) Gleaming tiled streets are lined with splendid shrines. The crowd, richly robed, moves rhythmically through them.

20 (*m.s.*) White and black veils float through the throng. Dozing water-carriers. Placidly splashing fountains.

21 (*m.s.*) A silvery channel runs into the rectangular pool sunk in the courtyard of the magnificent mosque.

22 (*l.s.*) White-turbaned worshippers fill the courtyard, gradually occupying the whole space with their rich oriental robes and their kneeling figures.

23 (*m.s.*) Praying, kneeling figures, robed in wide silk gowns.

24 (*l.s.*) Rhythmically, throughout the courtyard of the mosque, prayers are offered. The melody of Tokhtasin's song takes a sharp, unexpected turn and, as if they too heard it, the hundreds of supplicants in the broad courtyard suddenly stretch out their arms towards the mosque.

25 (*l.s.*) Into the sky towers the heavy minaret of the mosque. With the song's melody the camera glides up the towering form.

26 (*m.s.*) Tokhtasin begins his song anew. Now he sings of Tamerlane the terrible warrior—Tamerlane who long held the city of Urganj under siege.

27 (*l.s.*) The words of the song soar over the black tents of Tamerlane's encampment, from where Urganj can be seen in the distance.

28 (*l.s.*) Black and white streamers flap over the tents, which are ringed with upright spears, topped with the heads of the vanquished. Before his mounted marshals, against a background of the tents and the army stands 'he who limps, the iron one' . . .

29 (*m.s.*) Tamerlane . . .

30 (*c.u.*) . . . with narrowed eyes. He strokes a sparse beard. Not tall, he is slender—almost feeble in appearance. In his simple robe and plain black skull-cap, a common handkerchief for girdle, he seems quite ordinary.

31 (*l.s.*) Turned towards distant Urganj, like a fearsome wall, stands the army of Tamerlane.

32 (*m.s.*) Without looking towards his standing officers—young and old—Tamerlane quietly speaks:
 'Water is the strength of that city.'
After a moment of silence, he adds:
 'Take away the water from Urganj . . .'
 And without pause we hear the cracking of whips in the air . . .

33 (*m.s.*) Tamerlane stands surrounded by his officers. Through the air the cracking whips whistle shrilly. A wind shakes the tents . . .

34 (*l.s.*) The pavilion of Tamerlane in the distance. The foreground is filled with running half-naked labourers carrying mattocks and spades. Driving them on are the warriors of Tamerlane, cracking their long whips.

35 (*m.s.*) The frightened faces of the diggers run past the camera.

36 (*l.s.*) The crowded stooping backs of the running slaves. Long whips lash them forward.

37 (*m.s.*) The singer Tokhatsin continues his sad song. He sings of the great distress and privation of the city of Urganj, besieged by Tamerlane. His song carries over on to . . .

38 (*fade-in*) . . . water trickling from the channels . . .

39 (*m.s.*) . . . the emptied lake . . .

40 (*c.u.*) . . . a shrivelled water-skin . . .

41 (*l.s.*) The half-demolished wall of the citadel, strewn with the bodies of the city's defenders, dying of thirst. Captives are barely able to drag themselves and the bricks upon their backs to the repair work on the huge gaps in the wall.

42 (*m.s.*) Scattered over the ground near the wall lie empty water-skins. Crazed with thirst, a man seeks in vain at drop of water in them.

43 (*l.s.*) A street of the city, piled high with corpses. Captives are carrying beams through the street. One of the carriers loses his hold—and falls.

44 (*m.s.*) Pits, filled with dry lime. Around them stand perplexed masons, with helplessly hanging hands—there is nothing with which to mix the mortar. In the background slaves are throwing beams behind the broken wall.

45 (*m.s.*) Captains and masons. Among them is a tall mason— the foreman.

46 (*c.u.*) His long black hand scoops up a handful of dusty lime. His voice:
 'There's nothing with which to mix the mortar!'

47 (*m.s.*) Wounded fighters lie dying in the courtyard of the mosque.

48 (*m.s.*) A silent crowd of mothers in another corner of the mosque.

49 (*m.s.*) A crowd of bound captives near the mosque's arcade . . .

50 (*c.u.*) . . . Captives dying of thirst . . .

51 (*c.u.*) . . . Faces of sullen Mongol captives . . .

52 (*l.s.*) Under a high arch of the mosque can be seen the kneeling figure of the Emir of Kharesm—praying.

53 (*m.s.*) Young, handsome, languid, clothed in his golden robes of kingship, the Emir of Kharesm kneels on his royal carpet. The suppliant elders approach him with decorum. A captain comes to the Emir's side. Humbly bowing, he whispers: 'Emir—there is no water to mix the mortar.'

54 (*m.s.*) The figure of a warrior runs into the frame with a cry:
 'Emir—there is no water!'
And he falls at the feet of his lord . . .

55 (*m.s.*) Frenzied mothers cry:
 'Emir—there is no water!'

56 (*m.s.*) 'Water, water!'—the wounded groan.

57 (*m.s.*) 'Water! Water! Water!'—different voices throughout the square take up the cry.

58 (*m.s.*) 'Water! Water!'—the bound captives strain towards the Emir.

59 (*m.s.*) The Emir looks towards the captives. The captains repeat:
 'No water to mix the mortar! What are we to do?'
The cry rises from the square:
 'Water! Water!'

60 (*c.u.*) The Emir tersely commands:
 'Mix the mortar with their blood.'

61 (*m.s.*) In deathly fear the captives shrink from the Emir's arch. Warriors throw themselves upon the captives.

62 (*m.s.*) The warriors of the Emir seize the captives . . .

63 (*m.s.*) The Emir again kneels on his carpet, continuing his prayer.

64 (*c.u.*) Scimitars flash through the frame . . .

65 (*c.u.*) A curved knife flashes through the frame . . .

66 (*c.u.*) The stretched neck of a prisoner.

67 (*c.u.*) Blood drips into a tub . . .

68 (*c.u.*) Blood drips into a tub . . .

69 (*m.s.*) A line of bound captives is dragged through the frame.

70 (*c.u.*) A heap of lime with an empty gutter above.

71 (*m.s.*) Prisoners pushed to their knees . . .

72 (*c.u.*) A warrior (*outside the frame*) slashes his scimitar . . .

73 (*c.u.*) A lime pit. Through the empty gutter flows a thick black liquid . . .

74 (*c.u.*) Greedy hands hastily mix the dark mortar.

75 (*m.s.*) Beams and stones speedily fill the breech in the wall.

76 (*l.s.*) With a last effort, the besieged feverishly repair the citadel wall. Suddenly from the distance can be heard the roar of the enemy. The numbed masons throw themselves on to the wall to defend their city.

77 (*l.s.*) Crowds of people run in panic up the broad stairs. The enemy's roar comes nearer.

78 (*l.s.*) The court of the great mosque. The frightened people huddle together. The roar grows close.

79 (*m.s.*) The Emir rises from his knees. People crowd about him.

80 (*l.s.*) On to the citadel walls stagger the last defenders of the city.

81 (*l.s.*) From the desert comes the black cloud of the attacking army of Tamerlane.

81a (*l.s.*) The hordes of Tamerlane ride across the plain.

81b (*l.s.*) Under the walls of Urganj drives Tamerlane's army.

82 (*l.s.*) Against a background of his attacking warriors—the lame figure of Tamerlane.

83 (*c.u.*) His eyes blaze. A smile plays upon his thin lips.

84 (*m.s.*) Those near him glance towards him, trembling.

85 (*c.u.*) Tamerlane's eyes blaze with a merry flame. He cries out:

 'He who controls water, holds power!'

86 (*l.s.*) Fresh hordes roll under the citadel walls.

87 (*m.s.*) The weakened defenders retreat from the walls.

88 (*l.s.*) Slowly retreating from the invisible enemy, the defenders cross the square . . .

89 (*l.s.*) . . . and run towards the mosque, scattering the dead beneath their feet. (*The camera pans up the minaret.*) The distant roar of the victorious foe.

90 (*m.s.*) On the platform of the minaret, the Emir, leaning on his sword-bearer, looks over the picture of the city's death.

91 (*l.s.*) From above can be seen the courtyard of the mosque, filled with dead.

 One group of people, seeing him, stretch out their arms, asking him to relieve their thirst.

92 (*m.s.*) The city square is strewn with dead. In the middle of the square a single crawling figure strains upwards, crying: 'Water!'

93 (*m.s.*) Turning slowly towards his sword-bearer, the Emir speaks, as if in answer to the dying man:
 'Water—is blood . . .'
 A young guard is dying on the steps leading from the platform. Without looking at him, the Emir descends the steps of the minaret.

94 (*l.s.*) The warriors of Tamerlane burst through the breech in the city wall, laying waste to everything in their path.

95 (*m.s.*) Hanging across the wall are the defenders, dead of thirst . . .

96 (*l.s.*) Others who have died of thirst are strewn over the flight of broad stairs . . .

97 (*m.s.*) The dried-up lake. At its bottom are more bodies . . .

98 (*m.s.*) More dead—beside empty water-vessels.

99 (*m.s.*) Dead—beside shrivelled water-skins.

100 (*m.s.*) In the midst of jewelry and precious stones lies a merchant, dead of thirst . . .

101 (*m.s.*) In a half-darkened cell of the old academy, an old scholar has died—resembling a mummy, bent over his withered parchment.

102 (*l.s.*) The imprisoned wives of the Emir are dying in their harem like quail in festive cages. The rooms have doors of rare woods and windows of mica.

103 (*m.s.*) Motionless, they lie naked or dressed in splendid gowns, upon the rugs and divans of the harem.

104 (*m.s.*) At the edge of a dried sunken basin, a young wife of the Emir is dying of thirst. At the bottom of the basin are some dead fish. Over all these pictures of death expands the music of roaring and crashing sound.

105 (*c.u.*) Two of the Emir's wives have died in each other's arms.

106 (*m.s.*) In the depths of the great hall of the harem sits the Emir.

107 (*m.s.*) The Emir stares before him, whispering:
 'He who controls water—is the victor . . .'
 He dies.

108 (*l.s.*) Tamerlane's warriors gallop into the square of Urganj . . .

109 (*l.s.*) They push their way up the broad stairs—their race upwards is accompanied by the music of the attack.

110 (*l.s.*) A group of the last defenders together with an old mason are hiding at the head of a street. In the distance we see an advance company of the conquerors. We hear the music of Tokhtasin's song (but without words).

111 (*m.s.*) A group of masons dives through the gap in the wall . .

112 (*m.s.*) . . . running in the concealing shadows of a cemetery, dodging among the ancient tombs of believers.

113 (*l.s.*) Diverted from the city of Urganj, the river that once kept the city alive flows turbulently through the channel walls of a temporary canal. It is guarded by Tamerlane's sentinels. In the distance his army is entering the city.

114 (*m.s.*) The water is guarded by his sentinels . . .

115 (*m.s.*) From the shadows the groups of masons throw themselves upon the guards . . .

116 (*l.s.*) The army of Tamerlane is passing through the gate of the conquered city. Battle elephants move in the midst of the throng.

117 (*l.s.*) On to the vanquished square Tamerlane enters, surrounded by a dusty retinue.

118 (*m.s.*) Having rendered the guards harmless, the masons break down the walls of the canal.

119 (*l.s.*) Water rushes through the gap, which rapidly widens. The whole canal wall collapses and the river burst overflowing on to the sand.

120 (*c.u.*) 'So take our water—that you took from us!'—cry the masons, as they themselves are engulfed by the swirling waters of the freed river.

121 (*l.s.*) The wild torrents of water rush towards the army of Tamerlane, still passing through the city gate.

122 (*m.s.*) The throng of dusty warriors is swept up in the rushing water . . .

123 (*m.s.*) The water dashes against the horsemen, rising over them . . .

124 (*m.s.*) In the swirling torrents are caught camels, men, pavilions . . .

125 (*l.s.*) In uncontrollable panic the army fights against the water . . .

126 (*m.s.*) All is washed away in the powerful flood . . .

127 (*m.s.*) . . . of the rising water.

128 (*m.s.*) Surrounded by his captains, Tamerlane speaks:
The theme of his speech is that no strength is greater than the strength of Nature . . .
Turning and se ng the fate of his army, he flees with his retinue, head bent down between his shoulders . . .

129 (*l.s.*) Tamerlane's army retreats in confusion before the on-rushing water.

130 (*l.s.*) The water rushes over the desert towards the horizon. People, horses, camels, sheep are swimming and drowning in the flood . . .

131 (*m.s.*) The battle elephants circle deliberately. Drowning men try to climb on to them.

132 (*l.s.*) A tremendous mass of water flows over the desert. Cutting through the noise of the water is a new noise—the howl of a wind . . . of an approaching sand-storm . . .

133 (*l.s.*) Howling and whistling the sand-storm attacks the water . . .

134 (*l.s.*) The walls of the dead city. There the dead defenders fearlessly gaze with wide eyes and, as though slightly smiling, listen to the duel of the water and sand.

135 (*l.s.*) The blowing sand gradually veils the water from sight . . .

136 (*m.s.*) . . . The water sinks into the sand . . .

137 (*m.s.*) . . . As the sand runs with the wind, it forms broad curving dunes . . .

138 (*l.s.*) Over the curving sand-dunes we can see in the distance the dead city . . .

139 (*l.s.*) The city is buried in sand.

140 (*l.s.*) The ruined mosque, engulfed by sand . . .

141 (*l.s.*) The endless desert . . .

142 (*m.s.*) . . . The scattered skeletons of people, horses . . .

143 (*m.s.*) . . . skeletons of camels, half covered with bricks.

144 (*m.s.*) An overturned chest—scattered gold coins.

145 (*c.u.*) The gold coins sliding over the sand make an unexpectedly loud sound . . .

BIBLIOGRAPHY

OF EISENSTEIN'S WRITINGS
AVAILABLE IN ENGLISH

The following list is an attempt to collate all signed articles and published interviews in which Eisenstein's ideas have appeared in this language. Of these, his most basic writings have been starred (★) for the benefit of those who may wish to review the theoretical development of Eisenstein.

1927

1. Interview, *Eisenstein, Creator of 'Potemkin'*. The American Hebrew, 28th January 1927.

★2. *MASS MOVIES*. The Nation, 9th November 1927. Another English translation appeared in the New York Times, 25th December 1927, as translated from Die Weltbühne (Berlin), 6th December 1927. Written by Louis Fischer on the basis of conversations with Eisenstein.

1928

3. Interview with Joseph Wood Krutch, *The Season in Moscow (III): Eisenstein and Lunacharsky*. The Nation, 27th June 1928.

★4. *THE SOUND FILM* (a joint statement by Eisenstein, Pudovkin and Alexandrov). Close Up (London), October 1928. Two previous appearances in English were a translation from the Berlin Vossische Zeitung, included in a dispatch by William L. McPherson to the New York Herald Tribune, 2nd September 1928; and in the New York Times, 7th October 1928. Originally published as 'Statement' in the magazine Zhizn Iskusstva (Leningrad), No. 32, 1928.

5. *Two Scenes Out of USSR Film 'October'* (Fragments of the Scenario); written in collaboration with G. Alexandrov. The Daily Worker, 3rd November 1928.

6. Interview with Theodore Dreiser, in 'Dreiser Looks at Russia', Liveright, 1928.

1929

7. Interview with Alfred Richman, *Serge M. Eisenstein*. Dial, April 1929. An interview given in 1926.

8. *The New Language of Cinematography*. Close Up, May 1929. Originally published as a foreword to the Russian edition of Guido Seeber's 'Der Trickfilm' (Moscow, 1929).

9. *The Man Who Put Karl Marx on the Screen*. New York Herald Tribune, 22nd December 1929. A partial translation by William L. McPherson of an article written by Eisenstein for the Berlin Vossische Zeitung on a planned film treatment of Marx's 'Capital'.

1930

*10. *THE SOVIET FILM*, in 'Voices of October', Vanguard, 1930. Manuscript dated 1928. Written especially for incorporation into Joseph Freeman's essay on Soviet films in this volume.

11. Amsterdam interview, *M. Eisenstein's Next Film*. New York Times, 16th February 1930. Translation of an interview given to the newspaper Het Volk, on the occasion of Eisenstein's trip to Holland to lecture to the Film-Liga.

12. Interview with H. W. L. Dana, *Revolution in the World of Make-Believe; Eisenstein, Russian Master of the Screen, Sets Forth His Theories*. Boston Evening Transcript, 1st March 1930. An interview given in 1929.

*13. *A RUSSIAN VIEW OF SCENARIOS*. New York Times, 30th March 1930. A partial translation of Eisenstein's German preface ('Drehbuch? Nein: Kinonovelle!') to the published treatment of *Old and New*—'Der Kampf um die Erde' (Berlin, 1929).

14. Interview with Mark Segal, *Filmic Art and Training*. Close Up, March 1930.

*15. *THE FOURTH DIMENSION IN THE KINO: I*. Close Up, March 1930. Dated 19th August 1929, translated by W. Ray, originally published in the newspaper Kino (Moscow), No. 34, 1929.

*16. *THE FOURTH DIMENSION IN THE KINO: II*. Close Up, April 1930. Dated Moscow-London, Autumn 1929, translated by W. Ray.

17. Report by Samuel Brody, *Paris Hears Eisenstein*. Close Up, April 1930. A résumé of Eisenstein's lecture at the Sorbonne University, entitled 'Les Principes du Nouveau Cinéma Russe', on 17th February 1930. The full text is printed in La Revue du Cinéma, April 1930.

18. Interview with Harry Alan Potamkin, *Eisenstein Explains Some Things That Make Sovkino*. The Daily Worker, 24th May 1930.

19. New York interview, *Eisenstein in America*. To-day's Cinema News and Property Gazette (London), 27th May 1930.

*20. *THE CINEMATOGRAPHIC PRINCIPLE AND JAPANESE CULTURE; WITH A DIGRESSION ON MONTAGE AND THE SHOT*. Transition (Paris), No. 19, Spring-Summer 1930. Translated by Ivor Montagu and S. S. Nolbandov; reprinted in Experimental Cinema, No. 3, 1932. Originally published as an afterword entitled 'Outside the Frame', in Nikolai Kaufman's brochure 'Japanese Cinema' (Moscow, 1929).

21. *Doing Without Actors*. Written in collaboration with Alexandrov, Cinema, June 1930. Translated by Ivor Montagu and S. S. Nolbandov.
22. Interview with Mark Segal, *The Future of the Film*. Close Up, August 1930.

1931

*23. *THE DYNAMIC SQUARE*. Close Up, March, June 1931. An article based on the speech made by Eisenstein during a discussion on the wide film in relation to motion picture technique at a meeting organized by the Technicians Branch of the Academy of Motion Picture Arts and Sciences, in conjunction with the Directors and Producers branches, Fox Hills Studio, Hollywood, 17th September 1930. This also appears, in a condensed version, in Hound and Horn, April 1931.

*24. *THE PRINCIPLES OF FILM FORM*. Close Up, September 1931. Dated Zurich, 2nd November 1929; translated by Ivor Montagu. Reprinted in Experimental Cinema, No. 4, 1932.

25. *The Intellectual Cinema*. Left (Davenport, Iowa), Autumn 1931. Translated from the German by Christel Gang.

26. Interview with Morris Helprin, *Eisenstein's New Film, Russian Director in Mexico at Work on 'Que Viva Mexico!'* New York Times, 29th November 1931.

27. *A Mexican Film and Marxian Theory; a communication*. New Republic, 9th December 1931. A reply to Edmund Wilson's article, 'Eisenstein in Hollywood', New Republic, 4th November 1931.

1932

28. Interview with Lincoln Kirstein, *Que Viva México!* Arts Weekly, 30th April 1932.

29. New York interview, *Eisenstein's Monster*. Time, 2nd May 1932.

30. Berlin interview, *Eisenstein's Plans*. Living Age (Boston), July 1932.

*31. *OCTOBER AND ART*. Soviet Culture Review, No. 7–9, 1932. Reprinted in International Literature (Moscow), October 1933, in a section, 'Autobiographies', and in The Daily Worker, 29th January 1934.

*32. *DETECTIVE WORK IN THE GIK*. Close Up, December 1932. The first of three articles written for Close Up, and dated Moscow, October 1932; translated by W. Ray. The series of three articles, all on the State Institute of Cinematography, are an expansion of an article 'Much Obliged', published in Proletarskoye Kino (Moscow), No. 17–18, 1932.

1933

*33. *CINEMATOGRAPHY WITH TEARS*. Close Up, March 1933. Translated by W. Ray. Second of a series of three articles on GIK.

*34 *AN AMERICAN TRAGEDY*. Close Up, June 1933. Translated by W. Ray. Third of a series on GIK.

35. Interview with Marie Seton, *Eisenstein Aims at Simplicity*. Film Art (London), Summer 1933.

36. *The Cinema in America; impressions of Hollywood, its life and values* International Literature, July 1933. Translated by S. D. Kogan. Originally published as 'Overtake and Surpass' in Proletarskoye Kino, No 15–16, 1932.

37. Interview with Bella Kashin, *Career of Sergei Eisenstein, Who Is Now Preparing His Film, 'Moscow'*. New York Times 17th December 1933.

1934

*38. *OLD AND NEW;* written in collaboration with Alexandrov. In Lewis Jacobs' 'Film Writing Forms', Gotham Book Mart, 1934. The original treatment for the film, as translated from the German edition, 'Der Kampf um die Erde' (Berlin, Schmidt, 1929).

*39. *QUE VIVA MEXICO!* written in collaboration with Alexandrov, Experimental Cinema, 1934. Synopsis of the proposed film, written in 1931.

40. *The Difficult Bride*. Film Art, Spring 1934. Translated by Marie Seton. Originally published in Literaturnaya Gazeta (Moscow), No. 30, 11th July 1933

*41. *ON FASCISM, THE GERMAN CINEMA, AND REAL LIFE* (An open letter to the German Minister of Propaganda Göbbels). International Theatre (Moscow), October 1934. A reply to the propaganda minister's address to German film producers in February 1934. This also appears, in another translation, as 'Open Letter to Dr. Goebbels' in Film Art, Winter, 1934. A partial translation, from the Pariser Tageblatt, appeared in the New York Times, 30th December 1934.

1935

42. *The New Soviet Cinema; entering the fourth period*. New Theatre, January 1935. Translated by Leon Rutman. Originally published as 'At Last!' in Literaturnaya Gazeta, No 154, 18th November 1934.

43. Interview, *Eisenstein's New Film* International Literature, May 1935.

*44. *FILM FORM, 1935—NEW PROBLEMS* Life and Letters To-day (London), September; December 1935. Based on material submitted to the All-Union Creative Conference on Cinematographic Questions, Moscow, January 1935. Translated by Ivor Montagu. Reprinted in New Theatre and Film, April, May, June 1936, as 'Film Forms: New Problems'.

45. *The Enchanter from the Pear Garden*. Theatre Arts Monthly, October 1935. Originally published in a brochure issued in connection with Mei Lan-Fang's Moscow performances.

46. Interview with Louis Fischer, in 'Soviet Journey', Smith & Haas. 1935.

1936

*47. *THROUGH THEATRE TO CINEMA.* Theatre Arts Monthly, September 1936. Translated by Jay Leyda and Paya Haskell. Originally published as 'The Middle of Three (1924–1929)', in Sovietskoye Kino (Moscow), No. 11–12, November–December, 1934.

48. Interview with Leo Lania, *Films in Birth.* Living Age, November 1936. Translated from Die Neue Weltbühne (Prague), 4th June 1936.

*49. *PROGRAMME FOR TEACHING THE THEORY AND PRAC-TICE OF FILM DIRECTION.* Life and Letters To-day, No 6, No. 7,. 1936. The syllabus adopted as the basis for the course in Film Direction at the Higher State Institute of Cinematography (V.G.I.K.). Translated by Stephen Garry, with Ivor Montagu. Originally published in Iskusstvo Kino (Moscow), April 1936.

50. *Foreword* In Vladimir Nilsen's 'The Cinema as a Graphic Art' (on a theory of representation in the cinema), London, Newnes, 1936. Translated by Stephen Garry. Reprinted in Theatre Arts Monthly, May 1938.

51 Interview with Joseph Freeman, in 'An American Testament', Farrar & Rinehart, 1936. The meeting recorded here took place in 1927.

1937

*52. *THE MISTAKES OF BEZHIN LUG.* International Literature, No. 8, 1937. Originally published in the pamphlet 'About the Film *Bezhin Lug* of Eisenstein' (Moscow, 1937).

53. *The Epic in Soviet Film.* International Literature, No 10, 1937.

1938

54. *Director of 'Alexander Nevsky' Describes How the Film Was Made.* Moscow News, 5th December 1938. Reprinted in The Daily Worker, 19th March 1939.

1939

*55. *THE SOVIET SCREEN.* Moscow, Foreign Languages Publishing House, 1939. A pamphlet written for a series, issued in connection with the Soviet pavilion's exhibit at the New York World's Fair.

*56. *MY SUBJECT IS PATRIOTISM.* International Literature, No. 2, 1939. Reprinted in The Daily Worker, 1st April 1939.

57. *Foreword.* In 'Soviet Films 1938–1939', Moscow, State Publishing House for Cinema Literature, 1939. Dated April 1939.

*58. *MONTAGE IN 1938.* Life and Letters To-day, June, July, August, September, October, November 1939. Translated by Stephen Garry; technical check by Ivor Montagu. Reprinted with alterations in this volume as *Word and Image*. Originally published in Iskusstvo Kino, January 1939.

BIBLIOGRAPHY

1940

*59. *PRIDE*. International Literature, April–May 1940. Reprinted as edited by Ivor Montagu in The Anglo-Soviet Journal, April 1941. Originally published in Iskusstvo Kino, January–February 1940.

60. *Eisenstein Makes His Debut in Opera; Noted Film Director Discusses His Work on 'The Valkyrie'*. Moscow News, 28th November 1940.

61. *To the Editors of 'International Literature'; a communication*. International Literature, November–December 1940. Reprinted in The Daily Worker, 14th January 1941.

1941

*62. *FASCISM MUST AND SHALL BE DESTROYED*. In 'In Defence of Civilization Against Fascist Barbarism', Moscow, VOKS, 1941. Reprinted in a condensed version in New Masses, 25th November 1941.

1942

63. *American Films Reflect Fighting Qualities of American People*. Information Bulletin, Embassy of the USSR (Washington), 1942 (Special Supplement). Partial text of a speech read at the Conference on American and British Cinema, Moscow, 21st–22nd August 1942.

64. *'Ivan Grozny.'* VOKS Bulletin, No. 7–8, 1942.

1945

65. *How We Filmed 'Ivan the Terrible'*. Film Chronicle (Moscow), February 1945.

*66. *IN A REGISSEUR'S LABORATORY*. Film Chronicle, February 1945. Notes made during the preparation and production of *Ivan the Terrible:* 'The First Vision', and 'On the Set'.

*67. *IVAN THE TERRIBLE, A FILM SCENARIO*. Life and Letters, November, December 1945; January, February, April, May, June, July 1946. A translation, by Herbert Marshall, of the published treatment for Parts I and II, as originally planned for *Ivan the Terrible*.

1946

68. *P-R-K-F-V*. An introduction (translated by Jay Leyda) for 'Sergei Prokofiev: His Musical Life', by Israel Nestyev. New York, Alfred A. Knopf, 1946. The introduction is dated Alma-Ata, November 1942–Moscow, November 1944.

69. *Charlie the Kid*. Sight and Sound, Spring 1946; *Charlie the Grown-Up*. Sight and Sound, Summer 1946. A translation, by Herbert Marshall, of Eisenstein's contribution to 'Charles Spencer Chaplin', Moscow, 1945.

SOURCES

1. *The Journal of Eugène Delacroix*, translated from the French by Walter Pach. Covici-Friede, 1937. This appears in the entry for 13th January 1857, and is a draft preface for Delacroix's proposed Dictionary of the Fine Arts.

PART I: *Word and Image*

2. John Livingston Lowes, *The Road to Xanadu*. Houghton Mifflin, 1930, p. 330.
3. Ambrose Bierce, *The Monk and the Hangman's Daughter: Fantastic Fables*, Boni, 1925, p. 311.
4. *The Complete Works of Lewis Carroll*. Random House, 1937.
5. Sigmund Freud, *Wit and Its Relation to the Unconscious*, translated by A. A. Brill. Dodd, Mead, 1916, pp. 22–23.
6. Kurt Koffka, *Principles of Gestalt Psychology*. Harcourt, Brace, 1935, p. 176.
7. *The Works of Leo Tolstoy*. Oxford University Press, 1937 (Centenary Edition). Vol. 9, *Anna Karenina*, translated by Louise and Aylmer Maude. Part II, Chapter 24, p. 216.
8. Guy de Maupassant, *Bel Ami*, translated by Ernest Boyd. Knopf, 1923, p. 335.
9. George Arliss, *Up the Years from Bloomsbury*. Little, Brown, 1927 p. 289.
10. *The Notebooks of Leonardo da Vinci*, arranged and rendered into English by Edward MacCurdy. Garden City Publishing Company, 1941. The broken arrangement of this passage represents Eisenstein's adaptation into script form.
11. Leonardo da Vinci, *Traité de la Peinture*. Paris, Delagrave, 1921. Footnote by Joséphin Péladan, p. 181.
12. Published in *Literaturnaya Gazeta* (Moscow), No. 17, 26th March 1938.
13. *Bemerkungen ueber die neueste preussische Zensurinstruktion*, Von ein Rheinlander. In Karl Marx, *Werke und Schriften. Bis Anfang 1844, nebst Briefen und Dokumenten*. Berlin, Marx-Engels Gesamtausgabe. Section 1, Vol. I, semi-volume 1.
14. Alexander Sergeyevich Pushkin, *Polnoye Sobraniye Sochinenii*. Leningrad, Academia, 1936. Vol. II, p. 403.
15. Ibid., p. 377.
16. Ibid., pp. 409–10.
17. *Peter I*, gouache painted in 1907, in the collection of the State Tretiakov Gallery, Moscow.

18. Pushkin, edition cited. Vol. III, Chapter 1, stanza XX (cited translation by Babette Deutsch, in *The Works of Pushkin*, Random House, 1936).

19. Tolstoy, edition cited. Vol. 18, *What Is Art?*, p. 201.

20. Viktor Maksimovich Zhirmunsky, *Vvedeni v Metriku, Teoria Stikha*. Leningrad, Academia, 1925, pp. 173–4.

21. Ibid., p. 178.

22. Not found in de Musset's collected works.

23. *The Works of John Milton*. Columbia University Press, 1931. Vol. II, *Paradise Lost, The Verse*.

24. Hilaire Belloc, *Milton*. Lippincott, 1935, p. 256.

25. Milton, edition cited. Book VI, lines 78–86.

26. Ibid., Book I, lines 531–53.

27. Ibid., Book VI, lines 231–46.

28. Ibid., Book V, lines 622–24.

29. Ibid., Book VI, lines 853–71.

PART II: *Synchronization of Senses*

1. E. M. Forster, *Aspects of the Novel*. Harcourt, Brace, 1927, p. 213.

2. Richard Hughes, 'Lochinvarovic'. In *A Moment of Time*. London, Chatto & Windus, 1926, p. 26.

3. Thomas Medwin, *Journal of the Conversations of Lord Byron: Noted During a Residence with His Lordship at Pisa, in the Years 1821 and 1822*. Baltimore, E. Mickle, 1825, pp. 73–74.

4. *Journal des Goncourt*, Vol 3, Paris, Charpentier, 1888.

5. S.M.E., 'The Future of Sound Films'. Sovietski Ekran (Moscow), No. 32, 1928.

6. S.M.E., 'Not Coloured, but of Colour'. Kino Gazeta (Moscow), 24th May 1940.

7. Henry Lanz, *The Physical Basis of Rime*. Standford University Press, 1931, p. 271.

8. Karl von Eckartshausen, *Aufschlüsse zur Magie aus gepruften Erfahrungen über verborgene philosophische Wissenschaften und verdeckte Geheimnisse der Natur*, Vol. 1. München, Lentner, 1791. (Second Edition, pp. 336–39.)

9. Louis-Bertrand Castel, *Esprit, Saillies et Singularités du P. Castel*. Amsterdam, 1763, pp. 278–348. A guide to the voluminous literature of colour-music is provided by the *Oxford Dictionary of Music*.

10. René Ghil, *En Methode à l'Oeuvre* (first published in 1891). In *Oeuvres Complètes*, Vol. 3. Paris, Albert Messein, 1938, p. 239.

11. Hermann L. F. Helmholtz, *Physiological Optics*. Rochester, Optical Society of America, 1924.

12. Max Deutschbein, *Das Wesen des Romantischen*. Cöthen, Otto Schulze, 1921, p. 118.

13. Cited in Lanz, op. cit., p. 167.

14. *The Japanese Letters of Lafcadio Hearn*, edited by Elizabeth Bisland. Houghton Mifflin, 1910.

15. Ibid., letter of 5th June 1893.

16. Ibid., letter of 14th June 1893.
17. Diagram reproduced from the *T'u Shu Chi Ch'eng*, a small reprint of the K'*ang Hsi* encyclopedia. Vol. 1116, Chapter 51.
18. In Le Cahier Bleu, No. 4, 1933. The translation in the text has not been made from the French original.
19. *The Works of Friedrich Nietzsche*. Vol. XI, *The Case of Wagner*, translated by Thomas Common. Macmillan, 1896, pp. 24–25.
20. In the collection of the National Gallery, London.
21. Georgi Bogdanovich Yakulov (1884–1928). There are some plates of this artist's work for the Kamerny Theatre, Moscow, in *The Russian Theatre*, by Joseph Gregor and René Fülöp-Miller.
22. Frank Rutter, *El Greco*. Weyhe, 1930, p. 67.
23. In the collection of the Metropolitan Museum, New York.
24. Maurice Legendre and A. Hartmann, *Domenikos Theotokopoulos called El Greco*. Paris, Editions Hyperion, 1937, p. 16.
25. (Manuel de Falla), *El 'Cante Jondo' (Canto primitivo andaluz)*. Granada, Editorial Urania, 1922.
26. John Brande Trend, *Manuel de Falla and Spanish Music*, Knopf. 1929, p. 23 ff.
27. Legendre and Hartmann, op. cit., p. 27.
28. Vasili V. Yastrebtzev, *Moi vospominaniya o Nikolaye Andreyeviche Rimskom-Korsakove*. Petrograd, 1915.
29. All these cited 'colour symphonies' are in the collection of the Freer Gallery of Art, Washington, D.C.
30. Max Schlesinger, *Geschichte des Symbols, ein Versuch*. Berlin, Leonhard Simion, 1912. (Cited from Gustav Floerke, *Zehn Jahre mit Böcklin*. F. Brückmann, 1902.)
31. (Friedrich Leopold Hardenberg), *Novalis Schriften*. Vol. II. Berlin, G. Reimer, 1837, p. 172.
32. François Coppée, Ballade. Cited in 'Le Sonnet des Voyelles', R. Etiemble. Revue de Littérature Comparée, April–June, 1939.

PART III: *Colour and Meaning*

1. Walt Whitman, *Leaves of Grass*, 'Locations and Times', Doubleday, Doran (Inclusive and Authorized Edition).
2. Der gelbe Klang. Eine Bühnenkomposition von Kandinsky. In *Der blaue Reiter*. Herausgeber: Kandinsky, Franz Marc. München, R. Piper, 1912.
3. Paul Gauguin, Notes Eparses: Genèse d'un tableau. In *Paul Gauguin* by Jean de Rotonchamp. Weimar, Graf von Kessler, 1906, pp. 218–20.
4. Painted in 1892. In the collection of A. Conger Goodyear, N.Y.
5. In the collection of Stephen C. Clark, New York.
6. *Further Letters of Vincent van Gogh to His Brother, 1886–1889*. Houghton Mifflin, 1929. Letter 534.
7. August Strindberg. *There Are Crimes and Crimes*, translated from the Swedish by Edwin Björkman. Scribner's, 1912.
8. T. S. Eliot, *Collected Poems*, 'Preludes: III', Harcourt, Brace.

9. Ibid., 'Portrait of a Lady.'
10. Ibid., 'The Love Song of J. Alfred Prufrock'.
11. Andrei Belyi (Boris Nikolayevich Bugayev), *Masterstvo Gogolya*. Moscow, 1934.
12. Possibly that in the collection of Lord Kinnaird, Rossie Priory, Inchture.
13. This citation has been translated from Eisenstein's text.
14. Frédéric Portal, *Des couleurs symboliques dans l'antiquité, le Moyen-Age, et les temps modernes*. Paris, Treuttel et Wurtz, 1857 (Partly cited from Georg Friedrich Creuzer, *Réligions de l'Antiquité*, Vol. II, p. 87.)
15. Havelock Ellis, 'The Psychology of Yellow'. Popular Science Monthly, May 1906.
16. Nikolai Yakovlevich Marr (1864–1934).
17. In an apocryphal letter published originally in Ogoniok (Moscow), 16th May 1926.
18. van Gogh, op. cit., letter 520.
19. Walt Whitman, *Leaves of Grass*, 'To You'.
20. Ibid., 'Song of Myself'.
21. Ibid., 'Salut au Monde!'
22. Ibid., 'Our Old Feuillage'.
23. Walt Whitman, *Leaves of Grass*, 'Song of the Redwood-Tree'.
24. Ibid., 'Sparkles from the Wheel'.
25. Ibid., 'Italian Music in Dakota'.
26. Ibid., 'When Lilacs Last in the Dooryard Bloom'd'.
27. Ibid., op. cit.
28. Ibid., 'The Wound-Dresser'.
29. Ibid., 'The Sleepers'.
30. Portal, op. cit.
31. *Parisismen: Alphabetisch geordnete Sammlung der eigenartigsten Ausdrucksweisen des Pariser Argot von Prof. Dr. Césaire Villatte*. Berlin-Schöneberg, Langenscheidtsche Verlagsbuchhandlung, 1888.
32. Cited in Eric Partridge, *A Dictionary of Slang and Unconventional English*, London, Routledge, 1937.
33. John S. Farmer and W. E. Henley, *Slang and Its Analogues Past and Present*, Vol. VII. London, 1890.
34. Maurice H. Weseen, *A Dictionary of American Slang*. Crowell, 1934.
35. *Goethe's Theory of Colours*, translated from the German by Charles Lock Eastlake. London, John Murray, 1840.
36. Portal, op. cit., p. 212.
37. Denis Diderot, *Lettres à Sophie Volland*. Paris, Gallimard, 1930. Vol. 1. Lettre XLVII, 20th Octobre 1760.
38. James Frazer, *The Golden Bough, a Study in Magic and Religion*, Macmillan, 1934. Part I, 'The Magic Art and the Evolution of Kings', pp. 15–16.
39. Maxim Gorky, 'Paul Verlaine and the Decadents'. *Samarskaya Gazeta* (Samara), Nos. 81, 85, 1896.
40. Ibid.
41. Havelock Ellis, 'The Psychology of Red'. Popular Science Monthly, August–September 1900.

42. Max Nordau, *Degeneration*. Appleton, 1895. Book I: Fin de Siècle. (Cited from Alfred Binet, Recherches sur les Altérations de la Conscience chez les Hystériques. In *Revue Philosophique*, Vol. XVII, 1889; and Ch. Féré, Sensation et Mouvement. In *Revue Philosophique*, 1886, pp. 28–29.

43. *Poetry and Prose of William Blake*. Random House, 1939. Annotations to Sir Joshua Reynolds' Discourses, p. 770.

44. Filipp Andreyevich Malyavin. This painting is in the collection of the State Tretiakov Gallery, Moscow.

45. Goethe, op. cit.

46. Lev Semyonovich Vygotski (1896–1934); Alexander Romanovich Luriya, author of *The Nature of Human Conflicts* (Liveright, 1932), and visiting lecturer at Columbia University.

4ñ. Jean d'Udine (Albert Cozanet), *L'Art et le Geste*. Paris, Alcan. 1910, pp. 48–49.

PART IV: *Form and Content: Practice*

1. *The Journal of Eugène Delacroix*, edition cited, p. 312.

2. *The Life of Hector Berlioz*, translated by Katherine F. Boult. Dutton, 1923, p. 38.

3. From Joyce's essay on James Clarence Mangan, published in 1903. Quoted in Herbert Gorman's *James Joyce*.

4. Piotr Pavlenko, *Red Planes Fly East*, translated by Stephen Garry. International Publishers, 1938, pp. 256–7.

5. Albert Schweitzer, *J. S. Bach*, translated by Ernest Newman. London, Breitkopf & Härtel, 1911. Vol. II, Chapter XXIII.

6. In a letter dated 3rd February 1865, as translated and published in Music & Letters, London, April 1923.

7. Charles Gounod, *Autobiographical Reminiscences*. London, Heinemann, 1896.

8. Tolstoy, edition cited, *War and Peace*, Book 6, Chapter 13.

9. Pushkin, edition cited, Vol. II, p. 431. (Cited translation by A. F. B. Clark in The Slavonic and East European Review, January 1937.)

10. Pushkin, edition cited, Vol. II, p. 468. (Cited translation by Oliver Elton in *The Works of Pushkin*, Random House, 1936.)

11. Entry for 10th March 1849.

12. Blake, edition cited, p. 816.

13. Gogol, *Arabesques*, 'The Last Days of Pompeii'.

14. Léo Larguir, *Cézanne ou le drame de la peinture*. Paris, Denoël & Steele, n.d., p. 32.

15. *Die Wiener Genesis*. Vienna, Dr. Benno Filser Verlag, 1931.

16. Auguste Rodin, *Art*. Translated from the French of Paul Gsell by Mrs. Romilly Fedden. Dodd, Mead, 1912, p. 82.

17. Pushkin, edition cited. Vol. II, p. 267.

18. *The Letters of Mozart and His Family*, edited by Emily Anderson. Macmillan, 1938. Vol. III, p. 1144.

19. *Correspondence of Wagner and Liszt*. Scribner's, 1897. Vol. I, letter 125, from Zurich, 16th August 1853.

INDEX